Waste Land

Meditations on a Ravaged Landscape

Photographs and Essays by David T. Hanson

Preface by Wendell Berry
Afterword by Mark Dowie

Additional Texts by:

William Kittredge

Susan Griffin

Peter Montague and Maria B. Pellerano

Terry Tempest Williams

Aperture

Aperture gratefully acknowledges the generous support of:

ROBERT GLENN KETCHUM AND ADVOCACY ARTS FOUNDATION,

CALIFORNIA COMMUNITY FOUNDATION,

THE LUND FOUNDATION,

FURTHERMORE, THE PUBLICATION PROGRAM OF THE J. M. KAPLAN FUND

and THE TURNER FOUNDATION, INC.

Without their help, this publication would not have been possible.

Library of Congress Catalog Number: 97-70513
Hardcover ISBN: 0-89381-726-0
Book design by Bethany Johns Design, New York
Jacket design by Roger Gorman/Reiner NYC
Photography of original prints by Cathy Carver
Typesetting and composition by Michelle M. Dunn
Separations, printing, and binding by Sfera Srl, Milan, Italy

The staff at Aperture for *Waste Land* is:
Michael E. Hoffman, Executive Director; Diana C. Stoll, Editor;
Ivan Vartanian, Associate Editor; Elizabeth Franzen, Managing Editor;
Stevan A. Baron, Production Director; Helen Marra, Production Manager;
Phyllis E. P. Thompson, Editorial Work-Scholar; Serena Park, Production Work-Scholar

Aperture publishes a periodical, books, and portfolios of fine photography to communicate with serious photographers and creative people everywhere. A complete catalog is available upon request. Address: 20 East 23rd Street, New York, New York 10010. Phone: (212) 598-4205, TOLL FREE (800) 929-2323. Fax: (212) 598-4015.

Aperture Foundation books are distributed internationally through: CANADA—General Publishing, 30 Lesmill Road, Don Mills, Ontario, M3B 2T6. Fax: (416) 445-5991. UNITED KINGDOM—Robert Hale, Ltd., Clerkenwell House, 45-47 Clerkenwell Green, London EC1R OHT. Fax: 171-490-4958. CONTINENTAL EUROPE—Nilsson & Lamm, BV, Pampuslaan 212-214, P.O. Box 195, 1382 JS Weesp. Fax: 31-294-415054.

For international magazine subscription orders for the periodical *Aperture*, contact Aperture International Subscription Service, P.O. Box 14, Harold Hill, Romford, RM3 8EQ, England. Fax: 1-708-372-046. One year: £30.00. Price subject to change. To subscribe to the periodical *Aperture* in the U.S. write Aperture, P.O. Box 3000, Denville, NJ 07834. One year: $40.00.

First edition
10 9 8 7 6 5 4 3 2 1

The image on the endpapers of Waste Land *is taken from* Targeted Terrain *(1995–96), a wall drawing in graphite on gunpowder and soil. It represents a scale map (1:62,500) of bombing targets at the Dugway Proving Ground, Utah, at the height of its operation in the mid 1950s. The site has been used for extensive chemical, biological, radiological, and conventional weapons testing.*

Preface by Wendell Berry

It is unfortunately supposable that some people will account for these photographic images as "abstract art," or will see them as "beautiful shapes." But anybody who troubles to identify in these pictures the things that are readily identifiable (trees, buildings, roads, vehicles, etc.) will see that nothing in them is abstract and that their common subject is a monstrous ugliness.

The power of these photographs is in their terrifying, because undeniable, particularity. They are representations of bad art—if by art we mean the ways and products of human work. If some of these results look abstract—unidentifiable, or unlike anything we have seen before—that is because nobody foresaw, because nobody cared, what they would look like. They are the inevitable consequences of our habit of working without imagination and without affection. They prove that our large-scale industrial projects are at once experimental, in the sense that we do not know what their consequences will be, and definitive because of the virtual permanence of these same consequences. And what we can see in these vandalized and perhaps irreparable landscapes we are obliged to understand as symbolic of what we cannot see: the steady seeping of poison into our world and our bodies.

David Hanson's art is here put forthrightly to the use of showing us what most of us, in fact, have not seen before, do not wish to see now, and yet must see if we are to save ourselves and our land from such work and such results. He has given us the topography of our open wounds.

Introduction by David T. Hanson

During the past fifteen years, my photographic work and mixed-media installations have investigated the contemporary American landscape as it reflects our culture and its most constructive and destructive energies. These works explore a broad range of American environments, from mines and power plants to military installations, hazardous waste sites, and industrial and agricultural landscapes, examining the relationship of humans with their environment in the late twentieth century. Beginning with the series *Colstrip, Montana*, and continuing through *Minuteman Missile Sites*, *Waste Land*, and *"The Treasure State": Montana 1889–1989*, these four bodies of work begin to reveal an entire pattern of terrain transformed by human beings to serve their needs. They become, finally, meditations on a ravaged landscape.

Focusing on the region where I grew up, *Colstrip, Montana* (1982–85) is an extended study of one of the largest coal strip mines in North America, its coal-fired power plant, and the modern-day factory town that it surrounds. The town of Colstrip was established in 1923 on top of some of the richest coal reserves in the world when the Northern Pacific Railroad began mining coal there for its steam locomotives. In 1959, Northern Pacific (having switched from steam power to diesel) sold the coal leases, mines, and townsite to the Montana Power Company. During the late 1960s and '70s, as more stringent federal air-quality control laws were passed and as nationwide demand for cleaner low-sulfur coal increased, Montana Power expanded the mine for its own coal needs as well as for sales to utility companies in the Midwest. Following the national energy crises of the early 1970s, Montana Power built a coal-fired electrical generating plant. At the peak of its production in the mid 1980s, the Colstrip mine produced 16 million tons of coal per year, half of it consumed by the power plant and the rest shipped to Minnesota and Wisconsin utilities.[1] Currently the largest generating power station west of the Mississippi, the Colstrip plant produces twice as much electrical energy as is consumed by the entire state of Montana. The plant is primarily owned by Washington and Oregon utilities, and two-thirds of its output is sent across thousands of miles of wires to light up Seattle, Portland, and even Los Angeles.

A sequence of sixty-six color photographs, *Colstrip, Montana* begins with images of the company houses and trailer parks, followed by photographs of the mine, power plant, industrial site, and surrounding land. The series ends with aerial views of the site and the ever-widening circle of devastation radiating from what Montana Power advertises as a "carefully planned, award-winning community."

As my work evolved, the aerial view increasingly seemed to be the most appropriate form of representation for the late twentieth-century landscape: an abstracted and distanced technological view of the earth, mirroring the military's applications of aerial photography for surveillance and targeting. The aerial view realizes the Cartesian rationalization and abstraction of space that has preoccupied Western culture and visual art for the past three hundred years. It delivers with military efficiency a contemporary version of the omniscient gaze of the Panopticon, the nineteenth century's ultimate tool for surveillance and control. The aerial perspective also allows for the framing of relationships between objects that may seem unrelated on the ground, and it permits access to sites with security restrictions. What otherwise cannot be pictured becomes available to the camera.

Minuteman Missile Sites (1984–85) examines more closely the industrial and military landscape in my native region through a series of aerial photographs of intercontinental ballistic missile silos and launch control facilities in the American West. When this work was completed, there were over 1,000 Minuteman silos spread across 80,000 square miles in eight states, each silo containing a nuclear missile nearly a hundred times as powerful as the atomic bomb dropped on Hiroshima.[2] Aerial views of targeted terrain, these images reveal some of America's "secret landscapes." These anonymous but deadly constructions hidden within the pastoral agricultural landscape of the High Plains form a complex, interconnected grid, and constitute one of the major capital investments of our culture. Some of these missile sites have recently been "retired" and destroyed as a result of changing post–Cold War geopolitics.

Our fifty-year-old nuclear era, a very brief moment in geological time, will leave a legacy of nuclear waste that will last for hundreds of thousands of years.

Waste Land (1985–86) is a study of hazardous waste sites throughout the United States, and it encompasses a wider range of American landscapes. In 1985, the U.S. Environmental Protection Agency's National Priorities List ("Superfund") consisted of 782 sites that were considered the most dangerous of over 400,000 hazardous sites throughout the country. From those, I selected sixty-seven sites that represented a cross-section of American geography and industrial waste activities. Again I used aerial photography to gain access to high-security areas and to contextualize the sites within their larger surrounding landscapes, as well as to minimize my own exposure to these highly toxic environments. *Waste Land* includes nineteenth-century mines, smelters, and wood-processing plants, landfills and illicit dumps, large petrochemical complexes, aerospace water-contamination sites, nuclear weapons plants, and nerve gas disposal areas. I sequenced the sites according to EPA's Hazard Ranking System, beginning with the federal facilities. They are located in urban, industrial, residential, agricultural, and rural areas. In some cases, the waste problems are dramatically evident, and in others they are invisible, con-cealed beneath suburban developments or industrial and military installations.

To provide a context and history for each *Waste Land* site, I employed a triptych format incorporating three different methods of site description: my aerial photograph; a U.S. Geological Survey topographic map that I modified to indicate the site as defined by EPA within its surrounding environment; and an EPA text that details the history of the site, its hazards, and the remedial action taken. Each EPA text dates from the time when the site was proposed for Superfund listing. These texts illustrate the mechanics of the bureaucracy that oversees and regulates hazardous waste in the United States; they also reveal some of the elaborate legal strategies used by individuals and companies to postpone or evade financial responsibility for the contamination and cleanup. Rarely, however, do the EPA texts' cool bureaucratic language touch on the sites' economic, political, and social costs, or the tremendous toll they have taken in human lives and suffering.

Of the sixty-seven sites included in *Waste Land*, only seven have been removed from the Superfund in the past ten years—all of these either for technical reasons or because the sites were small and the contamination relatively simple to address. Since 1980, only 132 of the current total of 1,259 sites have been removed from Superfund, while many remain essentially unchanged, pending litigation or environmental studies regarding feasible solutions. In reality none of these places will ever be fully reclaimed or returned to their original condition. Their "cleanup" merely amounts to emergency removal, stabilization, and long-term containment. Often the "cleanup" entails writing off the primary ecological problems as either insoluble or too expensive to consider.[3] Many sites present problems for which there are no known solutions; others will require years of complex remedial investigations and feasibility studies. A substantial number of sites for which solutions have been determined remain virtually untouched, awaiting the allocation of necessary cleanup funds. Many of the individuals and companies responsible for the contamination have used bankruptcy laws or a variety of other legal maneuvers to avoid paying for the cleanup, thus shifting the financial burden to the American taxpayer.

The Rocky Mountain Arsenal in Denver provides a particularly disconcerting example of the "creative," cost-effective solutions that the new "green" military is finding for the enormous cleanups it faces. The manufacture and subsequent demilitarizing and disposing of mustard gas, nerve gas, other chemical weapons, and conventional munitions (in addition to extensive pesticide manufacturing and disposal) have extensively contaminated the Arsenal, which has often been labeled "the most polluted site on Earth." In 1992, Congress officially designated the area as the Rocky Mountain Arsenal National Wildlife Refuge. The Arsenal has used its new status for strategic public-relations effect, including tours for grade-school children bused in from the Denver area to experience firsthand this "historic native grasslands and wildlife refuge" (complete with a Rocky Mountain Arsenal Coloring Book).

"The Treasure State": Montana 1889–1989 is a personal response to the recent centennial celebration: "100 Years of Progress in Montana." This series (1991–93) is a study of land use in Montana, examining the primary economic and industrial forces that have shaped and radically altered the state's environment. I photographed farms and cattle feed lots, timber clear-cuts and paper mills, mines and smelters, military bases, the oil and gas industries, industrial waste sites, railroads and airports, hydroelectric dams, urban and suburban environments, and tourist recreation areas. Each site is paired with one of Montana's imperiled wildlife species that have been impacted by it. The Latin and common names of the species have been etched onto the glass covering the print. Under a gallery spotlight, the etched text is projected onto the recessed print below, casting a kind of "ghost shadow" of the name onto the

photograph. The works are sequenced by the species' name, alphabetically within taxonomic class. The correspondences between sites and species are in most cases direct and documented: for example, the siltation and contamination of streams by logging and paper mills have severely impacted the bull trout, and the damming of major regional rivers like the Missouri and Big Horn has destroyed the breeding habitat for several bird species and disrupted the spawning of pallid sturgeon and other native fish. In some cases the correspondences are more broadly representative of the toll taken on native wildlife and habitat by increasing agriculture, industry, human population, and tourism. All of the animals included in this series have been heavily impacted by human activities; their numbers have declined significantly, and they are now vulnerable to extinction. Most of them are officially listed as endangered, threatened, or candidates for listing; some of them are already extirpated. All that remains are their names, faint traces evoking those that have disappeared.

One recent incident underscores the dangers that Montana's industrial environment currently poses to native species. In November 1995, a flock of snow geese migrating from the Arctic to California stopped over in Butte. Unfortunately, they landed in the Berkeley Pit, the world's largest toxic pond, filled with 28 billion gallons of highly poisonous mine wastes. Within the next two days, 342 snow geese were found dead in the lake, all of them poisoned and internally burned. Surrounded by one of the largest open-pit copper mines in the world, Butte is a part of the biggest Superfund hazardous waste site in the United States. Wastes from 130 years of gold and copper mining and smelting have heavily polluted the neighboring hillsides, grasslands, and 100 miles of the Clark Fork River. Instead of lush mountain valleys and pristine creeks and rivers with abundant wetlands and rich aquatic life, we are left with a barren wasteland, frequent fish kills, toxic dust storms, and the carcasses of snow geese floating in a sulfurous, poisoned pit.

Notes

1. The Colstrip mine currently produces about 10 million tons of coal per year. Since the mines first opened in 1923, approximately 350 million tons of coal have been dug up. The coal seam at Colstrip is part of the Fort Union Formation, which has almost 50 billion tons of coal left that are strip-mineable. The place that is now Colstrip was originally part of the tribal land of the Crow, who called it both "Where the Enemy Camp" and "Where the Colts Died."

2. The first Minuteman 1 missiles became operational in October of 1962, in the midst of the Cuban missile crisis (when the American public first saw aerial photographic "evidence" of Soviet activities). The yield of the Minuteman missiles varies from sixty to two hundred times that of the Hiroshima bomb, which had a yield of 23 kilotons.

3. For more than a century, Butte, Montana was known as "The Richest Hill on Earth." The cleanup of the vast Superfund site created there will cost an estimated $1 billion. But it will exclude the most serious environmental problems, which have been determined to be economically unfeasible or impossible to solve (including a $7 to $10 billion cleanup of an extensive bedrock and aquifer system that is permanently contaminated). Environmental engineers have estimated that fully reclaiming the Butte site to its original condition, were this even possible, would cost far more than the total mining revenues ever generated there.

Eating Ourselves Alive by William Kittredge

The Marion 8200 dragline at the Rosebud mine in eastern Montana can move a hundred tons of rock in one bite. More than one hundred million tons of coal have come out of the Rosebud so far.

There's an estimated fifty billion tons of coal under the plains of eastern Montana. That's a lot of Montana left to strip mine. The work's just beginning. But the draglines will get the work done. They're eating up the world in Montana, day and night, leaving wreckage.

In the 1950s, when I was a young man serving the United States as a very minor functionary in the intelligence operations of the Strategic Air Command, most of my work-mates and I believed we were performing sacred duties. We were cynical and knowing about the inefficiencies and injustices of military life in the way of minor-league time-servers anywhere, but our lives were redeemed because we knew chaos—the fiery furnace and the nuclear end of human decencies, all the millennia of human progress—was just a bad moment away.

Maybe it was. Citizens in the Soviet Union were just like us, and felt as threatened as we did. It was likely they felt, as we did, that weaponry could protect them from the barbarians. Ours were posturing cultures in a frightened time.

We felt great destructiveness was permissible in defense of ourselves and our people—in my case a young wife, our babies. Great sacrifices were regarded as absolutely necessary, including the devastation caused by nuclear testing, and even the lives of luckless citizens who turned up downwind. Gonna bake a cake, gotta break some eggs.

The Cold War was an orgy of mutual mistrust and paranoia, and it was hard to think of a response, once we were in it, other than gearing up to defend ourselves. Now history has moved on and we are no longer compelled to maintain such vast military forces. But nothing has changed. Around the world people are still ruining vast sections of their homelands, this time to drive the machinery of economic progress. Great dams on the rivers of the Pacific Northwest, built for flood control and irrigation water and hydroelectric power, together with too much commercial fishing and the siltation of their spawning beds from upstream logging, have nearly led to the extinction of the salmon fishery. On the Yangtze River in China, the reservoir behind the Three Gorges Dam, when filled, will back water over 372 miles of farmland, wildlife habitat, and spectacular scenery. Nine large towns will be flooded. In India twenty-one million people have been moved because of dams in the last forty years. A quarter of the people in the former Soviet Union live in areas of critical or catastrophic environmental degradation. The listing could go on and on—oil spills, nuclear accidents and worldwide deforestation, pesticide poisonings and killer air-pollution, holes in the ozone layer—make your own list. The wreckage is beyond imagining. And all for important economic projects. The operative notion is always urgency, heedlessness, forget the future. Our blindness is taken to be necessary and thus forgivable.

What do we think we're doing? Are we working to improve human lives? Or are we sacrificing the mantle of life covering the earth in an attempt to barricade ourselves against acknowledging our true, mortal situation? If so, it's a pathetic objective. Nobody wants to forgo progress. But we must learn to understand progress as a movement toward economic and political justice, toward joyous lives. Gross national product is simply power, and power for its own sake is a toy. We can only save ourselves through acts of the imagination. Do people have the force of will to tear out the dams? Could citizens of Montana decide they want to shut down the Marion 8200 dragline at the Rosebud mine? Could they decide the prairies are worth more than the devastation? Would that be heretical? Saying no to life, to the religion of economic progress? We have to quit wrecking the world piecemeal—bite by bite. Otherwise, we're just in the business of manufacturing a homemade coffin in space.

Colstrip, Montana

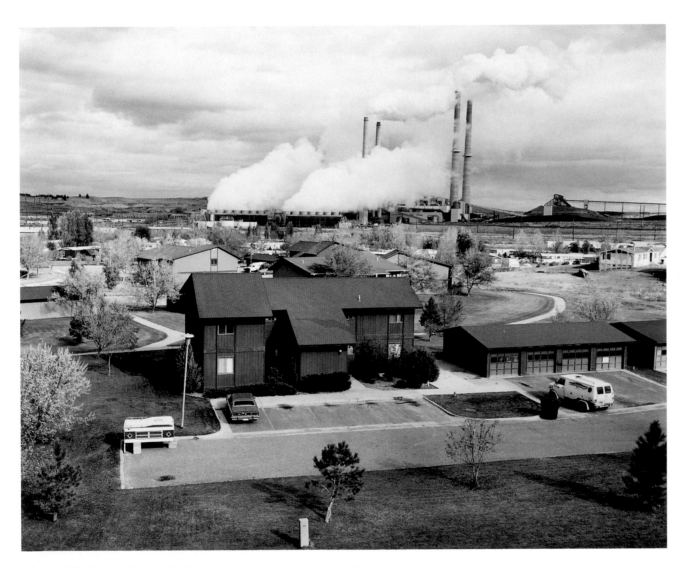

View from First Baptist Church of Colstrip: company houses and power plant
Series of Ektacolor prints, each 9 x 11"

1982–85

Colstrip, Montana is the site of one of the largest coal strip mines in North America. This sequence of sixty-six photographs was created in the early 1980s, when the mine was at the peak of its production, yielding 16 million tons of coal per year, half of which was consumed by the on-site power plant and the rest shipped to Minnesota and Wisconsin utilities. Currently generating more power than any other station west of the Mississippi, the Colstrip plant produces twice as much electrical energy as is consumed by the entire state of Montana. The plant is owned primarily by Washington and Oregon utilities, which use two-thirds of its output.

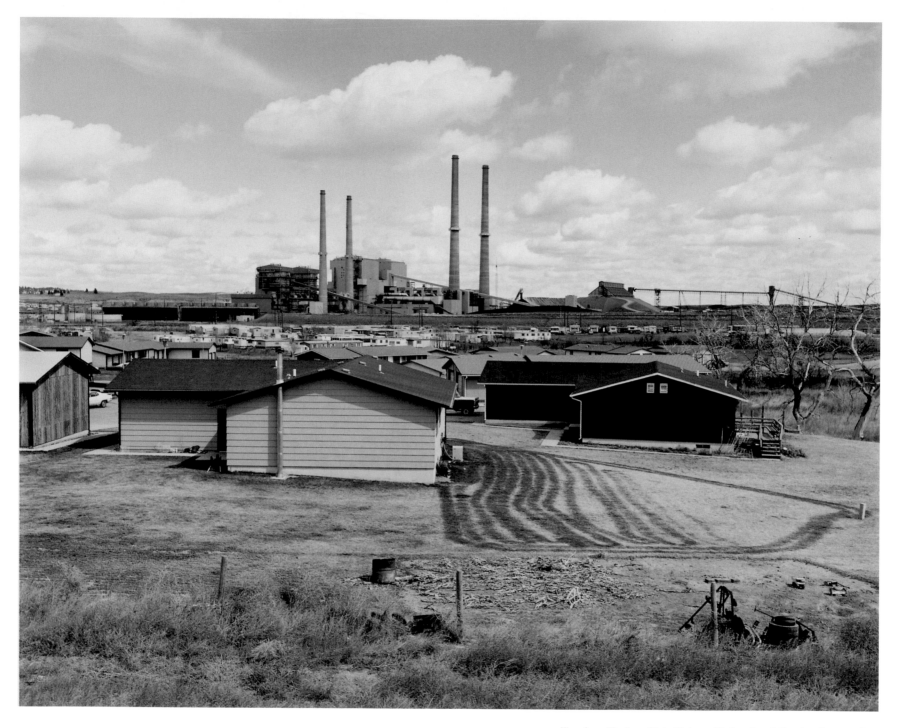

View from Montana State Highway 39: Sagebrush Court and power plant

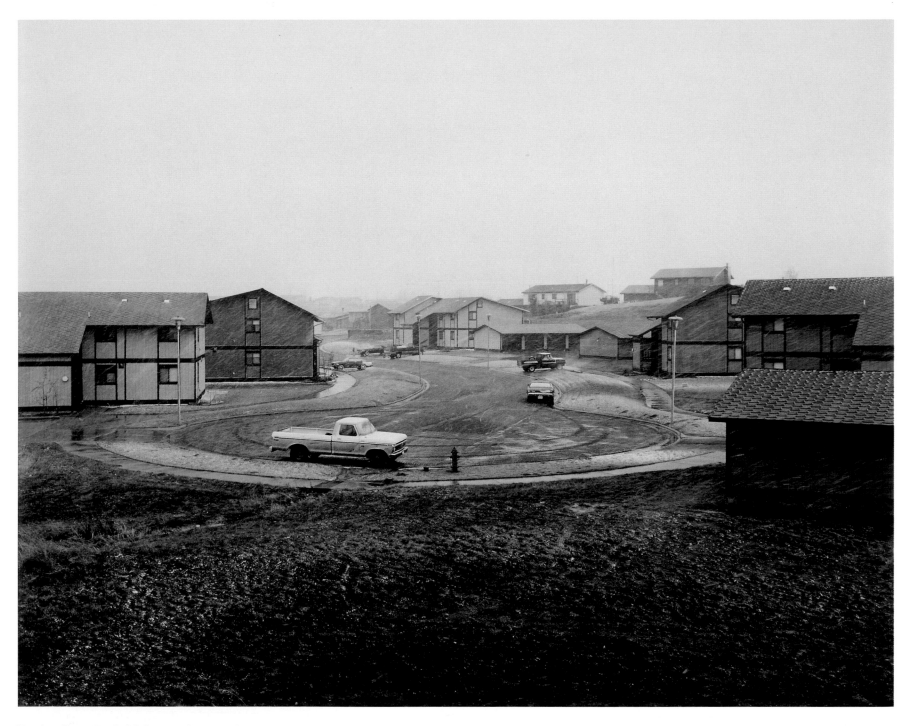

View from Power Road: Ash Street and company houses

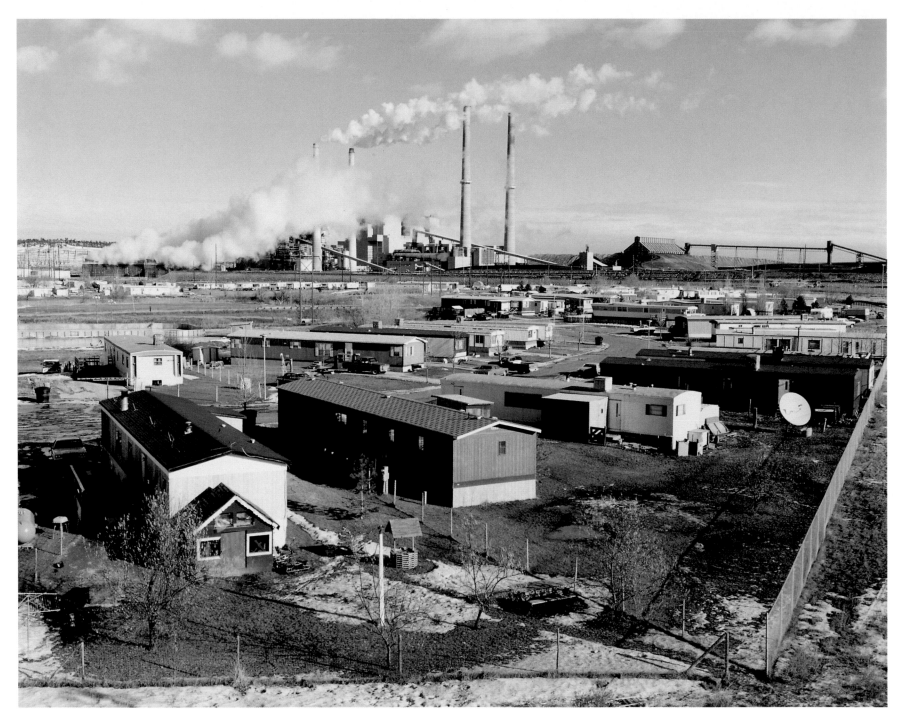

View from State Highway 39: Cottonwood Drive and power plant

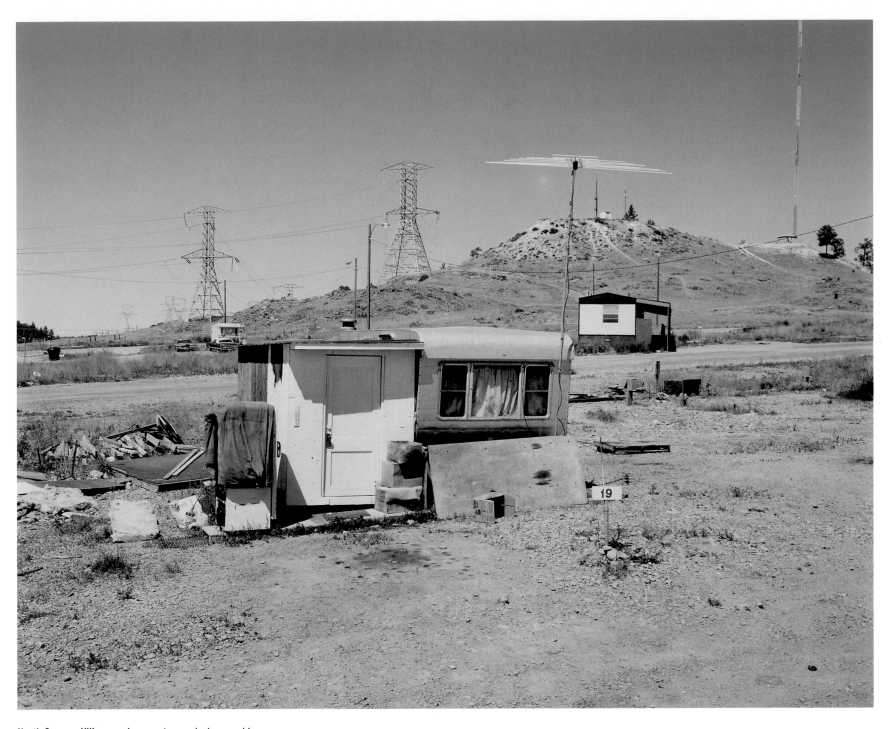

North Camper Village and power transmission corridor

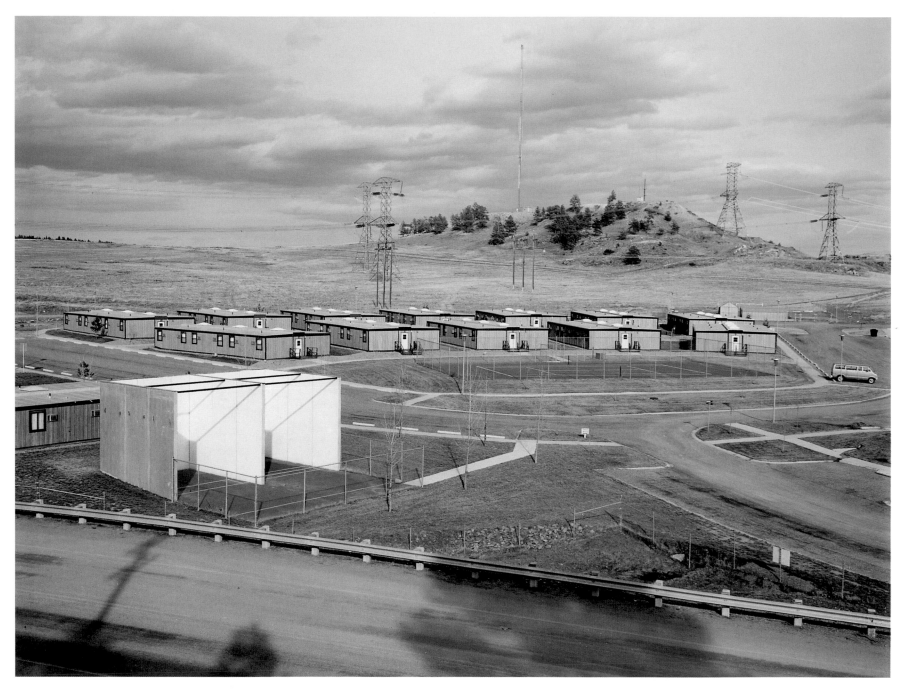

Bachelor Village, Power Road and power transmission corridor

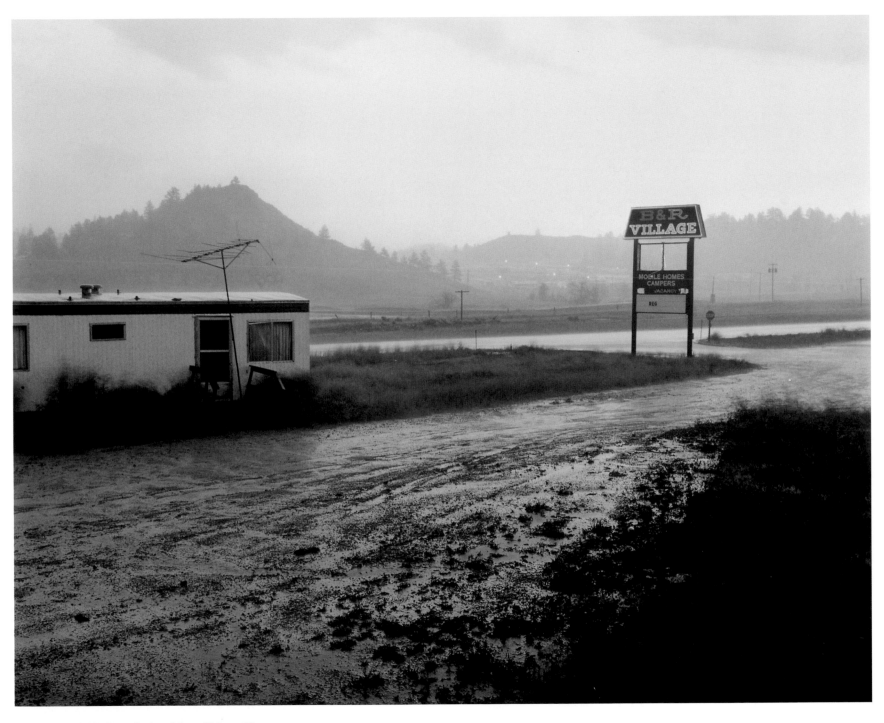

B & R Village Mobile Home Park and State Highway 39

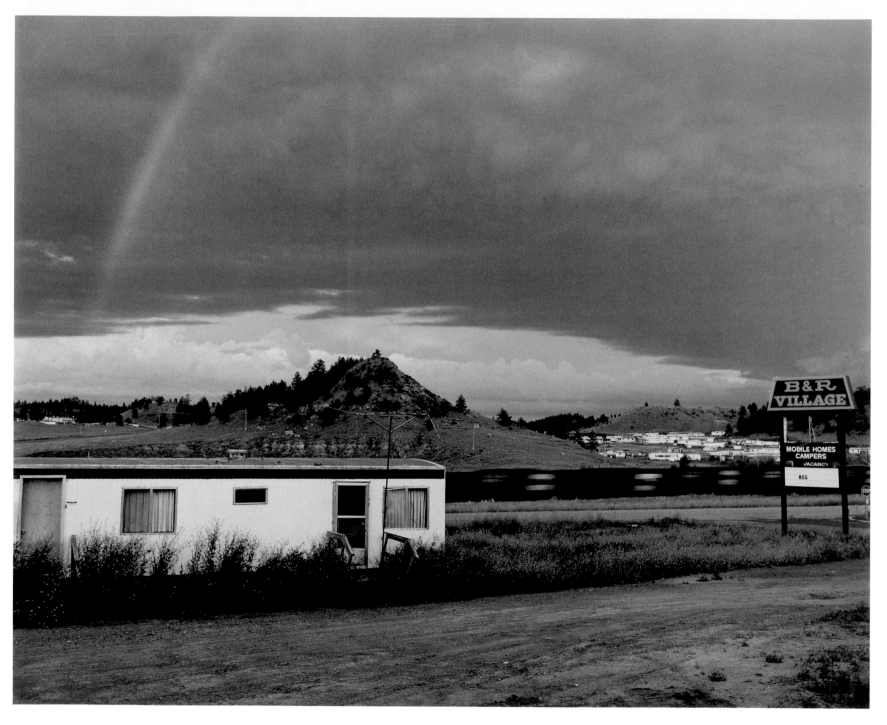

B & R Village Mobile Home Park and Burlington Northern coal train

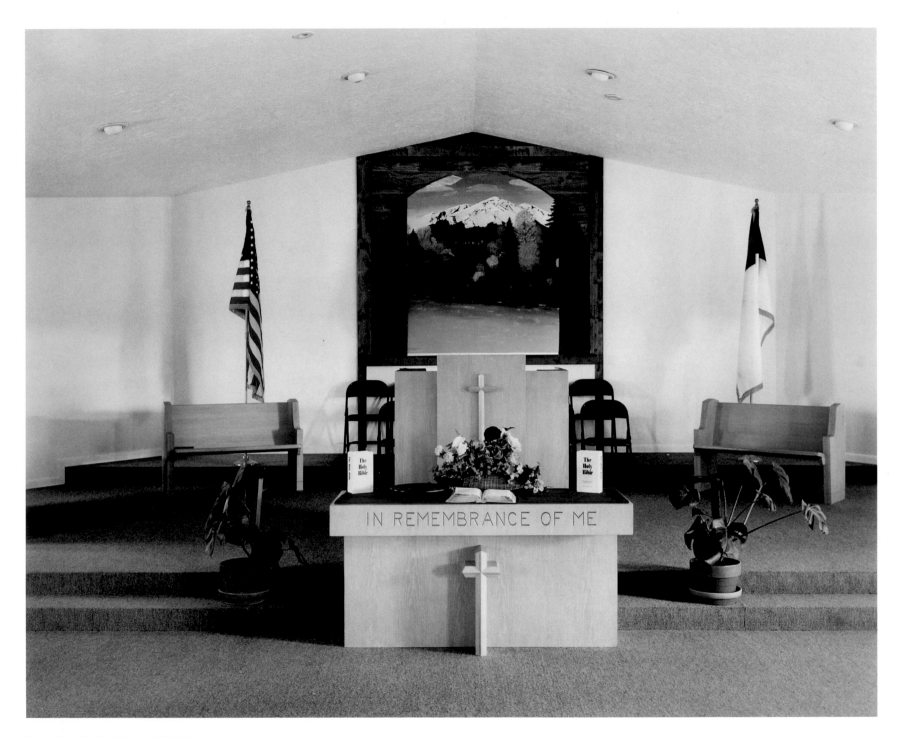

Pulpit, First Baptist Church of Colstrip

View from Sarpy Creek Road: new mine area and spoil piles

Semi-reclaimed mine land

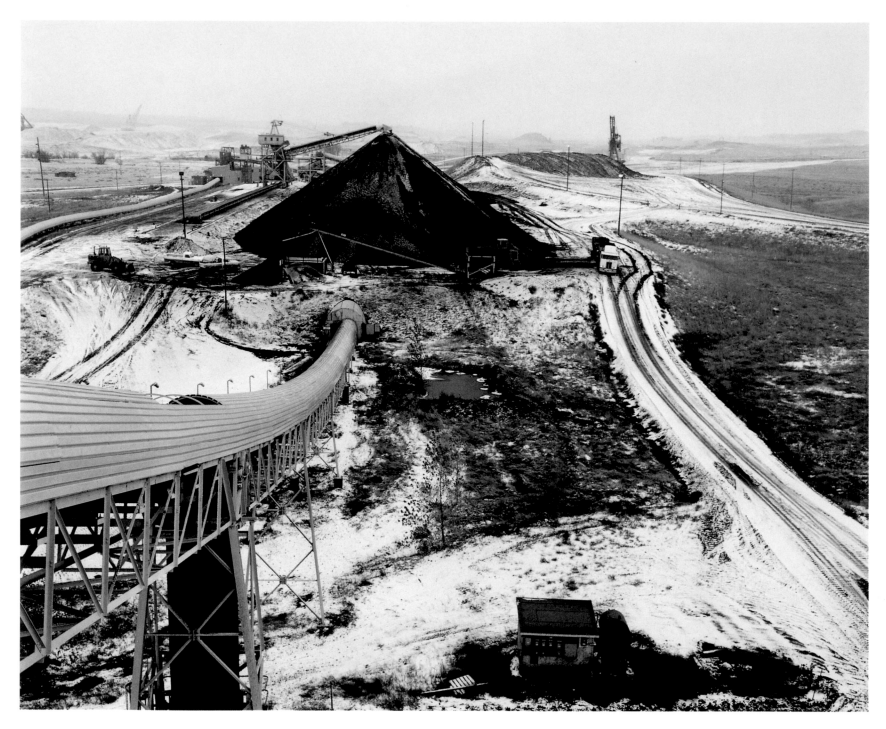

Coal storage area and railroad tipple

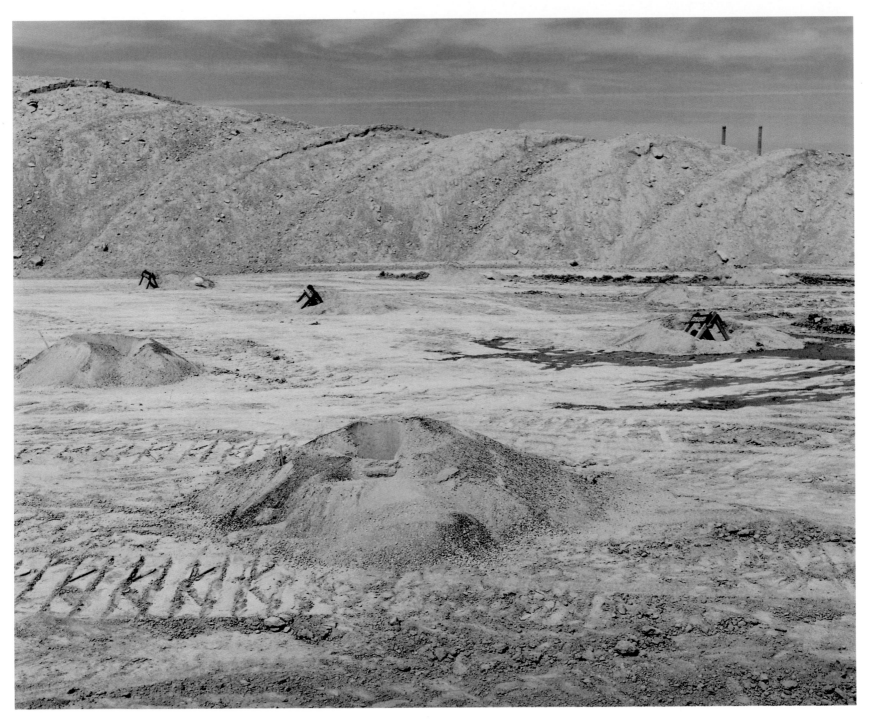

Drilling and loading explosives for an overburden blast

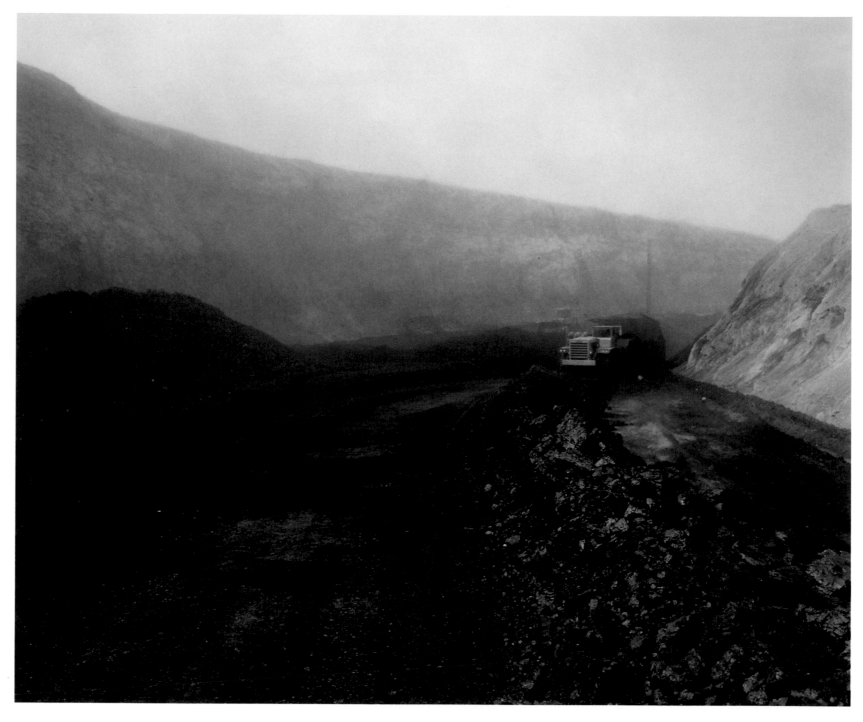

After a coal blast, in the pit

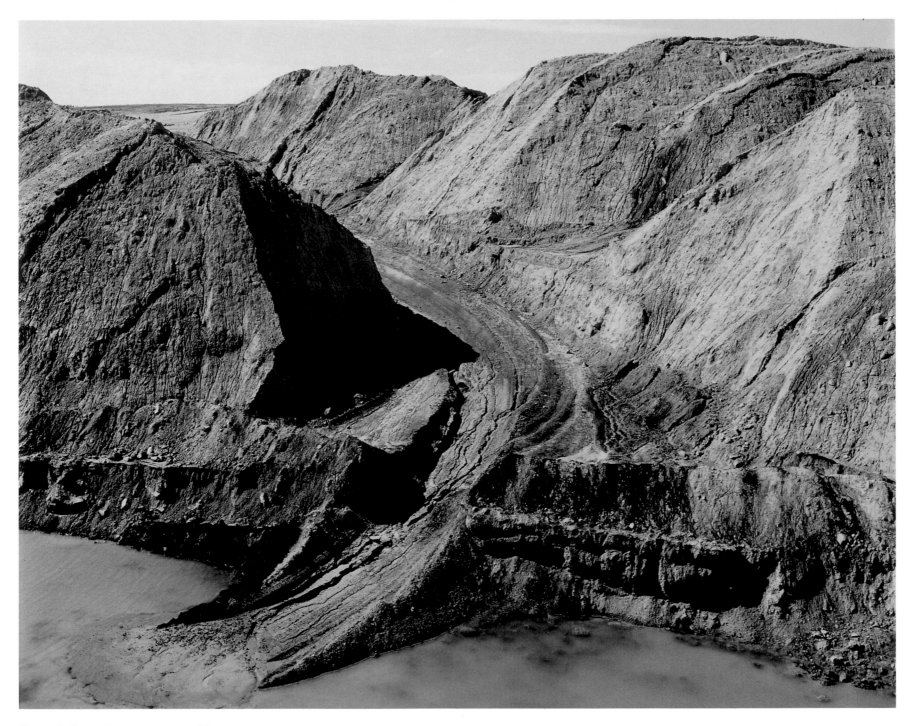

Mine spoil piles and intersected water table

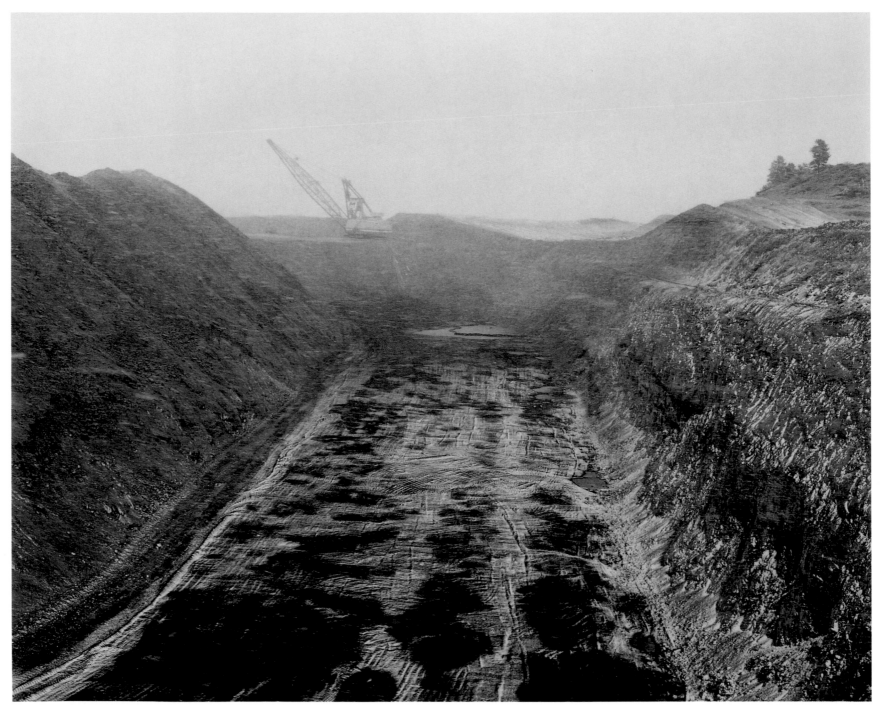

Rosebud mine pit, dragline and spoil piles

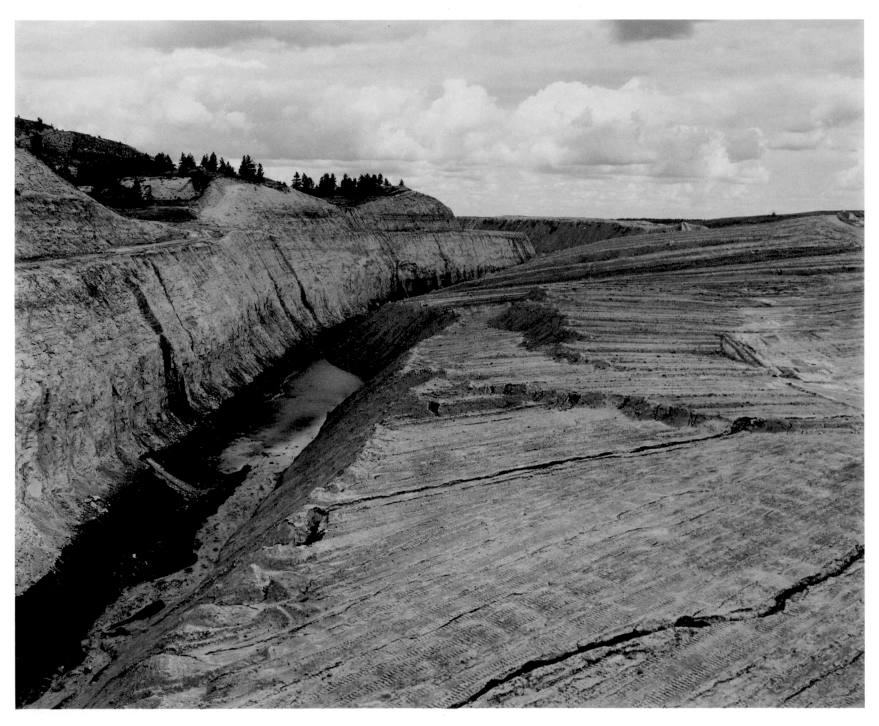

Abandoned strip mine and unreclaimed mine land

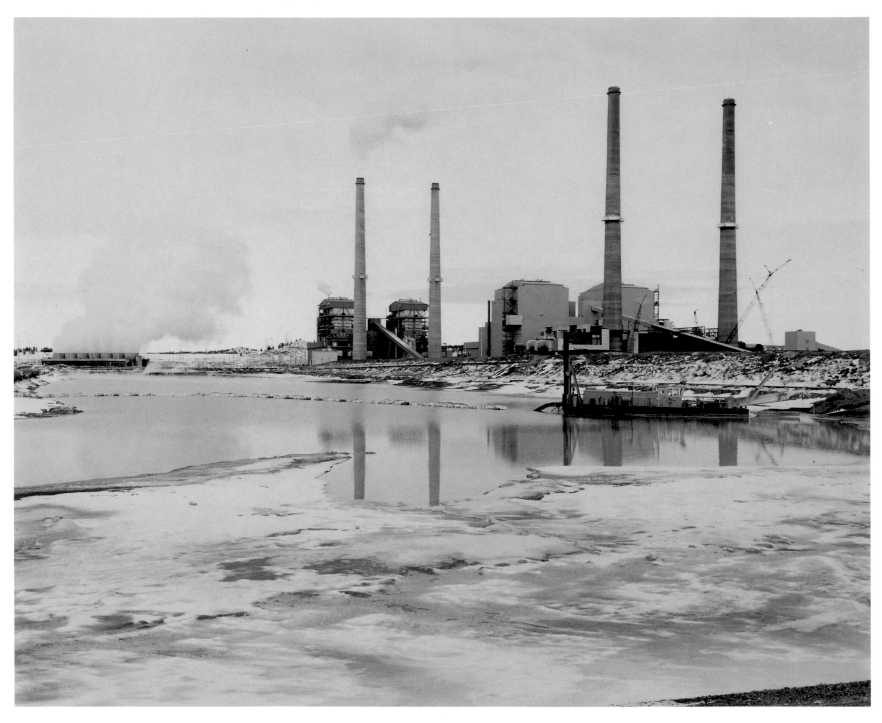

Power plant, waste pond and dredge

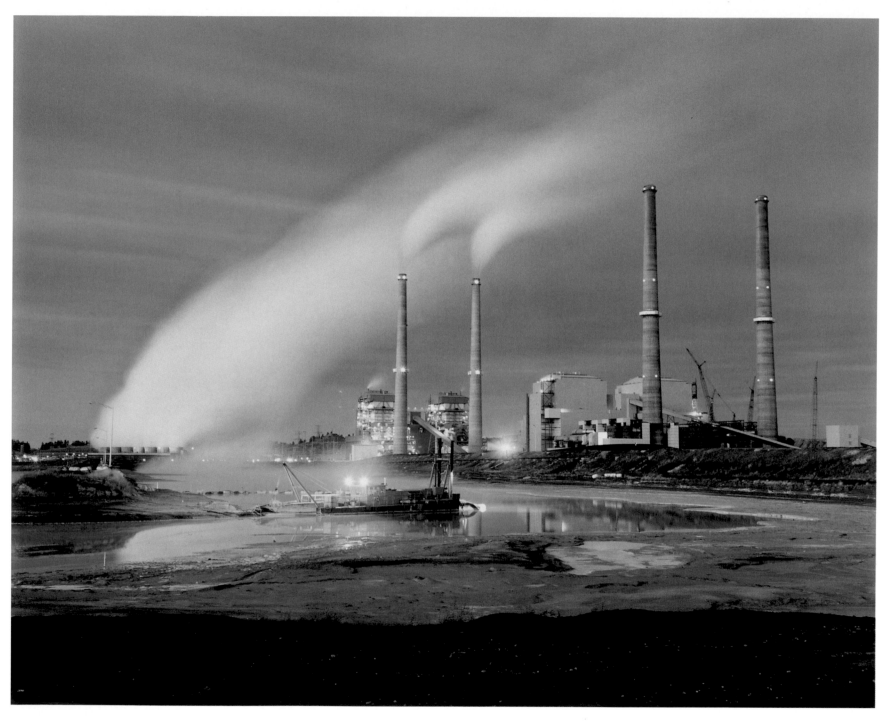

Power plant, waste pond and dredge

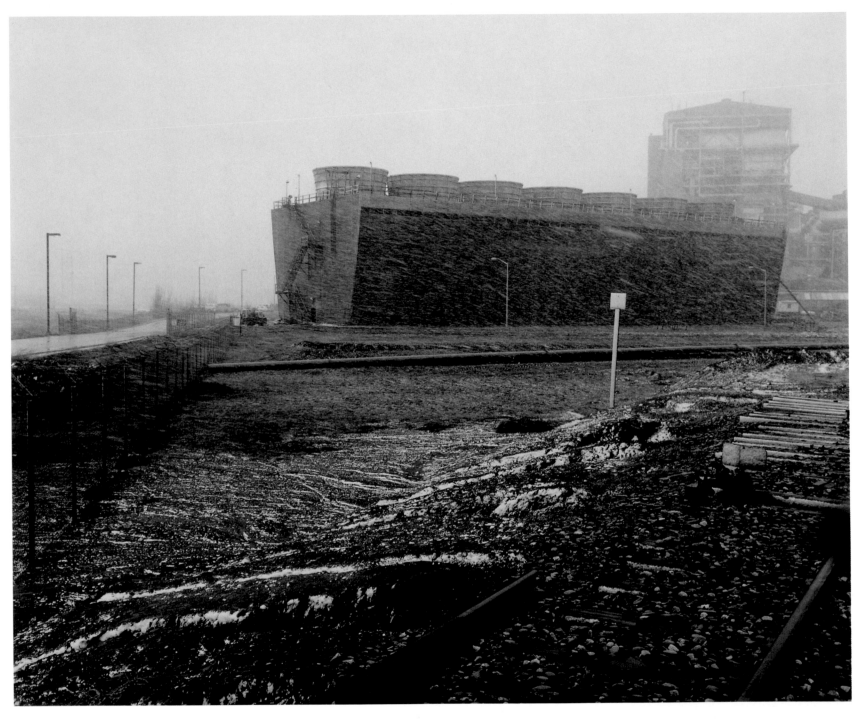

Cooling towers, power plant and railroad spur

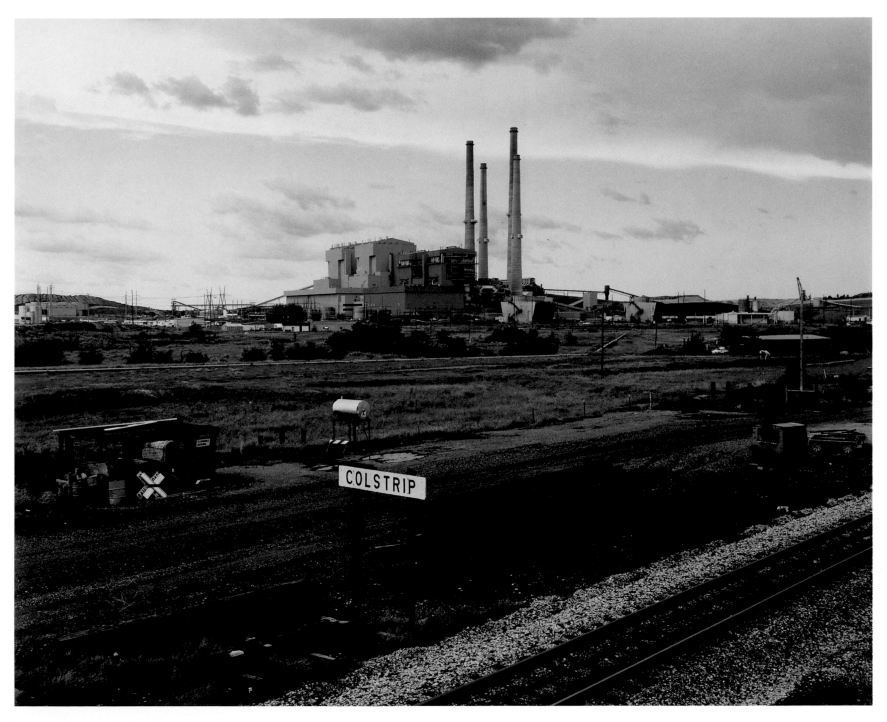

Burlington Northern switching yard and power plant

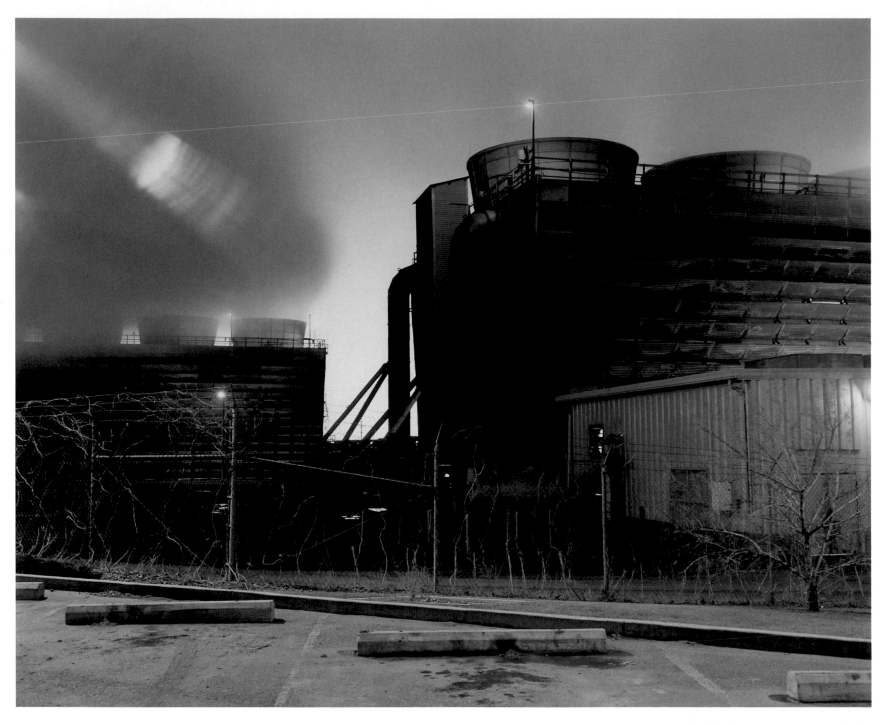

Cooling towers and company parking lot

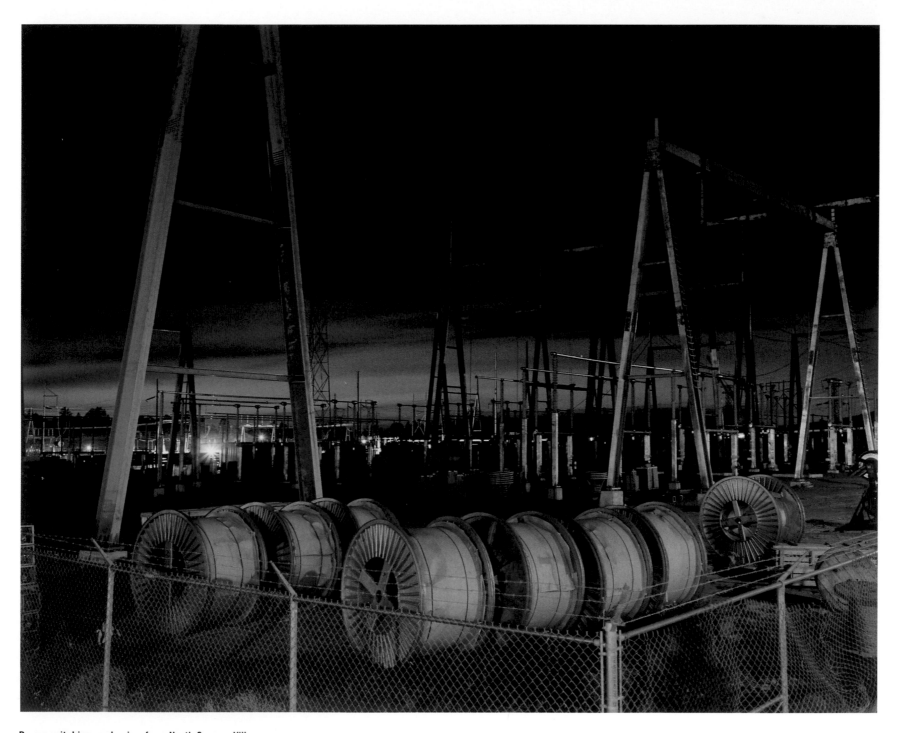

Power switching yard: view from North Camper Village

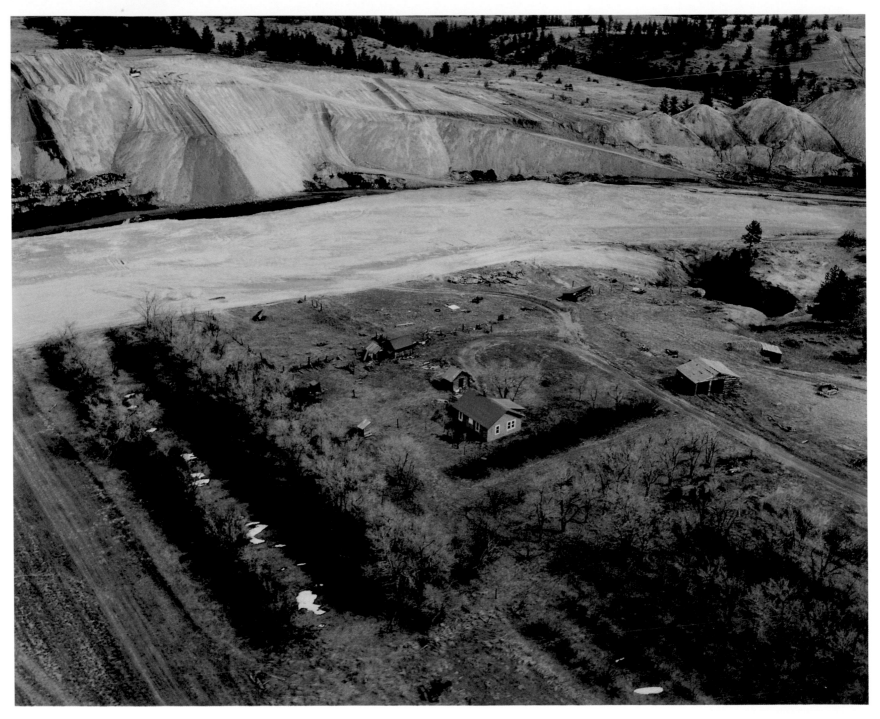

Coal strip mine and abandoned farm

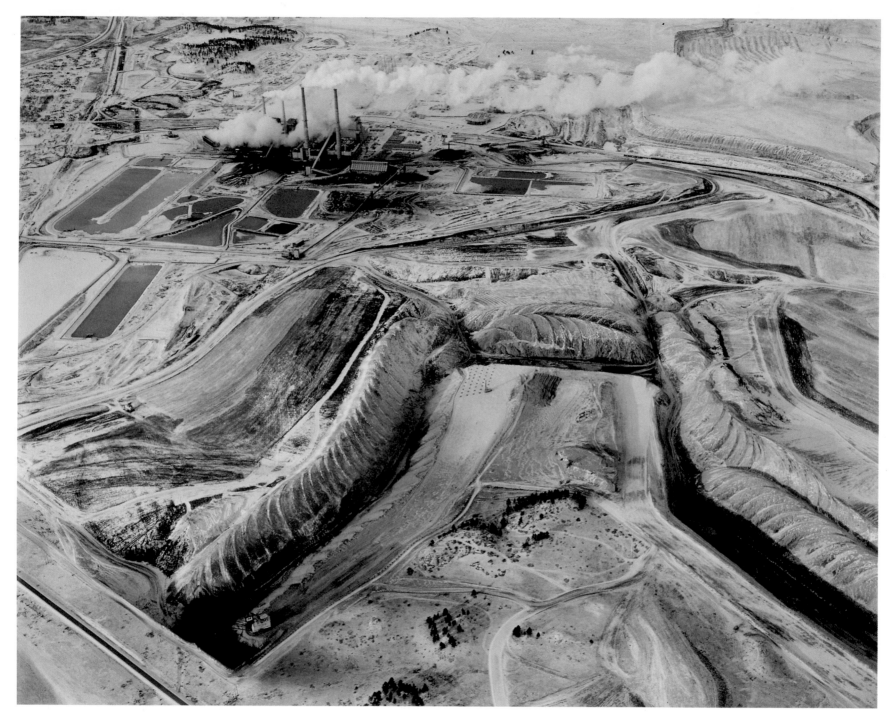

Coal strip mine, power plant and waste ponds

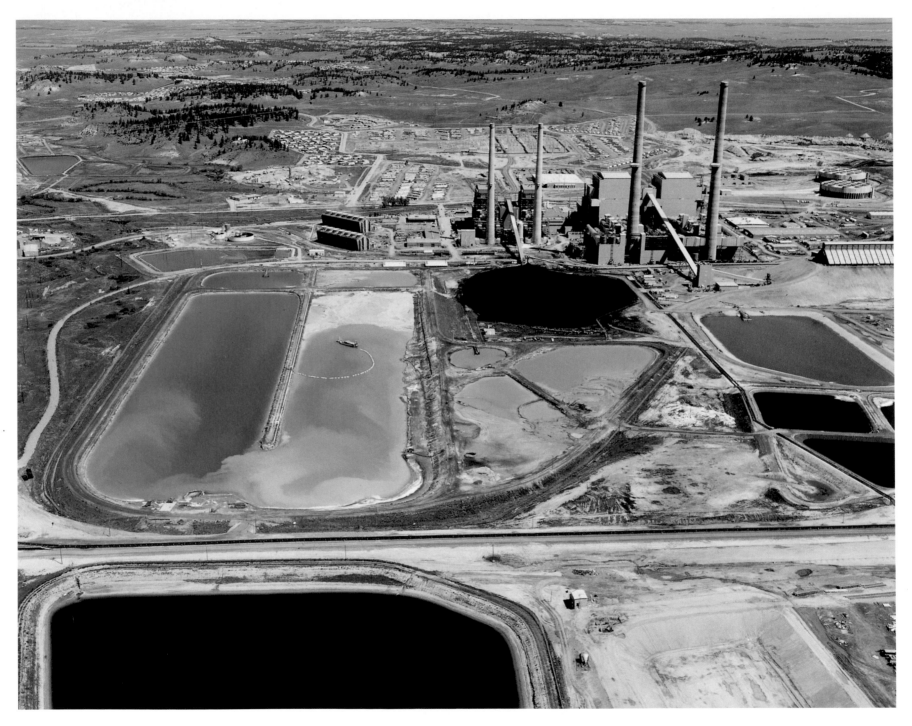

Power plant and waste ponds

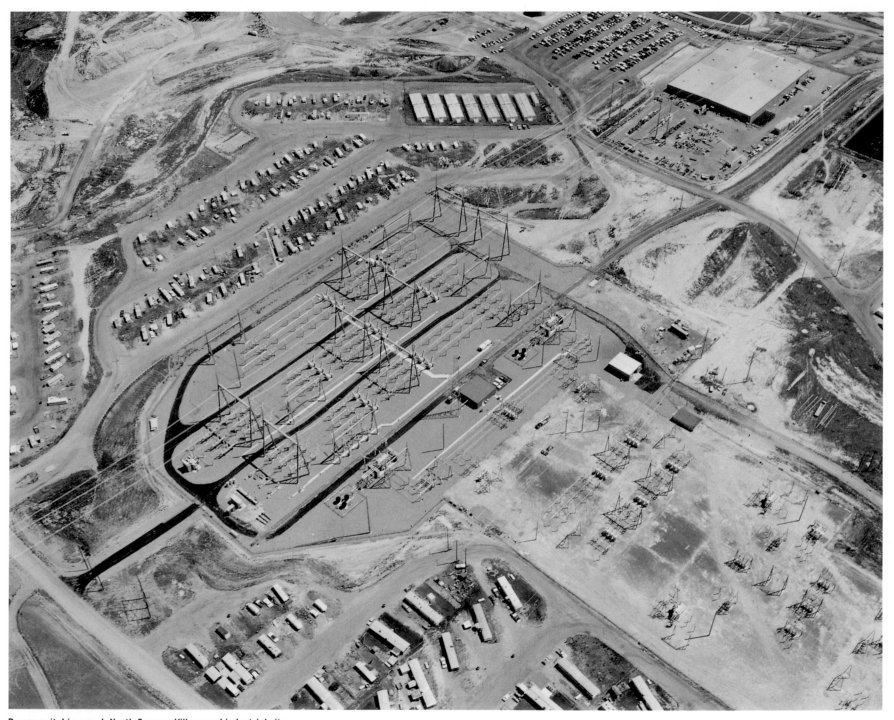

Power switching yard, North Camper Village and industrial site

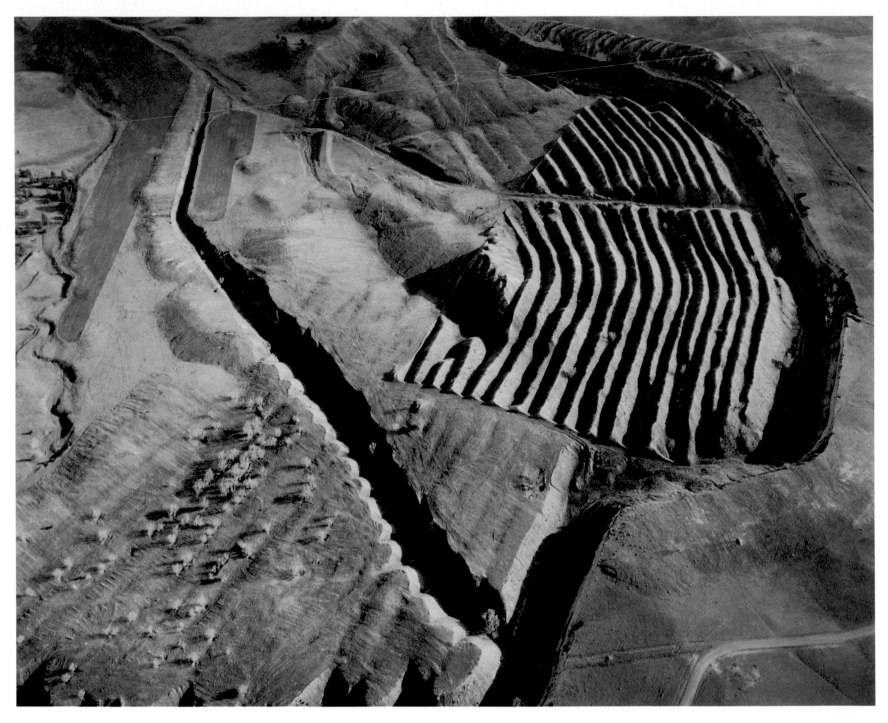

Unreclaimed mine land from the 1930s

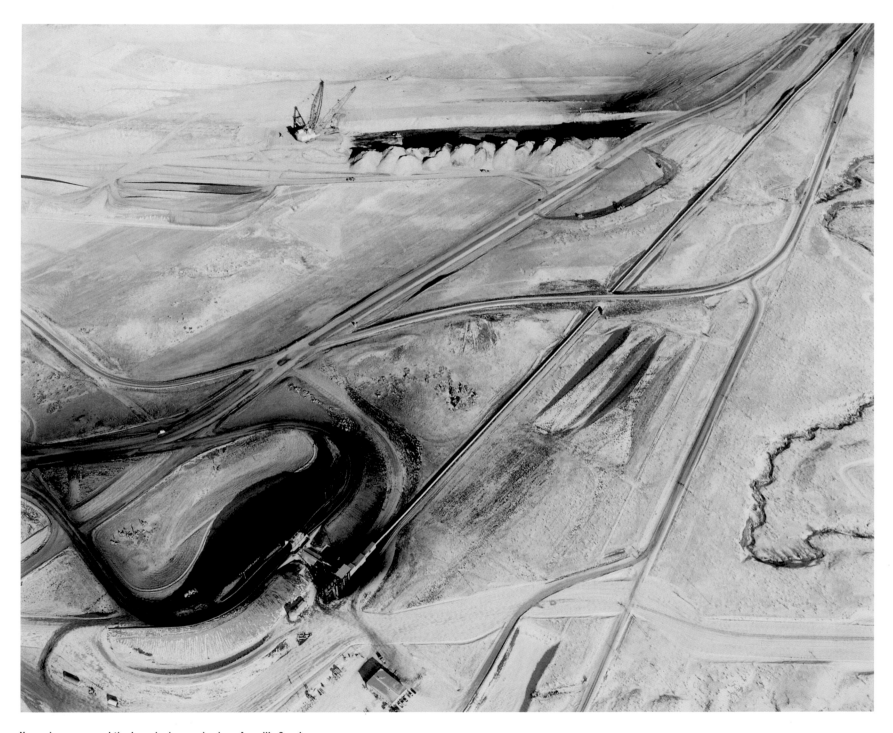

New mine area, coal tipple and mine roads along Armell's Creek

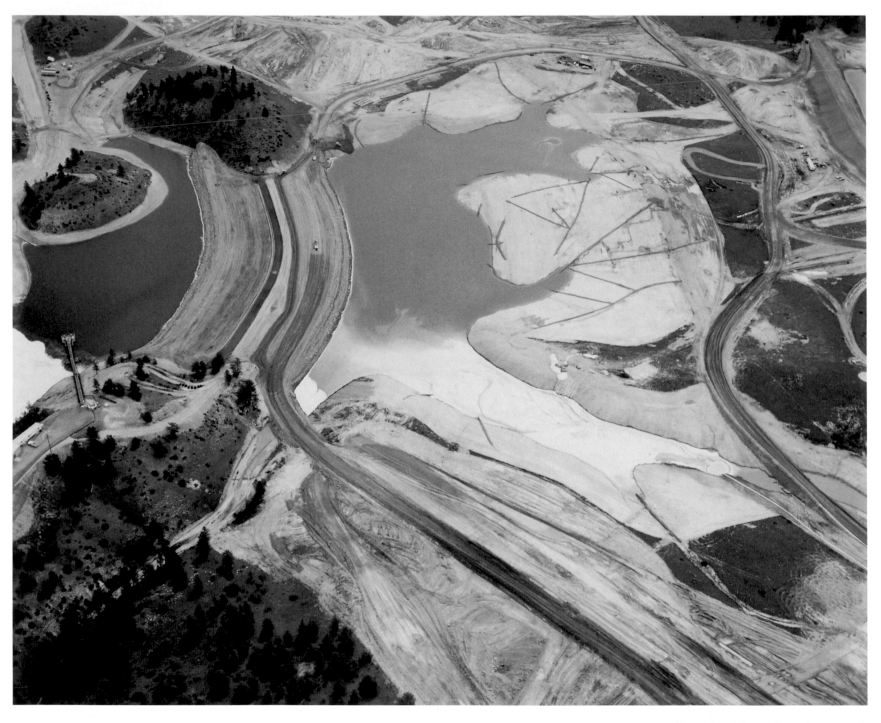

Excavation, deforestation and waste ponds

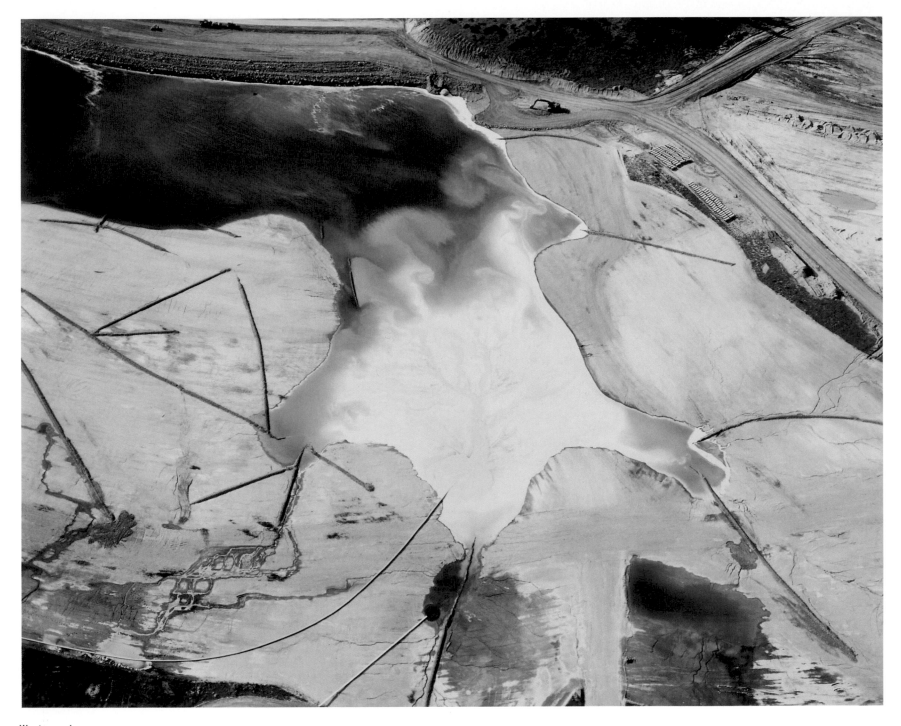

Waste pond

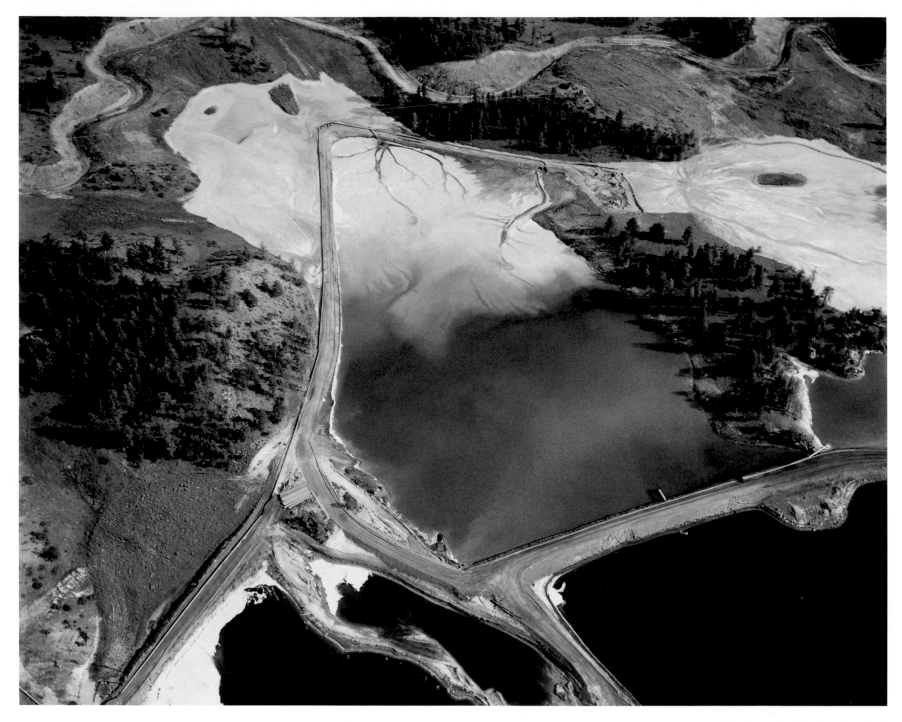

Waste ponds and evaporation ponds

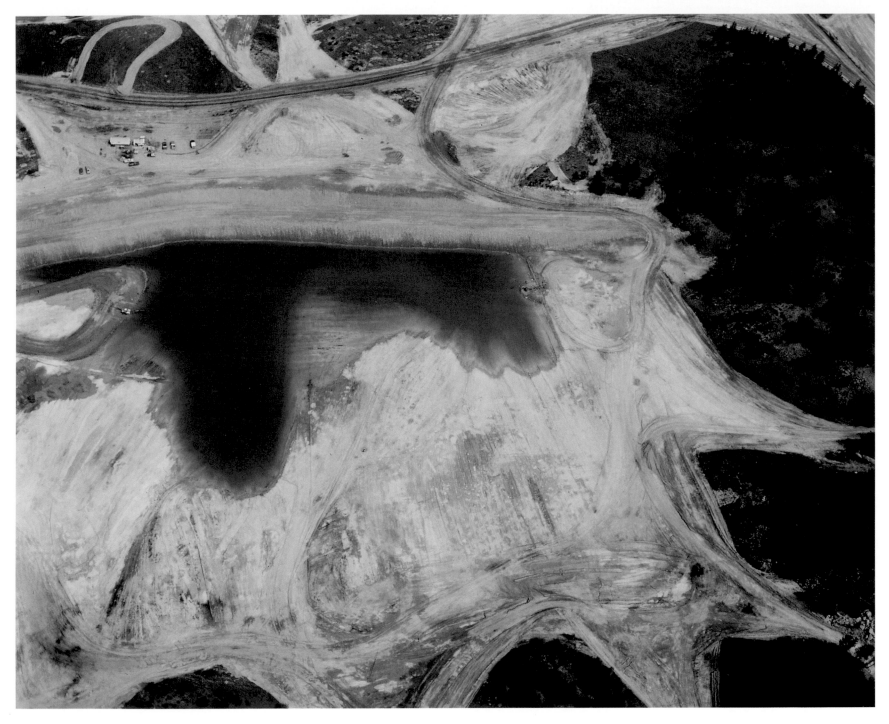

Excavation, deforestation and waste pond

Looking at This Landscape,
She Tries to Reason It Out by Susan Griffin

No thinking occurs this way of course. Along a perfectly clear, straight line leading from one point to another, to the next and then the next, until there is a neat conclusion. The idea of an irrefutable finding discovered by unbroken increments of logic is an illusion. Even the most analytical thought is more serpentine than this. Time interposes. Sleep. Dreams. You muse. You stare. In the course of two hours you follow several leads, meet several dead ends and then, defeated and hungry, you stop to take a meal. Which will be something you threw together ingenuously with the last bit of lettuce, since you have not driven down the hill to the market in several days, and there isn't any lettuce in the garden; there is hardly any garden at all, because you need to improve the soil and you can't do that now, it's been raining, which is just as well since you haven't the money to spend; so you're glad for these last three leaves, and the bit of leftover chicken you can add.

And though you miss that connection between the ground you are standing on and the food you eat, the meal, the filled feeling, the good taste of it, makes you a bit sleepy. You lie down maybe on the bed or maybe on the couch. You look at catalogs. You like to do this because the content of them is sufficiently far away from what you're trying to think through, and you are distracted. Which seems appropriate. To go any further now you have somehow got to untie the knot of yourself. There is the gardener's catalog with its beautiful clay sculpted borders you know you will never buy yet you like looking at the picture of them. Thinking. Imagining how they would be in your garden. Too stiff you think. A bit too formal. Then you shut your eyes. The pillow seems to swim but you know it's really you, your consciousness, moving off into that other space, the sleepy space and then suddenly you are awake again.

And what is it? You can hardly remember what the problem was. What you were thinking about. So you shake the last remnants of sleep off and climb the stairs and there it is, a bit bracing, the last sentence. And you can see that this was the problem. The last sentence. It turns you in the wrong direction. It sailed out of the sentence before it without skipping even a beat but that was the problem. It was rote. As sleek and shiny as you were able to make it, the words clever, it had lost contact with the ground of your thought. And you knew it not because you could see the illogic of it, which you couldn't then, not yet, but because it had a certain dullness under the shine. That spark of recognition that only comes when the words somehow hold a trace of all that you know that cannot quite be put into words was missing.

From this false start, this mistaken direction, there would have been no way to make that parabolic curve, the roundness, like a hill, a path around a lake, the eyes circumscribing, embracing, surrounded and held by at the same time encircling, the return, after a journey, back to where you started, except that you have traveled, and all the texture of your trip, the uneven ground you have treaded, the knowledge in the soles of your feet, has changed you, so that coming back, you are both different and more yourself.

Though the false start would have come back on you too, had already shown itself as defeat and exhaustion, the flatlands of despair from which no escape seems possible, and in which you believe you just have to continue, spiritless and doomed to the same direction. But now you are released from that fate. You have seen the error. Like a punch-drunk boxer who plugs away at every shadow you were stuck in argument, debate. Defensive, aggressive, overzealous in your effort, lurching forward too fast, you failed to notice what was there. Just in the sentence before. Something beautiful still to be teased open. A motion more subtle than speed. And from that discovery you are able to detect a trace of the erotic. That silent scent that will change an atmosphere by the smallest degree. But this, of course, is everything.

Minuteman Missile Sites

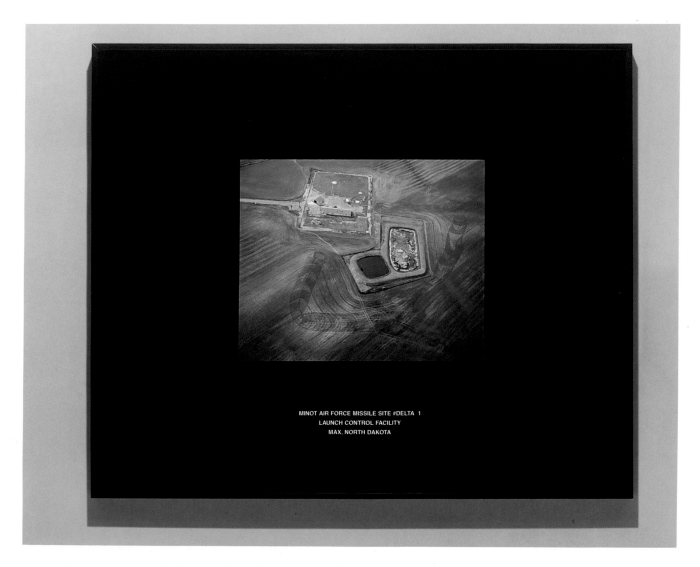

Minot Air Force Missile Site #Delta–1, Launch Control Facility, Max, North Dakota. Installation view.
Series of Ektacolor prints, each 20 x 24". The works on the following pages have been slightly cropped for reproduction.

1984–85

There are more than 1,000 Minuteman missile silos spread across 80,000 square miles in eight states throughout the Midwest. Each of these silos contains a missile with a destructive potential approximately a hundred times that of the bomb dropped on Hiroshima. The twenty works in this series reveal some of the secret constructions hidden within the pastoral landscape of the High Plains. The widespread nuclear waste left from the production of the missiles will remain deadly for more than 250,000 years.

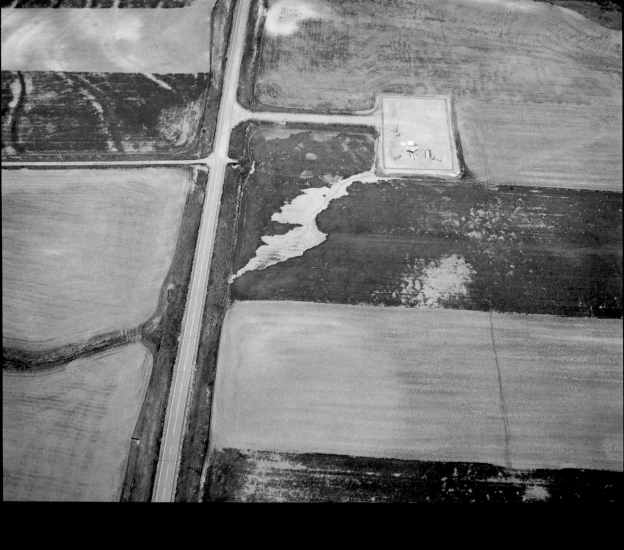

ELLSWORTH AIR FORCE MISSILE SITE #BRAVO–6

44th STRATEGIC MISSILE WING

WALL, SOUTH DAKOTA

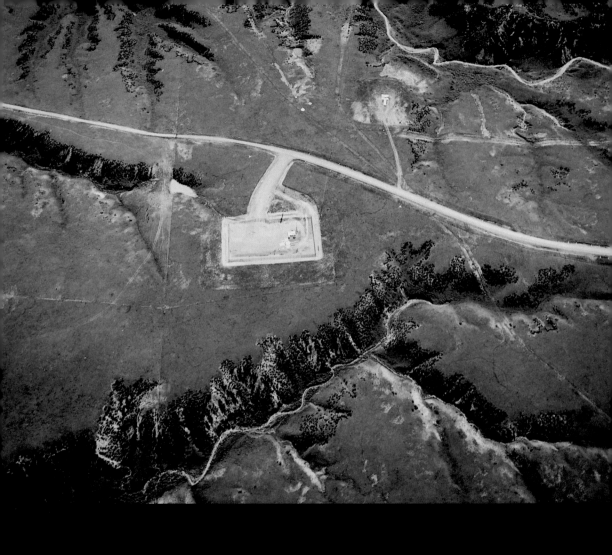

FRANCIS E. WARREN AIR FORCE MISSILE SITE #QUEBEC–6

90th STRATEGIC MISSILE WING

CHEYENNE, WYOMING

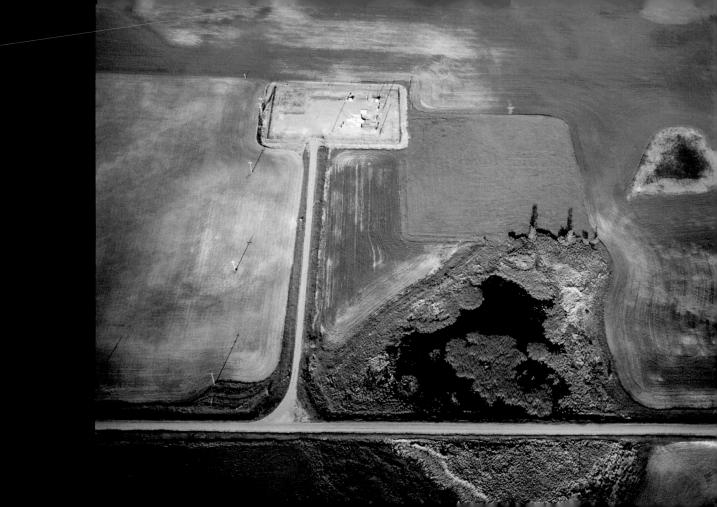

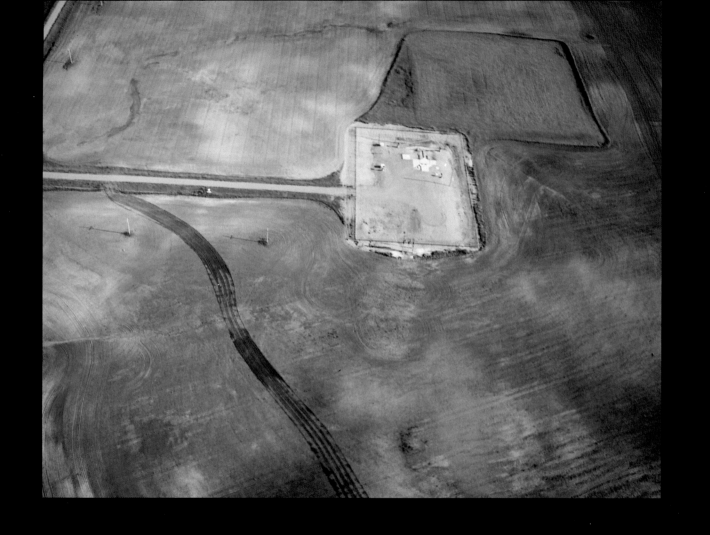

GRAND FORKS AIR FORCE MISSILE SITE #JULIET–42

321st STRATEGIC MISSILE WING

BARTLETT, NORTH DAKOTA

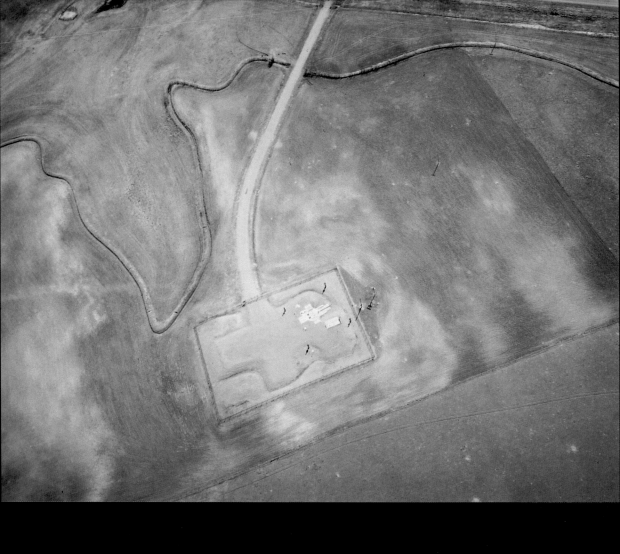

MALMSTROM AIR FORCE MISSILE SITE #KILO–8

341st STRATEGIC MISSILE WING

HARLOWTON, MONTANA

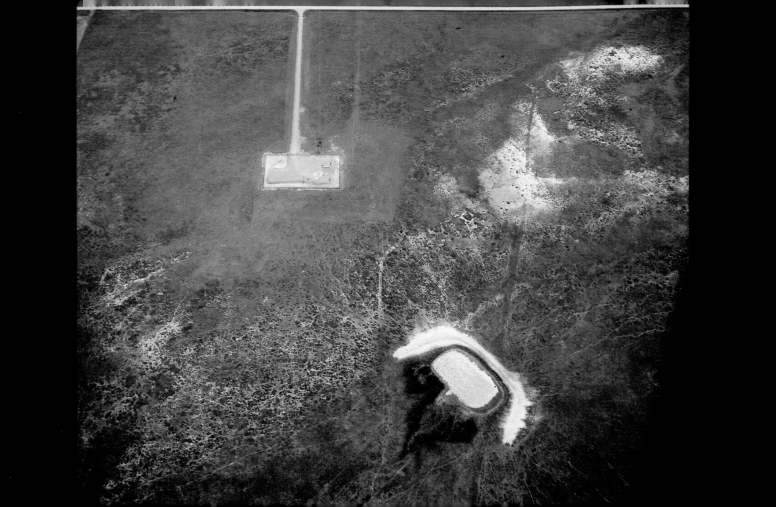

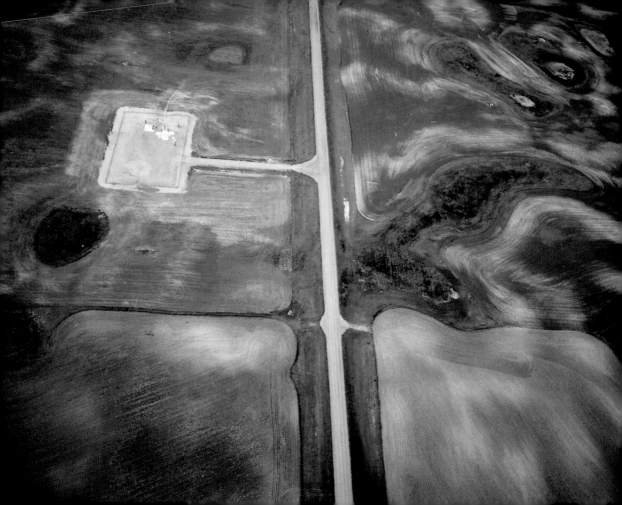

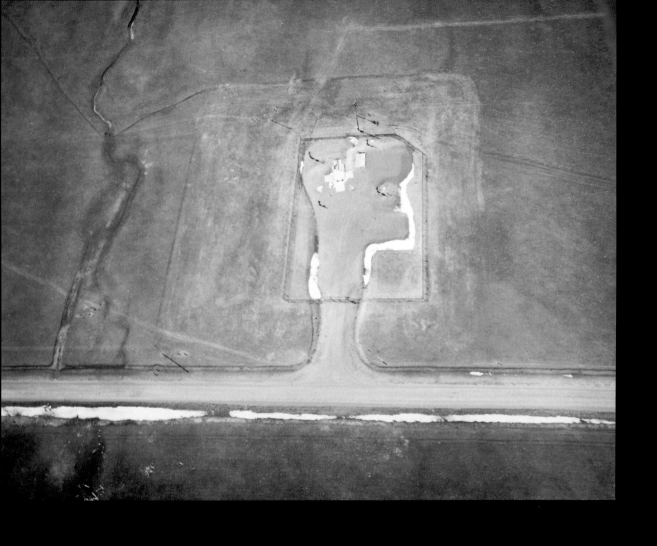

MALMSTROM AIR FORCE MISSILE SITE #LIMA–4

341st STRATEGIC MISSILE WING

Moving Into Hubris by Peter Montague and Maria B. Pellerano

What a strange journey these photographs take us on! Ordinary people could never witness such blasted landscapes—immense toxic tableaux, gaping industrial surgeries—in the way these photographs reveal them. To ordinary people on the ground, even people who care about the Earth, most such scenes are invisible, or merely visible in tiny proportion. Only from the air is their true magnitude, their immensity, revealed.

Several themes emerge from the images in this book:
• Industrial devastation is often located near water, which becomes the vehicle for poisons seeping off-site, creating real trouble. Toxic chemicals that originated at the sites pictured here can now be measured in the blood of seals, polar bears, and Inuit infants in the nothernmost reaches of the planet, as well as in the depths of all the world's oceans. Everything alive has been bathed in industrial poisons, nothing has escaped. We are fumigating the planet.
• Toxic industrial enterprise occurs remarkably close to human settlements— at the edges of cities, towns, trailer parks, or parking lots filled with workers' cars. At least forty million Americans live within four miles of a toxic dump, but most don't know it. Most Americans are oblivious to the devastation spreading outward around them. We are dismantling the web of life, losing species at roughly 1,000 times the prehistoric rate of loss. When we are finished what will remain are the pests we have not been able to exterminate—mosquitoes, chiggers, the house sparrow, the domestic cockroach, the Norway rat. . . .
• Strangely, the absence of humans in these photographs allows them to depict something fundamental about "developed" peoples: we have lost the knowledge that for nearly three million years allowed us to live side by side with the other creatures that were put here by the same force that put us here.

We have set ourselves apart as gods, and now feel we have a right to burn, bulldoze, plow, pave, poison, clear-cut, denude, and lay waste any part of the Earth that suits us. Humans have now appropriated 40 percent of the Earth's total net primary production on land.* Think of it: *one species (out of perhaps fifteen million living now on Earth) has confiscated for its own exclusive purposes 40 percent of all net primary production on the land.*

But is this not hyperbole? These problems—these immense toxic effusions have been solved—haven't they? The morning paper and the eleven o'clock news have led us all to believe so, as media coverage of these issues has disappeared or has put on a smiley face.

In truth, the devastation continues unchecked, on a grander scale than ever before. The government doesn't even know how many of these toxic embarrassments we have made and continue to make—some 31,000 of them, according to the National Academy of Sciences, though the official "Superfund" list contains a mere 1,200. The National Academy wrote in 1991, "A limited number of epidemiologic studies indicate that increased rates of birth defects, spontaneous abortion, neurologic impairment, and cancer have occurred in some residential populations exposed to hazardous wastes. We are concerned that other populations at risk might not have been adequately identified." And, said the Academy, "Millions of tons of hazardous materials are slowly migrating into groundwater in areas where they could pose problems in the future, even though current risks could be negligible."

David Hanson's photographs depict the "state of the art" in industrial devastation as of the mid 1980s. Twenty-five years of environmental activism have not made an appreciable difference. The human-centered philosophy (or religion) that gave rise to these shrines of ruin is still dominant, unremorseful, in some cases defiantly proud. If anything, the devastation is worsening today as we claw harder and harder to winnow the Earth's thinning reserves of iron, copper, gold, bauxite, timber, which our life-styles of hedonism and hubris demand. Running out of wood because we have cut the forests to stumps? Then we must substitute plastics on a grand scale. While manufacturing plastics, we create toxic waste by the megaton. What to do? Locate near a waterway, bury the unholy dregs in an enormous pit in the Earth (all perfectly legal), or burn it in an incinerator (throwing an immense toxic fume into the sky, sending it on its journey to the oceans and the Arctic), plant a row of trees to hide the view from the parking lot, keep busy. Hope no one flies overhead with a camera. . . .

* Net primary production is defined as "the amount of energy captured in photosynthesis by primary producers (blue-green plants that photosynthesize, thus turning carbon dioxide and water into carbohydrates) minus the energy they use in their own growth and reproduction."

Waste Land

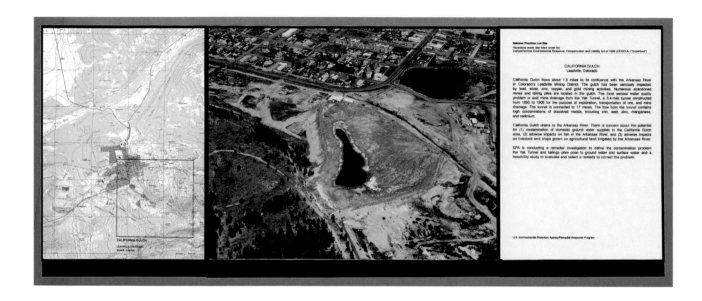

California Gulch, Leadville, Colorado. Installation view. Series of Ektacolor prints, modified U.S. Geological Survey maps, and gelatin silver-print text panels, each triptych 17 1/2 x 47". The sites are sequenced according to the U.S. Environmental Protection Agency's Hazard Ranking System.

1985–86

In 1980, from more than 400,000 toxic waste sites throughout the United States, the Environmental Protection Agency listed 400 as highly hazardous and in need of immediate attention. In only a few years, the number of sites on this "Superfund" list more than tripled. The *Waste Land* series examines sixty-seven of these sites, representing a cross-section of American geography and industrial waste activities. In each piece of this series, an aerial photograph is juxtaposed with a modified topographic map and an EPA site description that details the history of the site, its hazards, and the remedial action taken. These texts illustrate the bureaucratic nature of hazardous waste regulation and reveal some of the elaborate legal strategies that corporations and individuals have used to avoid responsibility for the contamination and cleanup.

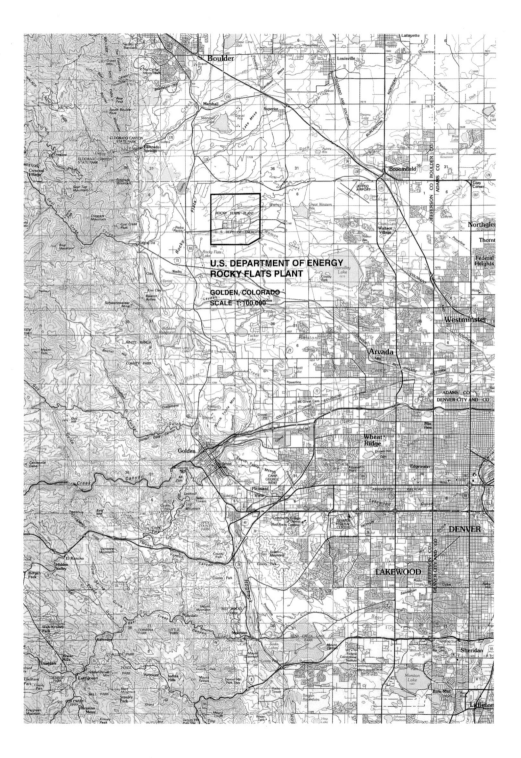

**U.S. DEPARTMENT OF ENERGY
ROCKY FLATS PLANT**

GOLDEN, COLORADO
SCALE 1:100,000

National Priorities List Site
Hazardous waste site listed under the
Comprehensive Environmental Response, Compensation and Liability Act of 1980 (CERCLA) ("Superfund")

ROCKY FLATS PLANT (USDOE)
Golden, Colorado

The Rocky Flats Plant began producing components for nuclear weapons in 1951 on a site of about 2,000 acres in Jefferson County, near Golden, Colorado. A buffer zone was acquired in 1974, bringing the total to 6,550 acres. Major operations at the plant, which is owned by the U.S. Department of Energy (USDOE), include fabrication and assembly of plutonium, beryllium, and uranium, recovery of plutonium, and separation of and research on americium. Dow Chemical Co. operated the plant from inception until June 30, 1975, when Rockwell International Corp. assumed operation.

Releases of plutonium and tritium have contributed to contaminated soils and sediments in surface water. USDOE has completed some remedial work such as capping and removing plutonium-contaminated soils and is improving liquid waste treatment systems to reduce discharge of liquid effluents, which are covered by a permit under the National Pollutant Elimination Discharge System. Three evaporation ponds have contributed to nitrate contamination of ground water. These ponds may be covered under the Resource Conservation and Recovery Act.

Approximately 80,000 people live within 3 miles of the facility.

USDOE continues to conduct remedial work by removing hot spots of contamination. A recent court settlement requires USDOE to conduct remedial activities on private land east of the plant as a condition of its sale to local governments. USDOE has begun to address the site through its internal cleanup program. The installation assessment phase is underway.

U.S. Environmental Protection Agency/Remedial Response Program

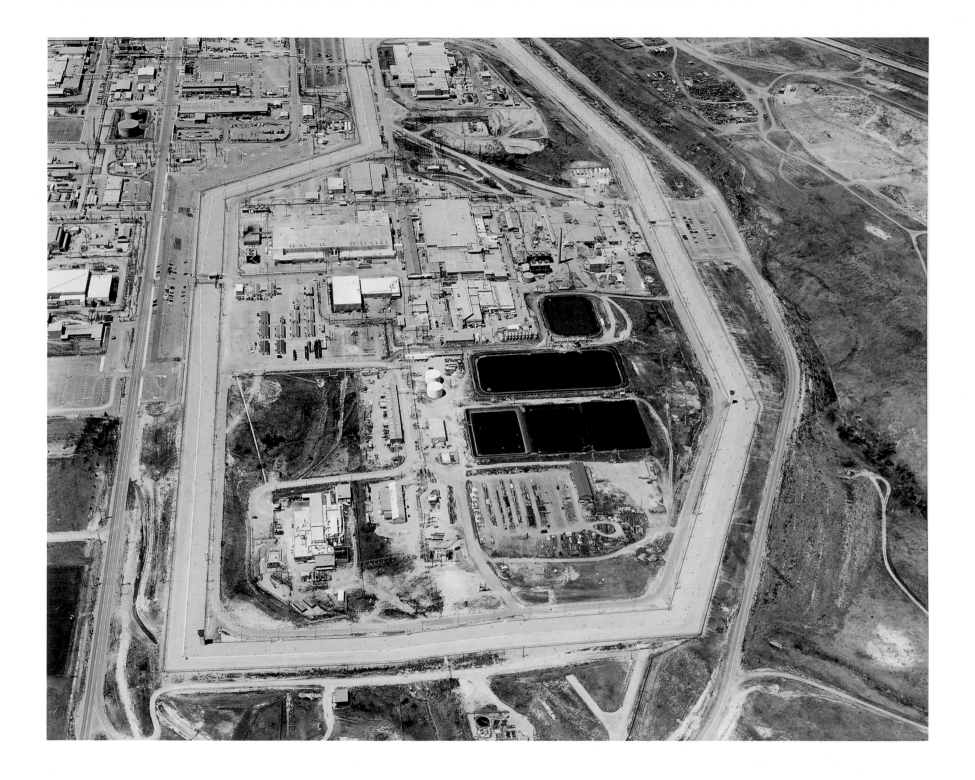

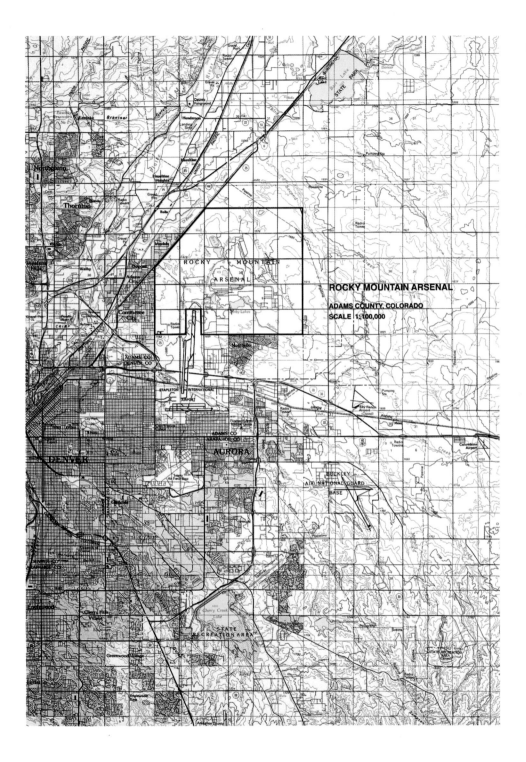

ROCKY MOUNTAIN ARSENAL

ADAMS COUNTY, COLORADO

SCALE 1:100,000

National Priorities List Site
Hazardous waste site listed under the
Comprehensive Environmental Response, Compensation and Liability Act of 1980 (CERCLA) ("Superfund")

ROCKY MOUNTAIN ARSENAL
Adams County, Colorado

The Rocky Mountain Arsenal (RMA) is located about 10 miles northeast of downtown Denver, Adams County, Colorado. It covers over 27 square miles. Since 1942, RMA has manufactured and demilitarized mustard gas, nerve gas, and chemical munitions. From 1952 until 1982, Shell Chemical Co. used the site to manufacture pesticides and herbicides.

The Army has identified 165 "possibly polluted" areas at RMA; six received Interim Status under the Resource Conservation and Recovery Act (RCRA) when the Army filed Part A of permit applications. Contamination from some of these areas has migrated and may continue to migrate off RMA, principally via ground water. The contaminated area covers about 4 square miles, with additional off-site ground water contamination.

Both the Army and Shell have constructed systems along the downgradient borders of RMA to control off-site migration. The systems pump out contaminated ground water, treat it with activated carbon to remove organic contaminants, and reinject the treated ground water. The Army is constructing a third system of this kind. The Army is also developing alternatives for controlling or eliminating the sources of contamination on RMA and the off-site contamination. These activities are part of the Installation Restoration Program, the specially funded program established in 1978 under which the Department of Defense has been identifying and evaluating its past hazardous waste sites and controlling the migration of hazardous contaminants from these sites. To date, the Army has spent more than $25 million on studies and control actions at RMA.

U.S. Environmental Protection Agency/Remedial Response Program

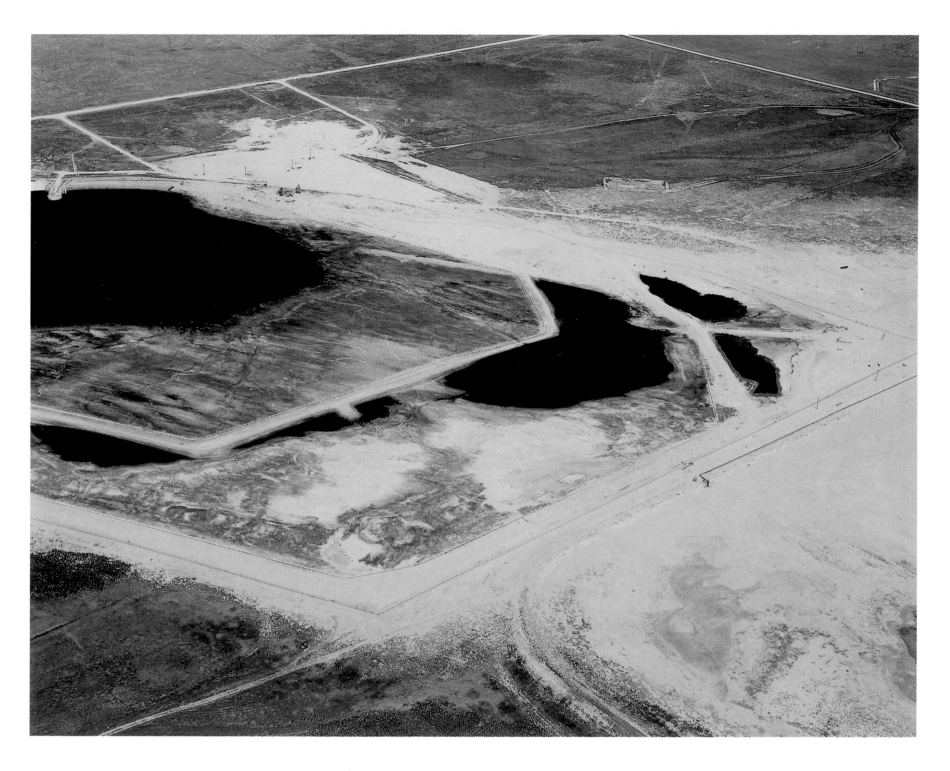

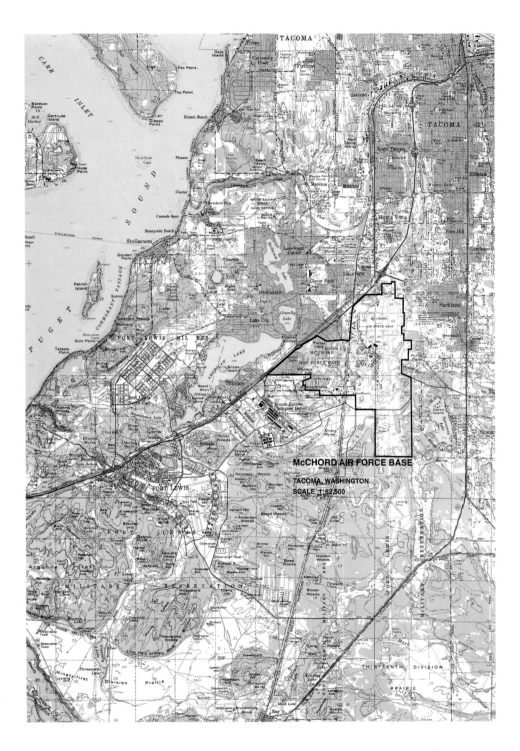

McCHORD AIR FORCE BASE

TACOMA, WASHINGTON

SCALE 1:62,500

National Priorities List Site

Hazardous waste site listed under the
Comprehensive Environmental Response, Compensation and Liability Act of 1980 (CERCLA) ("Superfund")

McCHORD AIR FORCE BASE
Tacoma, Washington

McChord Air Force Base covers about 6,000 acres just south of Tacoma in Pierce County, Washington. It is on an upland plain, 5 miles east-southeast of Puget Sound. Since 1940, almost 500,000 gallons of hazardous substances have been used and disposed of on the base. Methylene chloride, chloroform, benzene, arsenic, chromium, and mercury have been detected in test wells on the base, as well as in surface drainage (Clover Creek) leaving the base.

The site of concern here consists of the liquid waste spill and disposal area adjacent to the wash rack, and the industrial waste treatment system. The wash rack has been active since the 1940s. A wide variety of solvents, detergents, paints, and corrosion-removing compounds have been used there. Also, industrial wastes from other sources were directed to the wash rack. The industrial waste treatment system includes an oil skimmer with two leach pits. At times, oils were discharged directly into the leach pits, which had to be re-excavated because they were plugged from sludges and oils.

McChord Air Force Base, the Lakewood Water District, and American Lake Gardens (a private development) get their drinking water from the aquifer partially underlying McChord. (Lakewood was added to the NPL in September 1983 and American Lake Gardens in September 1984.) Well over 10,000 people within 3 miles of the base depend on the aquifer for their drinking water.

The Air Force has investigated the contamination as part of the Installation Restoration Program, the specially funded program established in 1978 under which the Department of Defense has been identifying and evaluating its past hazardous waste sites and controlling the migration of hazardous contaminants from these sites. The Air Force has constructed numerous wells to verify the contamination. Several contaminated areas have been found, although specific sources are still being investigated.

U.S. Environmental Protection Agency/Remedial Response Program

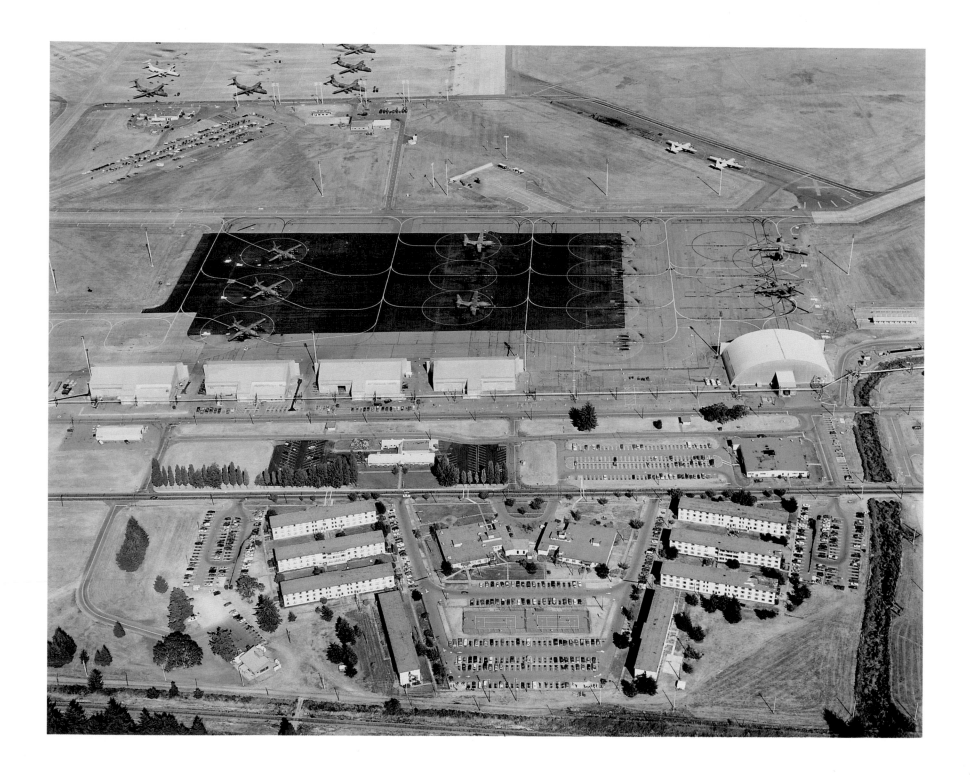

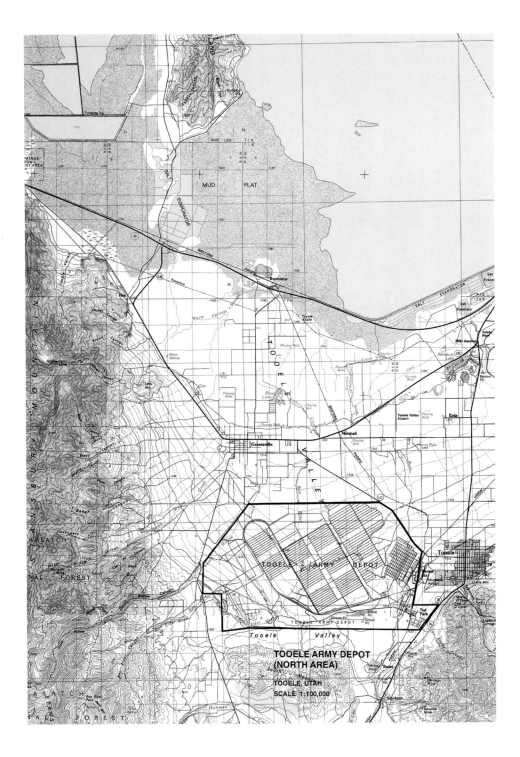

TOOELE ARMY DEPOT (NORTH AREA)
TOOELE, UTAH
SCALE 1:100,000

National Priorities List Site
Hazardous waste site listed under the
Comprehensive Environmental Response, Compensation and Liability Act of 1980 (CERCLA) ("Superfund")

TOOELE ARMY DEPOT (NORTH AREA)
Tooele, Utah

The Tooele Army Depot (TEAD), Tooele, Utah, consists of two separate areas, the North Area, and the South Area. The North Area covers about 39 square miles in Tooele Valley south and west of Tooele.

TEAD's mission is fourfold: store ammunition, demilitarize ammunition, rebuild military equipment, and store military equipment. In fulfilling its mission, TEAD conducts activities such as metal cleaning and stripping, steam cleaning, and boiler cleaning. Spills and leaks of oils, solvents, paint, and photographic chemicals may have contaminated ground water. Washing of explosive containers is another potential source of ground water contamination. Arsenic, nickel, chromium, and lead have been found in ground water beneath a waste pond in the North Area. Zinc, chloride, fluoride and chlorinated organic chemicals also have been detected.

TEAD is participating in the Installation Restoration Program, the specially funded program established in 1978 under which the Department of Defense has been identifying and evaluating its past hazardous waste sites and controlling the migration of hazardous contaminants from these sites. The Army has completed Phase I (records search) and Phase II (preliminary survey).

U.S. Environmental Protection Agency/Remedial Response Program

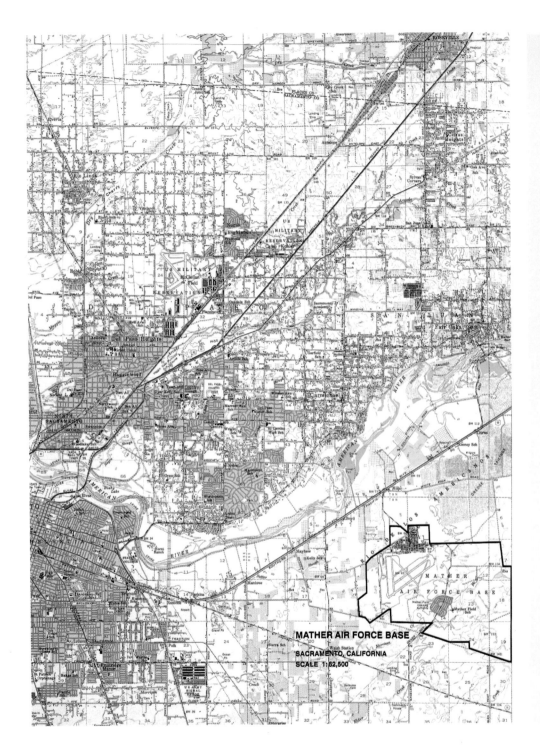

MATHER AIR FORCE BASE
SACRAMENTO, CALIFORNIA
SCALE 1:62,500

National Priorities List Site
Hazardous waste site listed under the
Comprehensive Environmental Response, Compensation and Liability Act of 1980 (CERCLA) ("Superfund")

MATHER AIR FORCE BASE
Sacramento, California

Mather Air Force Base is located near Sacramento, Sacramento County, California. Its mission as an air training command base is to train pilots and act as support for the Strategic Air Command. This effort includes maintenance of aircraft and other machinery.

A records search of base operations has located a disposal site in the Aircraft Control and Warning (AC&W) area of the base. This is the current NPL site. It is now occupied by the Strategic Air Command Security Police Headquarters. The Air Force has determined that spent trichloroethylene (TCE) was disposed of in a pit on the site from about 1958 to 1966. A well near the site was used for drinking water until October 1979, when it was shut down due to TCE contamination. The well now provides water for fire protection.

Mather Air Force Base is participating in the Installation Restoration Program (IRP), the specially funded program established in 1978 under which the Department of Defense has been identifying and evaluating its past hazardous waste sites and controlling the migration of hazardous contaminants from these sites. The Air Force has completed Phase I (records search). Phase II (preliminary survey) is underway.

Phase II of the IRP for Mather Air Force Base has been divided into stages. The first stage investigated the cause and extent of contamination at three areas on the base, including the AC&W Disposal Site, considered by the Air Force to have high priority. The second stage investigated 15 other areas on the base. The third stage, currently in progress, continues the ground water investigation of Stage 1, with the drilling of additional monitoring wells and ground water sampling.

The Mather Air Force Base (AC&W Disposal Site) was placed on the final NPL in July 1987. EPA is now proposing to expand this final site to include the entire base, not just the AC&W Disposal area. The original site had contaminated portions of the large aquifer near some base production wells. Since then, EPA has determined that additional areas of the base are responsible for further contamination of the aquifer, and may be responsible for contamination off-base.

U.S. Environmental Protection Agency/Remedial Response Program

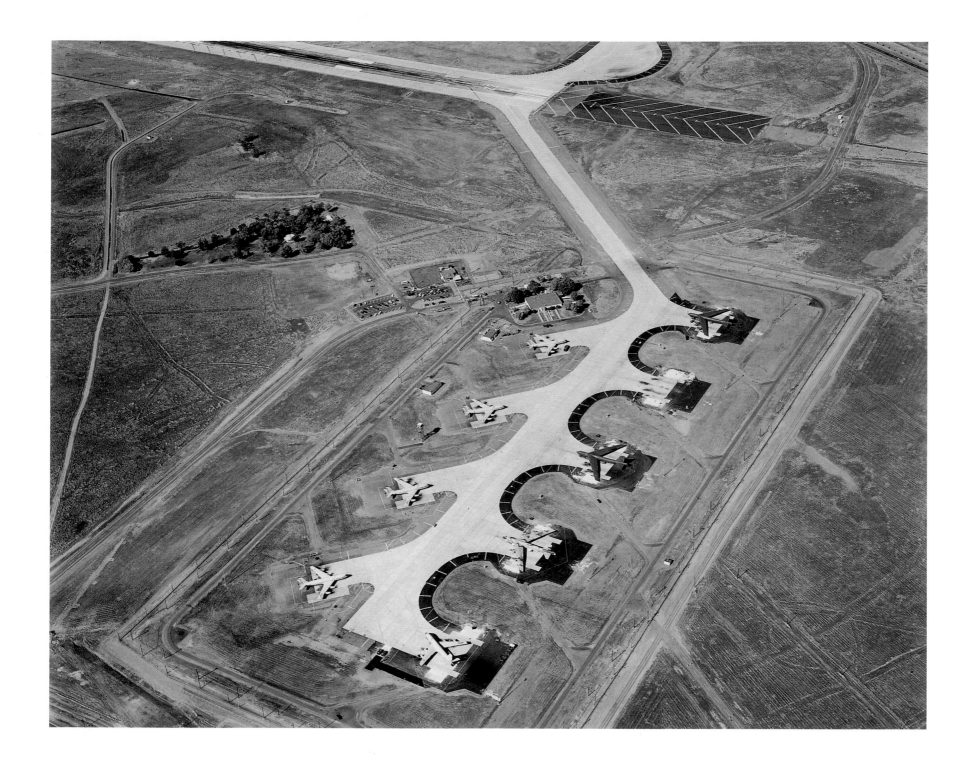

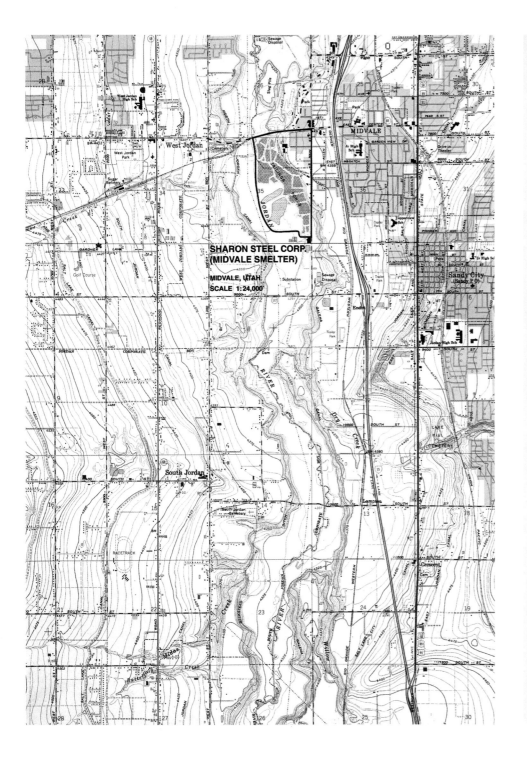

**SHARON STEEL CORP.
(MIDVALE SMELTER)**

MIDVALE, UTAH

SCALE 1:24,000

National Priorities List Site

Hazardous waste site listed under the
Comprehensive Environmental Response, Compensation and Liability Act of 1980 (CERCLA) ("Superfund")

SHARON STEEL CORP. (MIDVALE SMELTER)
Midvale, Utah

Sharon Steel Corp. owns a smelter in Midvale, Salt Lake County, Utah. Midvale (population 10,000) is a part of the Salt Lake City metropolitan area (population 936,000). Metals were smelted and milled on the 260-acre site from about 1910 to 1971. Approximately 10 million tons of mill tailings containing high concentrations of lead, arsenic, cadmium, chromium, copper, and zinc remain on the site. Sharon Steel purchased the site in 1979, intending to reclaim precious metals from the tailings. To date, the only thing the company has done is to sell the pyrite concentrate stored on-site.

Tailings have been blown from the site. In response to dust control ordinances, Sharon Steel has tried to return the material to the tailings pile. Ground water is contaminated with arsenic, zinc, cadmium, lead and chromium, according to analyses conducted by the State, and surface water may be contaminated. About 500,000 people within 3 miles of the site depend on ground water as a source of drinking water.

State and local officials have requested that the company repair its fences and remove gardens planted on the site by residents of nearby apartments. Analyses by the State indicate elevated levels of heavy metals in edible portions of food grown on the site.

U.S. Environmental Protection Agency/Remedial Response Program

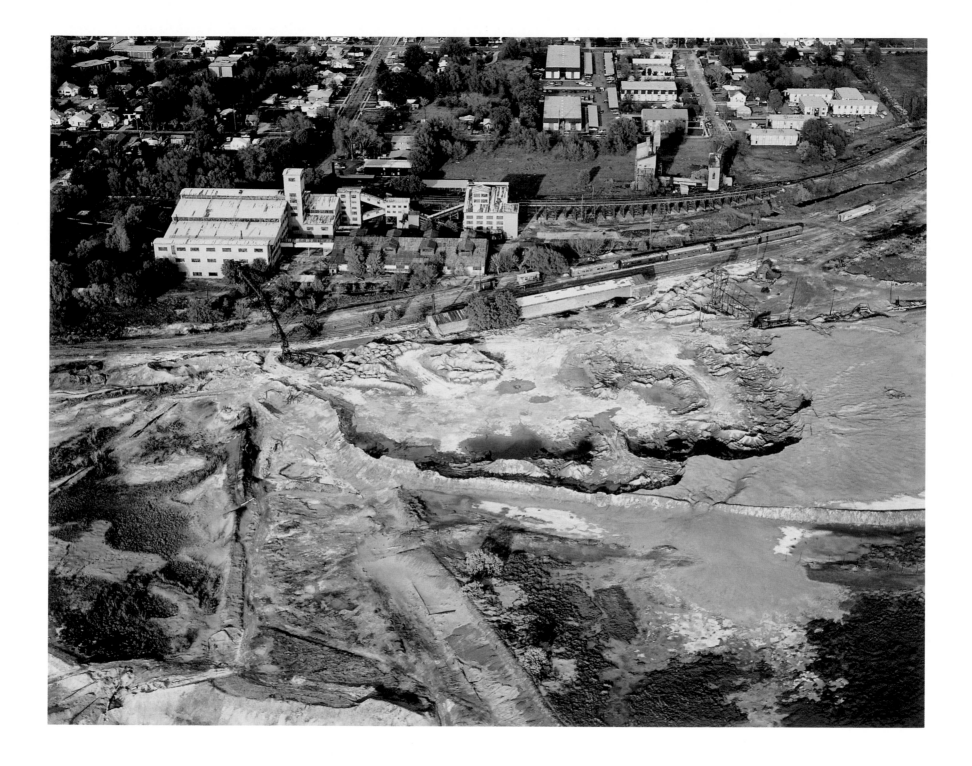

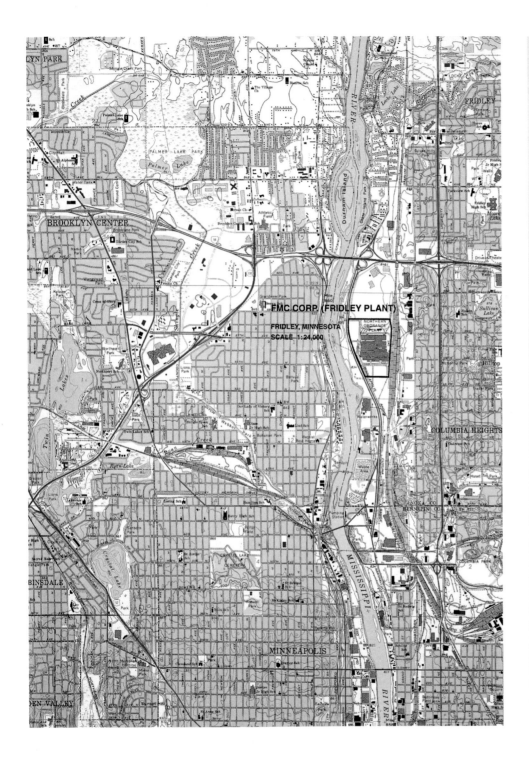

FMC CORP. (FRIDLEY PLANT)
FRIDLEY, MINNESOTA
SCALE 1:24,000

National Priorities List Site
Hazardous waste site listed under the
Comprehensive Environmental Response, Compensation and Liability Act of 1980 (CERCLA) ("Superfund")

FMC CORP. (FRIDLEY PLANT)
Fridley, Minnesota

The FMC Corp. Site occupies about 18 acres in Fridley, Minnesota, adjacent to the Mississippi River. From the early 1950s to the early 1970s, FMC, formerly Northern Pump Co., disposed of hazardous wastes (including solvents, paint sludges, and plating wastes) at two on-site locations, on an 11-acre unlined landfill. Records indicate that solvents and sludge were dumped directly into unlined pits and burned or buried. Three wells used by FMC for drinking and processing are contaminated with various toxic organic chemicals, including trichloroethylene, dichloroethylene, and methylene chloride. Fridley and Brooklyn Center draw drinking water from the contaminated aquifer. The ground water also discharges into the Mississippi River, which supplies water to Minneapolis 800 feet downstream of the FMC property. Low levels of trichloroethylene have been found in the city's drinking water.

On June 8, 1983, FMC, the State, and EPA entered an agreed order under Section 106 of CERCLA. That order provides, among other things, that FMC construct a large clay-lined vault on an uncontaminated portion of the site and place in it about 58,000 cubic yards of contaminated soils excavated from the site and from an adjacent property owned by the Burlington Northern Railroad. FMC did so by June 30, 1983. The order further provides for FMC to reimburse Minnesota and EPA for expenses (both past and future) related to the order and to apply to EPA for a permit (under the Resource Conservation and Recovery Act) for the vault. Finally, FMC has agreed to conduct a study to determine the extent of ground water contamination at the site and a feasibility study to identify alternatives for remedial action.

U.S. Environmental Protection Agency/Remedial Response Program

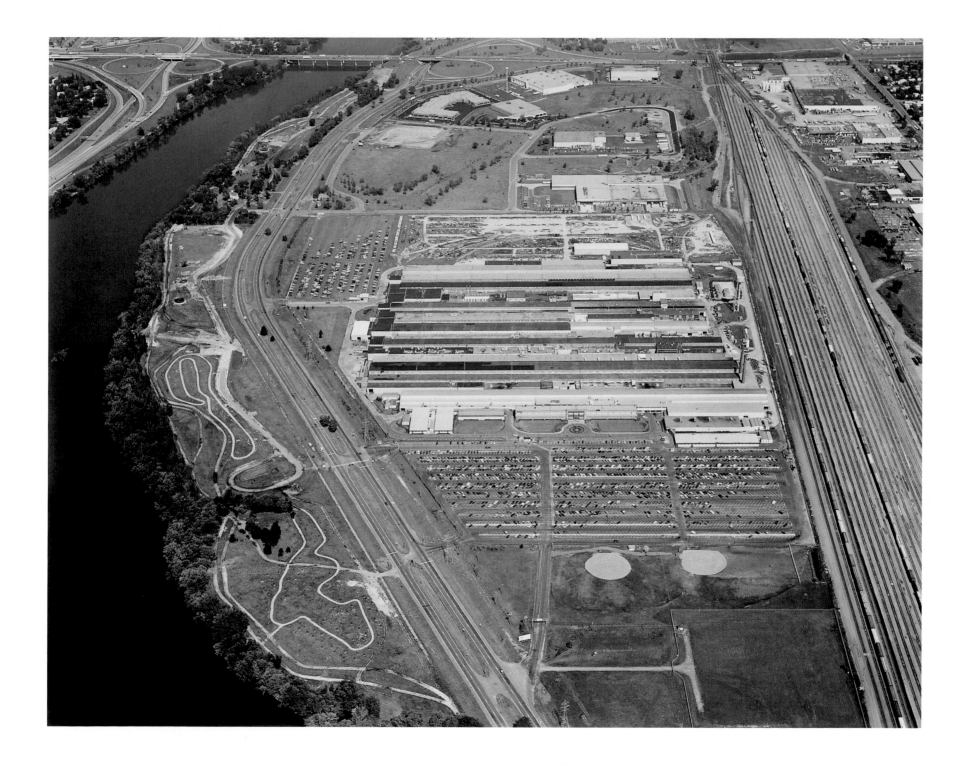

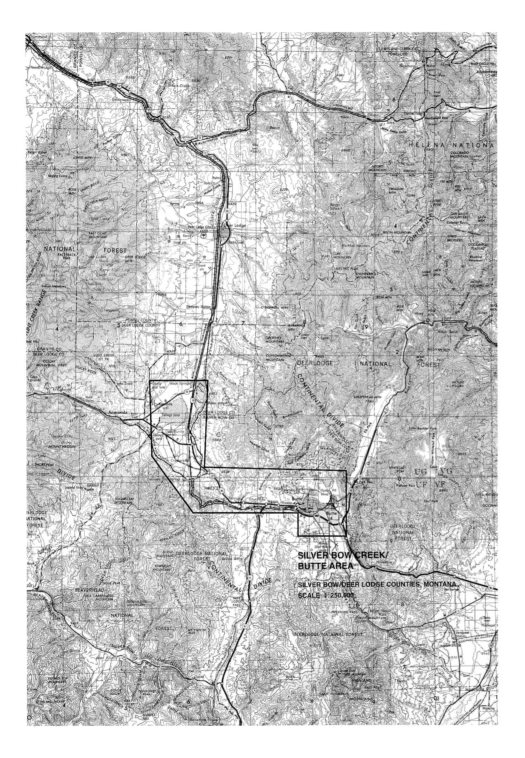

SILVER BOW CREEK/
BUTTE AREA

SILVER BOW/DEER LODGE COUNTIES, MONTANA
SCALE 1:250,000

National Priorities List Site
Hazardous waste site listed under the
Comprehensive Environmental Response, Compensation and Liability Act of 1980 (CERCLA) ("Superfund")

SILVER BOW CREEK/BUTTE AREA
Silver Bow/Deer Lodge Counties, Montana

The Silver Bow Creek Site covers about 24 stream miles in Silver Bow and Deer Lodge Counties, Montana. The creek, between where it meets Copper Creek in Butte and Warm Springs Ponds northeast of Anaconda, has been contaminated with a variety of wastes received from industrial, agricultural, and municipal activities for over 100 years. Contaminants such as heavy metals and phosphates have been detected in the creek, which is used for drinking, irrigation, and recreation. The State is attempting to remove some of the abandoned mine tailings from the banks of Silver Bow Creek to reduce its contamination.

EPA has conducted a remedial investigation/feasibility study (RI/FS) to determine the type and extent of contamination at the site. Preliminary evaluation of data indicates that sources upstream of the existing site are contributing to contamination in the creek. EPA considered two options for dealing with the upstream problems: proposing a separate Butte Area Site or expanding the existing Silver Bow Creek Site. EPA believes it is more appropriate to expand the Silver Bow Creek Site to include the Butte Area.

A thorough analysis of the relationship between the Silver Bow Creek Site and the Butte Area led EPA to conclude that the geographical relationship of the headwaters of Silver Bow Creek (which originate a short distance upstream of the Silver Bow Creek drainage area) and the portion of Silver Bow Creek downstream of the City of Butte favors treating these areas as one site for the NPL. In addition, EPA decided to analyze the nature and extent of contamination under one comprehensive RI/FS because it appears that contamination from both areas threatens the same surface water body and the same target population. The geographical relationship of the two areas suggests that the Butte Area is a major source of contamination to Silver Bow Creek, which is the major receiving water body for mining discharges and drainage from the Butte Area. EPA treats sources of and extent of contamination at other sites in this way and concluded that it was logical to evaluate the Butte Area and the Silver Bow Creek site together. Adding the Butte Area does not greatly expand the site geographically.

In June 1986, EPA proposed expansion of the Silver Bow Creek Site and requested public comment on the proposal. Following analysis of the comments received, EPA added the Butte Area to the Silver Bow Creek Site and renamed the site "Silver Bow Creek/Butte Area."

U.S. Environmental Protection Agency/Remedial Response Program

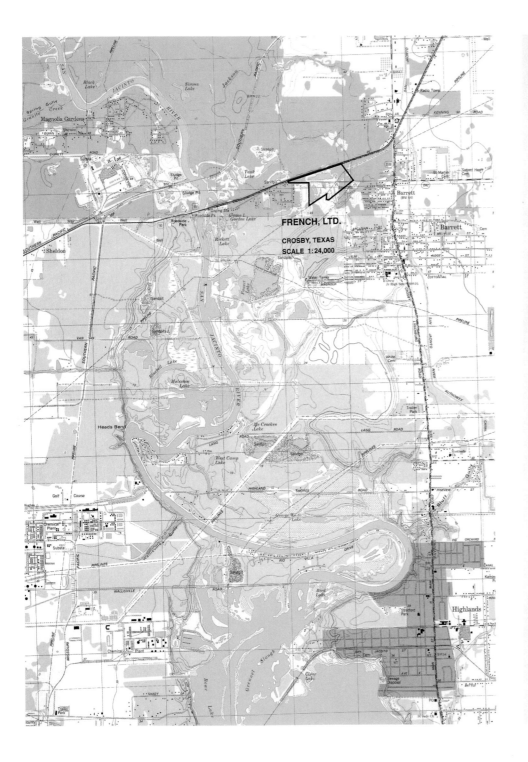

FRENCH, LTD.

CROSBY, TEXAS

SCALE 1:24,000

National Priorities List Site

Hazardous waste site listed under the
Comprehensive Environmental Response, Compensation and Liability Act of 1980 (CERCLA) ("Superfund")

FRENCH, LTD.
Crosby, Texas

The French, Ltd., Site is an abandoned waste pit on 15 acres in Crosby, Harris County, Texas. It is in the floodplain of the San Jacinto River and has been flooded on several occasions. The site received approximately 100,000 barrels of industrial waste per year between 1966 and 1972. Wastes included heavy metals, phenols, PCBs, oil, grease, acids, and solvents. During litigation with the State over violation of environmental law, the company declared bankruptcy and deeded the site to the State in 1973. No wastes have been disposed of at the site since then. The pit is located in permeable sands, and ground water is contaminated, as well as adjacent drainage ditches which discharge to the San Jacinto River. Low levels of contamination were measured in the air in the immediate vicinity of the pit.

In April 1982, EPA awarded a $437,000 Cooperative Agreement to Texas for a remedial investigation to determine the type and extent of contamination at the site and a feasibility study to identify alternatives for remedial action. In March 1983, EPA added $29,668 to the award.

In June, using about $83,000 in CERCLA emergency funds, EPA removed PCB-contaminated sludge from the pit and sent it to an approved landfill for disposal.

U.S. Environmental Protection Agency/Remedial Response Program

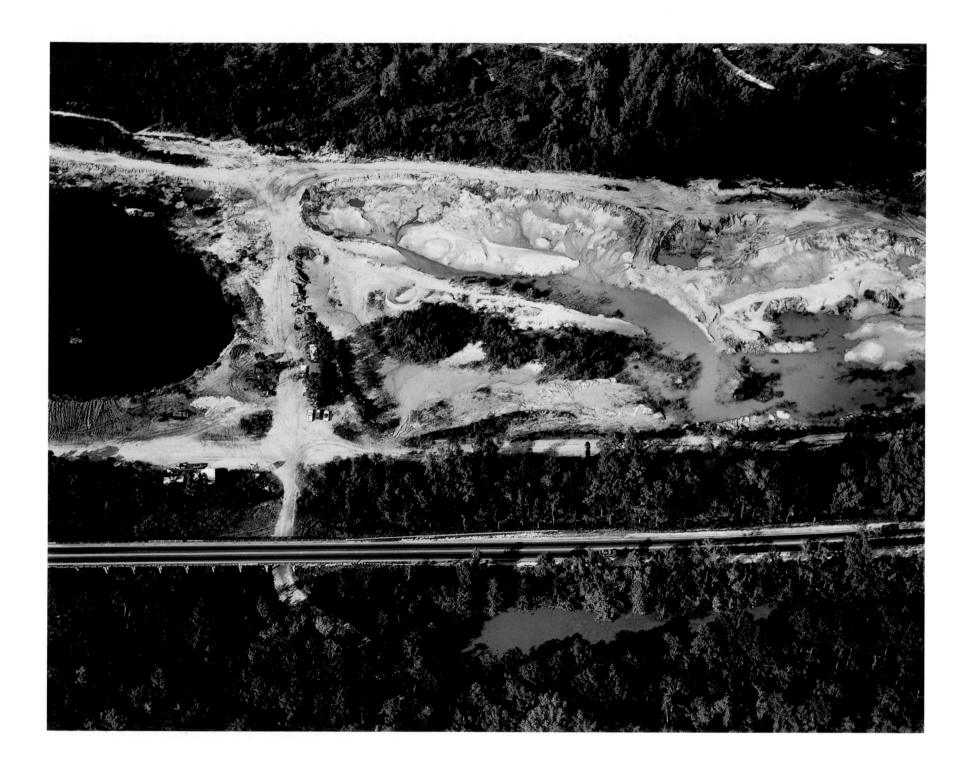

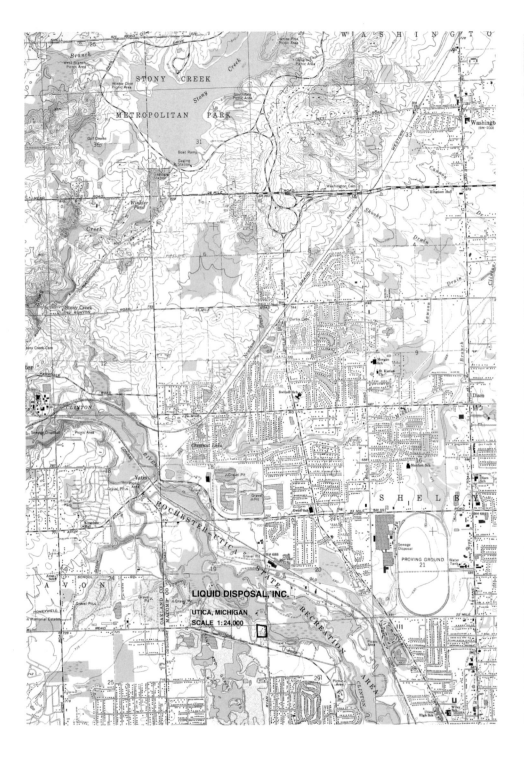

LIQUID DISPOSAL, INC.

UTICA, MICHIGAN

SCALE 1:24,000

National Priorities List Site
Hazardous waste site listed under the
Comprehensive Environmental Response, Compensation and Liability Act of 1980 (CERCLA) ("Superfund")

LIQUID DISPOSAL, INC.
Utica, Michigan

The Liquid Disposal, Inc. (LDI) Site covers 6 acres in Utica, Macomb County, Michigan. The site contains an incinerator for liquid wastes, various industrial liquids and sludges in two lagoons, numerous surface and buried tanks, over 1,000 drums, and numerous small containers. Following an incident in which hydrogen sulfide gas was produced and killed two workers, the citizens of Shelby township filed suit in January 1982 to permanently enjoin LDI from operating. In April 1982, LDI was forced into involuntary bankruptcy and closed permanently in May 1982. EPA and State investigations have revealed contamination of air, soil, surface water, and ground water in the vicinity of the site. In May 1982, EPA cleaned up a PCB-contaminated oil spill at the site. In July 1982, EPA removed liquid wastes from a lagoon that was in danger of overflowing and contaminated water from the area surrounding the incinerator. A total of $319,000 was expended on these cleanups.

In April 1983, EPA awarded a $346,732 Cooperative Agreement to Michigan for a remedial investigation/feasibility study to determine the type and extent of contamination at the site and identify alternatives for remedial action. In May 1983, $580,000 was approved for a third emergency action involving disposing of wastes in two lagoons, overpacking leaking drums, and removing miscellaneous wastes from the site.

U.S. Environmental Protection Agency/Remedial Response Program

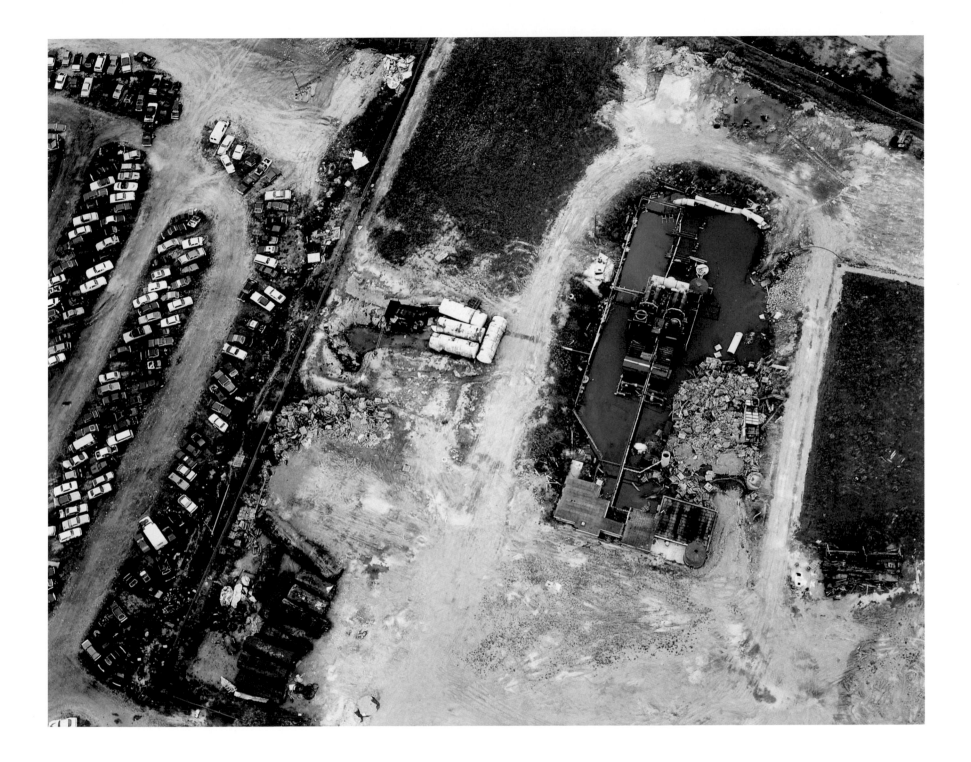

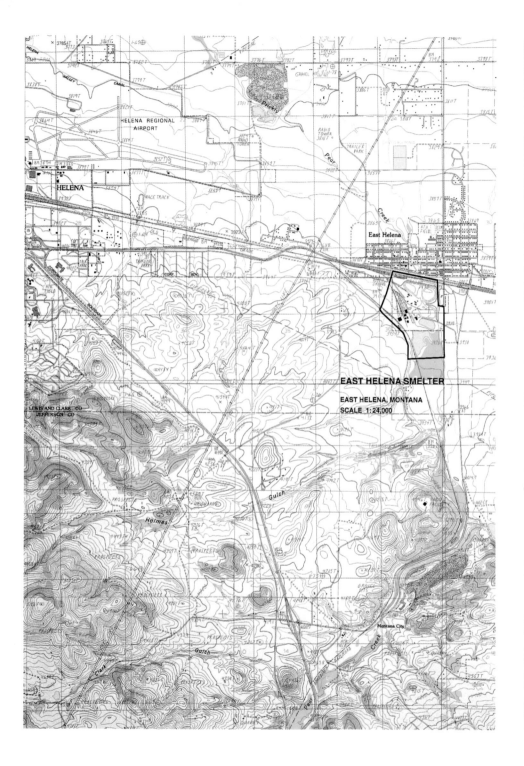

EAST HELENA SMELTER

EAST HELENA, MONTANA

SCALE 1:24,000

National Priorities List Site

Hazardous waste site listed under the
Comprehensive Environmental Response, Compensation and Liability Act of 1980 (CERCLA) ("Superfund")

EAST HELENA SMELTER
East Helena, Montana

The East Helena Smelter has been in operation in East Helena, Montana, since about 1889. The Asarco primary lead and zinc smelter has emitted particulates containing metals (including lead, cadmium, and arsenic) into the air throughout its history. Recent data obtained by EPA and the State indicate that an area of 8.4 square miles around the smelter contains at least 1,000 parts per million (ppm) of lead in the upper soil. The EPA Lead Smelter Study Task Force has recommended that values of 1,000 ppm or greater warrant further investigation. There are concerns that the soil can be re-entrained into the air as inhalable particulates, can be directly ingested (especially by young children), and can contaminate surface water and ground water. Analysis in 1975 indicated that children in East Helena had elevated levels of lead in their blood.

Several activities are underway at the site: (1) EPA has signed a Cooperative Agreement with the Montana office of the U.S. Geological Survey to develop a plan to investigate ground water flows and possible metal contamination in the study area; (2) the Centers for Disease Control and EPA will award money to the State to conduct a health screening study of East Helena children; and (3) EPA is preparing a contract to have Montana State University develop a plan to gather soils and vegetation data, which will better define the extent and nature of the area's soil contamination and its effects on the environment.

U.S. Environmental Protection Agency/Remedial Response Program

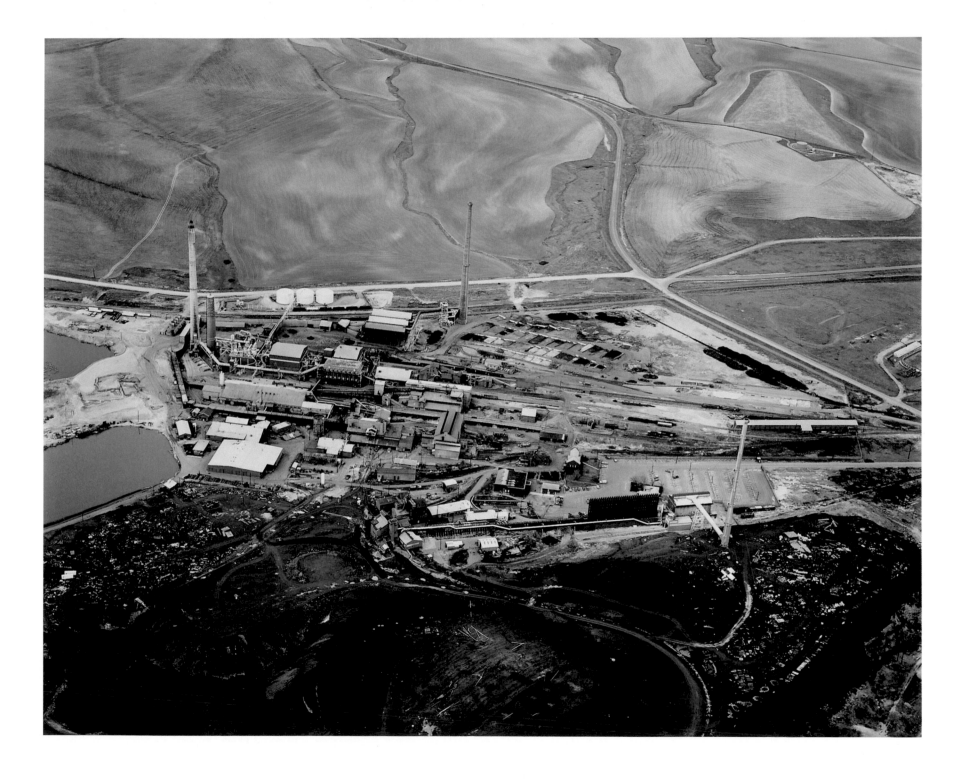

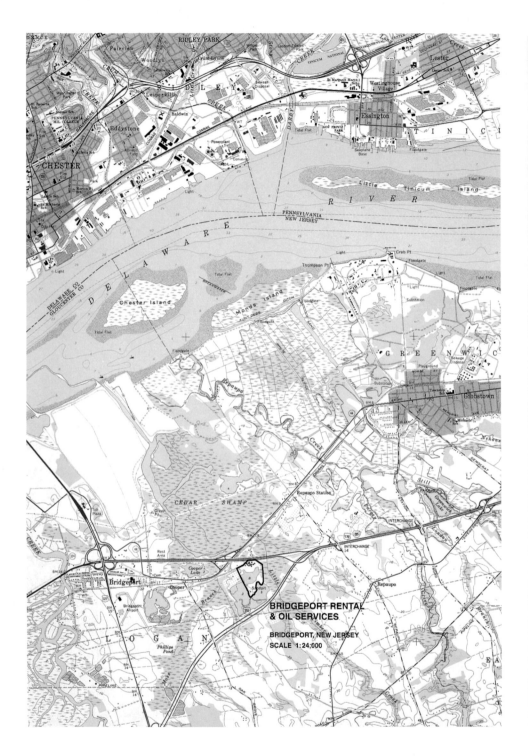

BRIDGEPORT RENTAL
& OIL SERVICES

BRIDGEPORT, NEW JERSEY
SCALE 1:24,000

National Priorities List Site

Hazardous waste site listed under the
Comprehensive Environmental Response, Compensation and Liability Act of 1980 (CERCLA) ("Superfund")

BRIDGEPORT RENTAL & OIL SERVICES
Bridgeport, New Jersey

Bridgeport Rental & Oil Services is a 27.2-acre site in Bridgeport, Gloucester County, New Jersey. It is adjacent to Cedar Swamp, a tidal area. Little Timber Creek, a tributary of the Delaware River, borders the site. The company operated from 1969 until 1980. The site holds more than 80 tanks and process vessels, drums, tank trucks, and an 11.8-acre unlined lagoon. The lagoon contains an estimated 50 million gallons of oil, oil-water emulsions, contaminated water, and sludge. The wastes, which contain heavy metals, PCBs, and other organic compounds, have seeped into the soil and contaminate surface waters and ground water supplying private drinking wells.

In the spring of 1981, $200,000, made available through Section 311 of the Clean Water Act, was used to lower the level of the lagoon, which was overflowing from heavy rains. In September 1981, with $410,000 made available through the Resource Conservation and Recovery Act, EPA started a remedial investigation to determine the extent and type of contamination and to evaluate alternative water supplies for local residents.

In the summer of 1982, the lagoon was lowered again, this time with $200,000 in CERCLA emergency funds. Also, a plan for an initial remedial measure was developed to lower the lagoon an additional 8 to 10 feet, treat the aqueous phase, discharge the water to Little Timber Creek, and dispose of the wastes off-site. A Superfund State Contract signed in December 1982 approved $3.3 million for site cleanup, $2.8 million of it to implement the plan. Funds are also provided for a feasibility study to identify alternatives for long-term remedial action at the site.

In June 1982, The Department of Justice, on behalf of EPA, entered into a Consent Decree with the owners and operators of the site under Section 7003 of the Resource Conservation and Recovery Act.

U.S. Environmental Protection Agency/Remedial Response Program

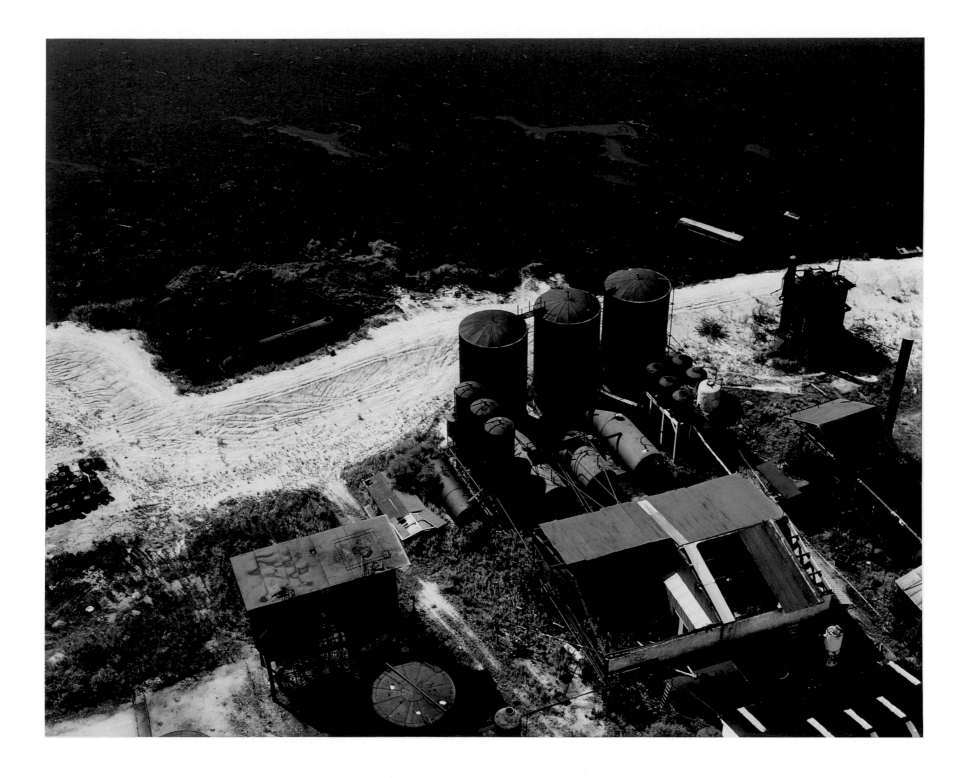

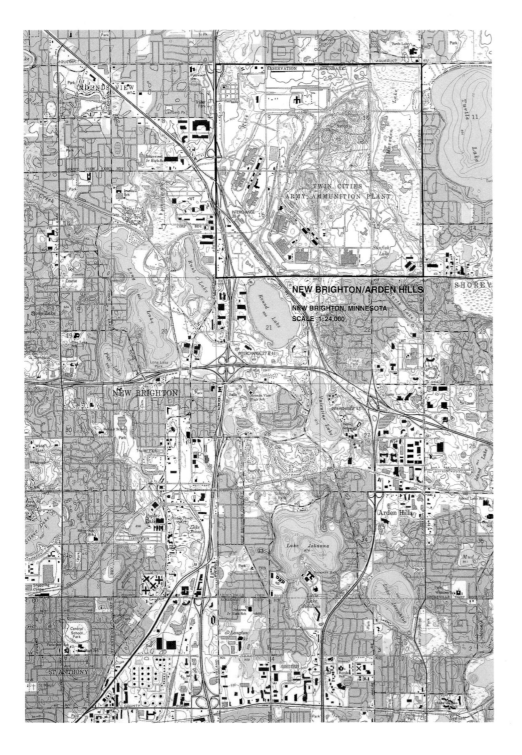

National Priorities List Site

Hazardous waste site listed under the
Comprehensive Environmental Response, Compensation and Liability Act of 1980 (CERCLA) ("Superfund")

NEW BRIGHTON/ARDEN HILLS
New Brighton, Minnesota

The New Brighton/Arden Hills Site covers 69,120 acres in the New Brighton/ Shoreview/Arden Hills area of Ramsey County, Minnesota. In June 1981, the State discovered trichloroethylene (TCE) and other organic chemicals in the Prairie du Chien-Jordan aquifer, which supplies drinking water to several communities. The plume of contaminated ground water is believed to be 6 miles long, 3 miles wide, and affect approximately 38,000 residents. Several suspected sources of contamination have been identified.

The State, in coordination with EPA, is making a hydrogeological study of the area to determine the type and extent of contamination and is also monitoring suspected sources to determine what they disposed of in the past, when record-keeping was not strictly regulated. The State continues to monitor contaminated wells in the area. The Department of the Army is making an extensive hydrogeological study of the Twin Cities Army Ammunition Plant in New Brighton. Both the State and EPA have met with Army officials to coordinate all phases of the study. The Army is also furnishing bottled water to homes with wells containing high levels of TCE.

In June 1983, EPA signed a $1,467,242 Cooperative Agreement with Minnesota for a remedial investigation to determine the type and extent of contamination at the site.

U.S. Environmental Protection Agency/Remedial Response Program

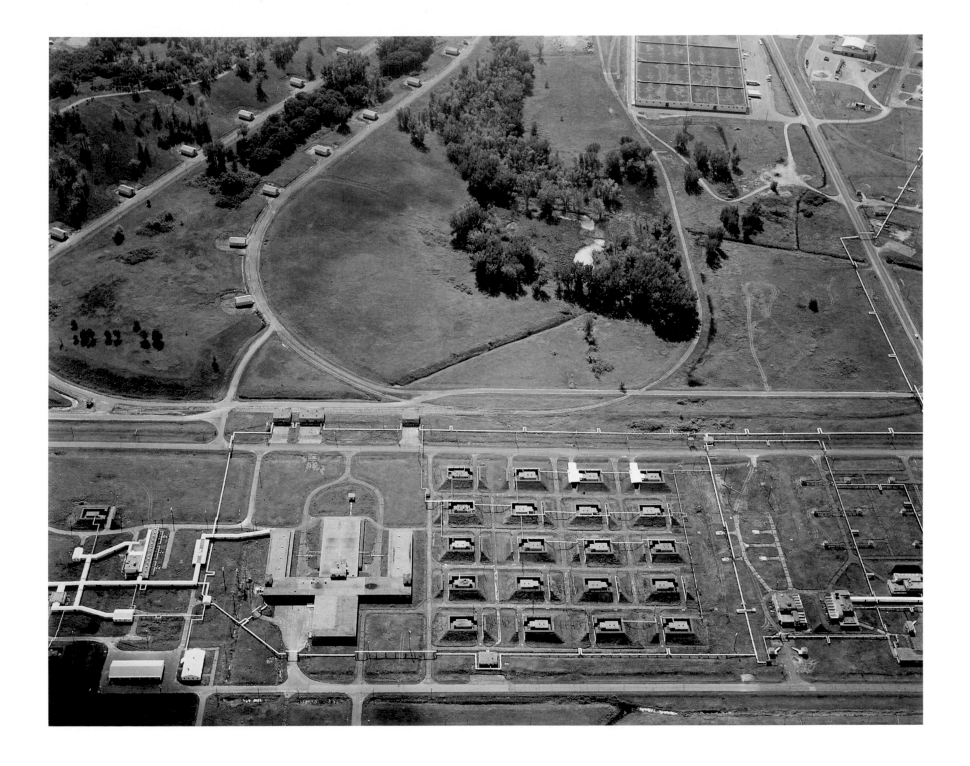

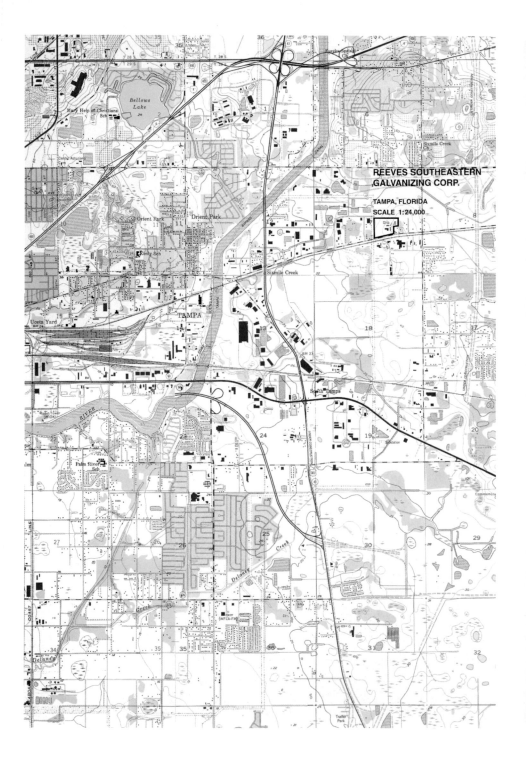

REEVES SOUTHEASTERN
GALVANIZING CORP.

TAMPA, FLORIDA

SCALE 1:24,000

National Priorities List Site

Hazardous waste site listed under the
Comprehensive Environmental Response, Compensation and Liability Act of 1980 (CERCLA) ("Superfund")

REEVES SOUTHEASTERN GALVANIZING CORP.
Tampa, Florida

Reeves Southeastern Galvanizing Corp. manufactures galvanized fence wire using the hot dip process on 3 acres east of Tampa, Hillsborough County, Florida. Wash water and periodic dumping of rinse baths from this process produce an acid liquid with high concentrations of iron, zinc, and chromium. Since the mid-1960s, this material has been discharged into two unlined percolation ponds on the property, contaminating both ground water and surface water with heavy metals. Consultants for Reeves, the State, and county have conducted numerous studies that document the extent of contamination at the site.

County wells are located about 1 mile upgradient of the site, and numerous private wells lie within 3 miles of the site in all directions.

In 1974, Hillsborough County issued a notice of violation and a compliance schedule to Reeves. In response, Reeves in 1981 installed an advance waste water treatment system to neutralize the acid and remove 90 percent of the heavy metals.

Reeves plans to remove the water from the percolation ponds and take soil borings to determine the depth of zinc contamination.

U.S. Environmental Protection Agency/Remedial Response Program

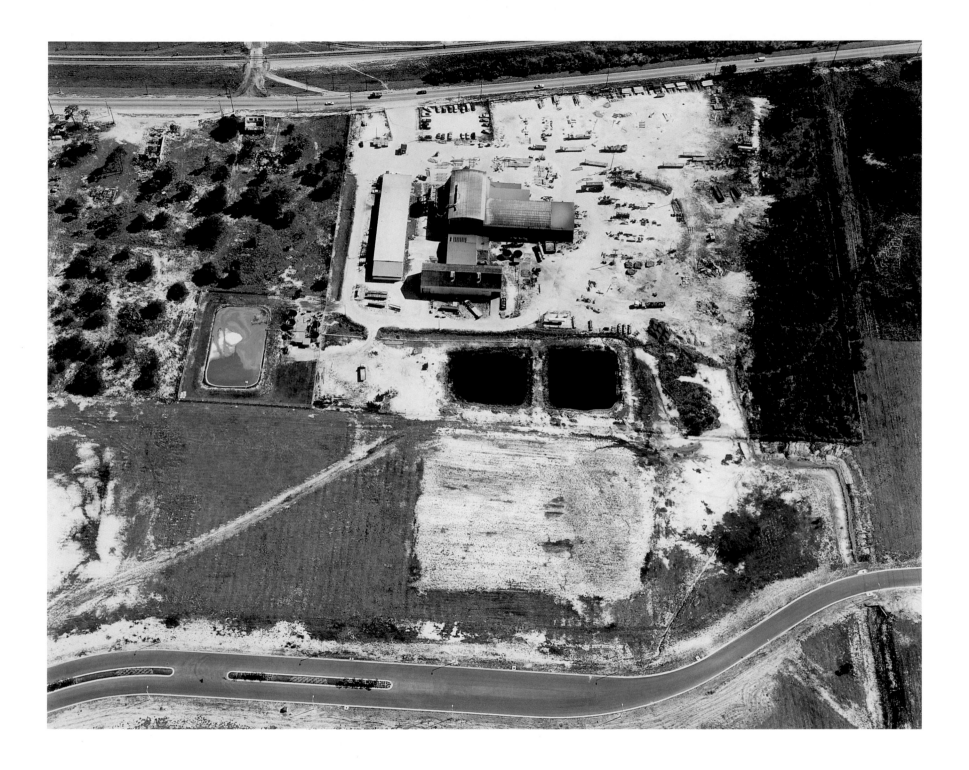

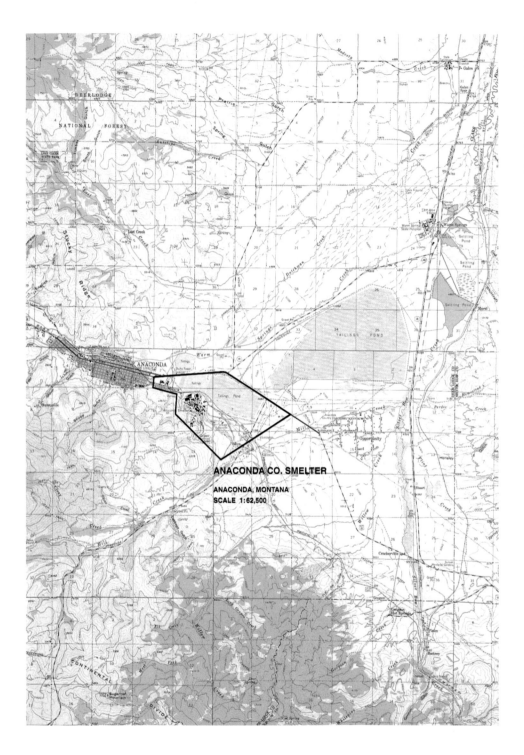

ANACONDA CO. SMELTER

ANACONDA, MONTANA
SCALE 1:62,500

National Priorities List Site

Hazardous waste site listed under the
Comprehensive Environmental Response, Compensation and Liability Act of 1980 (CERCLA) ("Superfund")

ANACONDA CO. SMELTER
Anaconda, Montana

The Anaconda Co. copper smelter covers 5,000 acres in Anaconda, Montana. It operated from the late 1800s until it closed in September 1980. For the most part, the wastes left on-site at closure still remain. The State and EPA are concerned over possible release of hazardous substances, primarily heavy metals, from the smelter wastes into surface water, ground water, and air.

The Anaconda Co. voluntarily entered into an agreement with EPA and the State for a study to identify and quantify hazardous materials at the smelter. The sampling and analysis of the results have been completed by the parties to the agreement.

EPA is planning a remedial investigation/feasibility study to determine the type and extent of contamination at the site and identify alternatives for remedial action. EPA is also negotiating with the company to have it take interim remedial measures to stabilize conditions at the site.

U.S. Environmental Protection Agency/Remedial Response Program

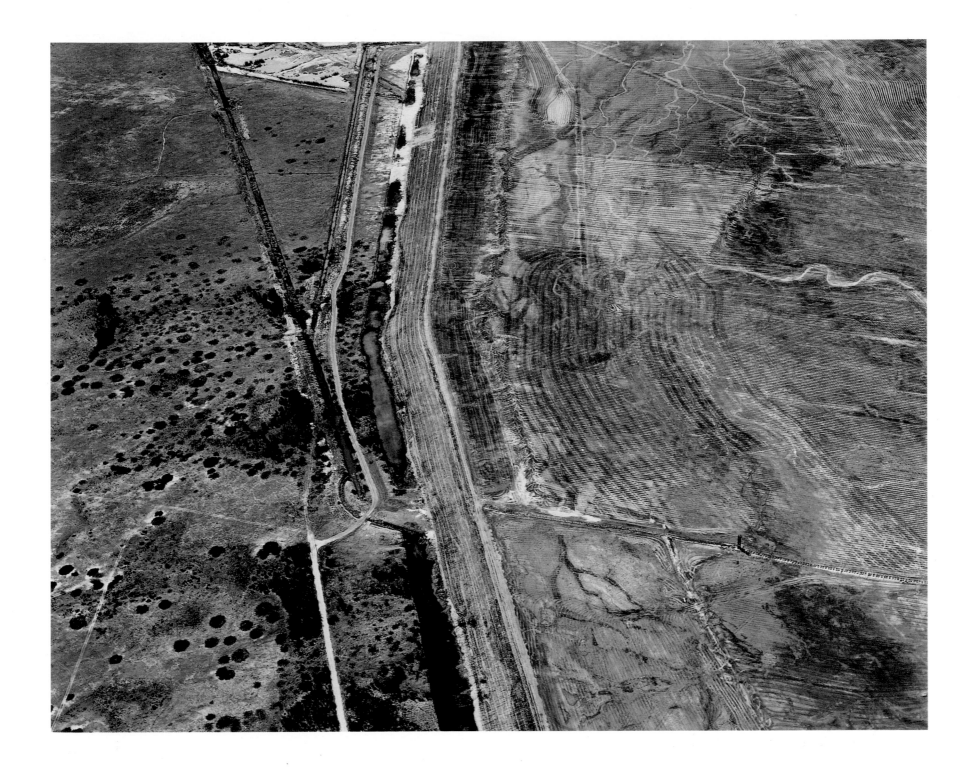

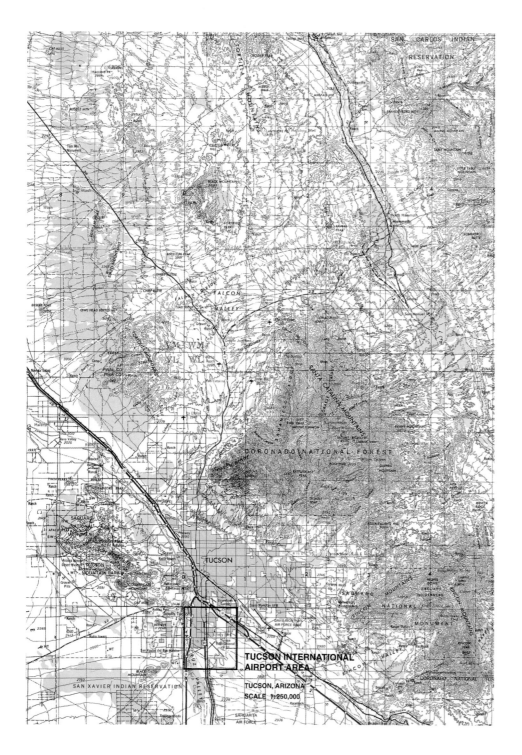

TUCSON INTERNATIONAL
AIRPORT AREA

TUCSON, ARIZONA
SCALE 1:250,000

National Priorities List Site
Hazardous waste site listed under the
Comprehensive Environmental Response, Compensation and Liability Act of 1980 (CERCLA) ("Superfund")

TUCSON INTERNATIONAL AIRPORT AREA
Tuscon, Arizona

The Tucson International Airport Area Site covers about 24 miles in a southwestern section of Tucson in Pima County, Arizona. The site encompasses the Tucson International Airport, Air Force Plant #44, portions of the San Xavier Indian Reservation, and residential areas of South Tucson west of the airport. Ground water at the site is contaminated with organic and metallic compounds, primarily trichloroethylene (TCE) and hexavalent chromium.

The ground water underlying the site is part of the Santa Cruz Basin, the aquifer Tucson uses as its principal source of water. The Tucson area, with a population of 517,000, is one of the largest metropolitan areas in the country that is totally dependent on ground water for its drinking water.

A preliminary investigation conducted by EPA, the State, and the city confirmed only one source of contamination: Air Force Plant #44, a missile manufacturing facility owned by the Air Force and operated by Hughes Aircraft.

In negotiations with EPA, the State, and the city, the Air Force agreed to take the necessary actions to clean up the contamination caused by the plant. In the portion of the site north of Los Reales Road, the extent and sources of the contamination are as yet unknown. The State has received $581,000 in CERCLA funds under a Cooperative Agreement with EPA to complete the investigation to identify the extent and sources of the contamination.

U.S. Environmental Protection Agency/Remedial Response Program

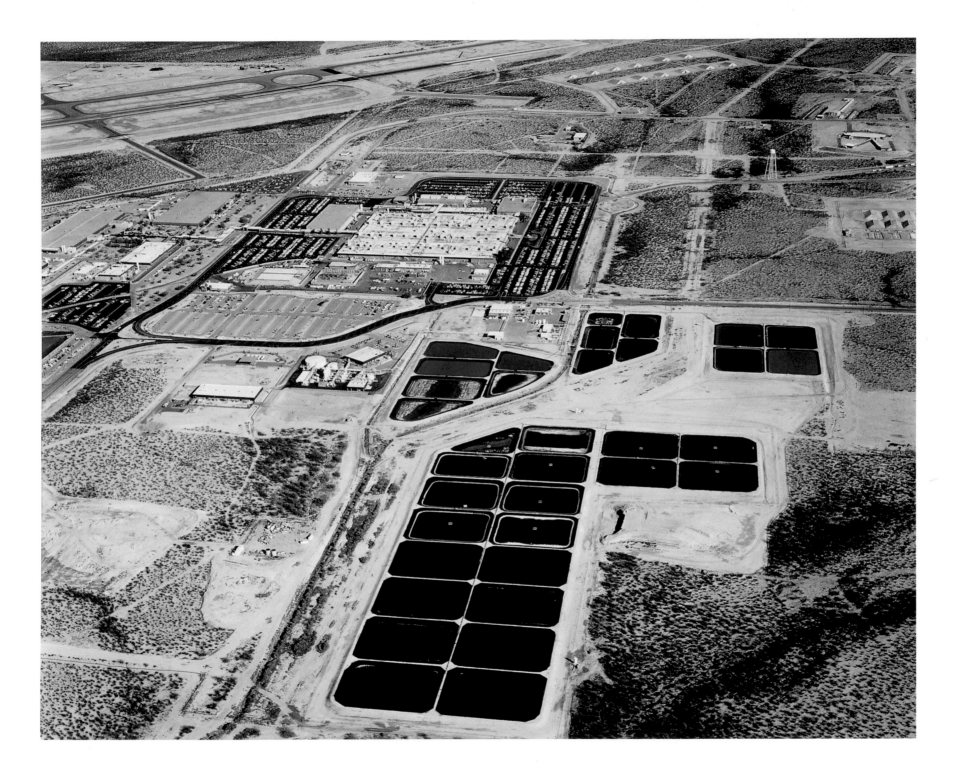

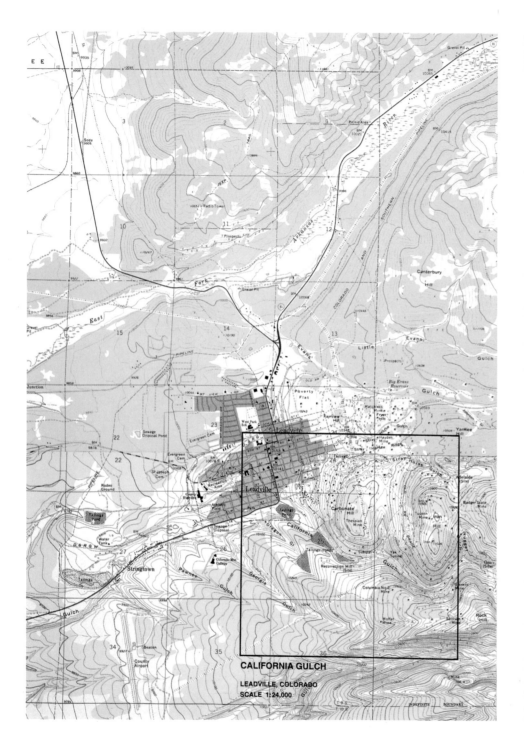

CALIFORNIA GULCH

LEADVILLE, COLORADO

SCALE 1:24,000

National Priorities List Site
Hazardous waste site listed under the
Comprehensive Environmental Response, Compensation and Liability Act of 1980 (CERCLA) ("Superfund")

CALIFORNIA GULCH
Leadville, Colorado

California Gulch flows about 1.5 miles to its confluence with the Arkansas River in Colorado's Leadville Mining District. The gulch has been seriously impacted by lead, silver, zinc, copper, and gold mining activities. Numerous abandoned mines and tailing piles are located in the gulch. The most serious water quality problem is acid mine drainage from the Yak Tunnel, a 3.4-mile tunnel constructed from 1895 to 1909 for the purpose of exploration, transportation of ore, and mine drainage. The tunnel is connected to 17 mines. The flow from the tunnel contains high concentrations of dissolved metals, including iron, lead, zinc, manganese, and cadmium.

California Gulch drains to the Arkansas River. There is concern about the potential for (1) contamination of domestic ground water supplies in the California Gulch area, (2) adverse impacts on fish in the Arkansas River, and (3) adverse impacts on livestock and crops grown on agricultural land irrigated by the Arkansas River.

EPA is conducting a remedial investigation to define the contamination problem the Yak Tunnel and tailings piles pose to ground water and surface water and a feasibility study to evaluate and select a remedy to correct the problem.

U.S. Environmental Protection Agency/Remedial Response Program

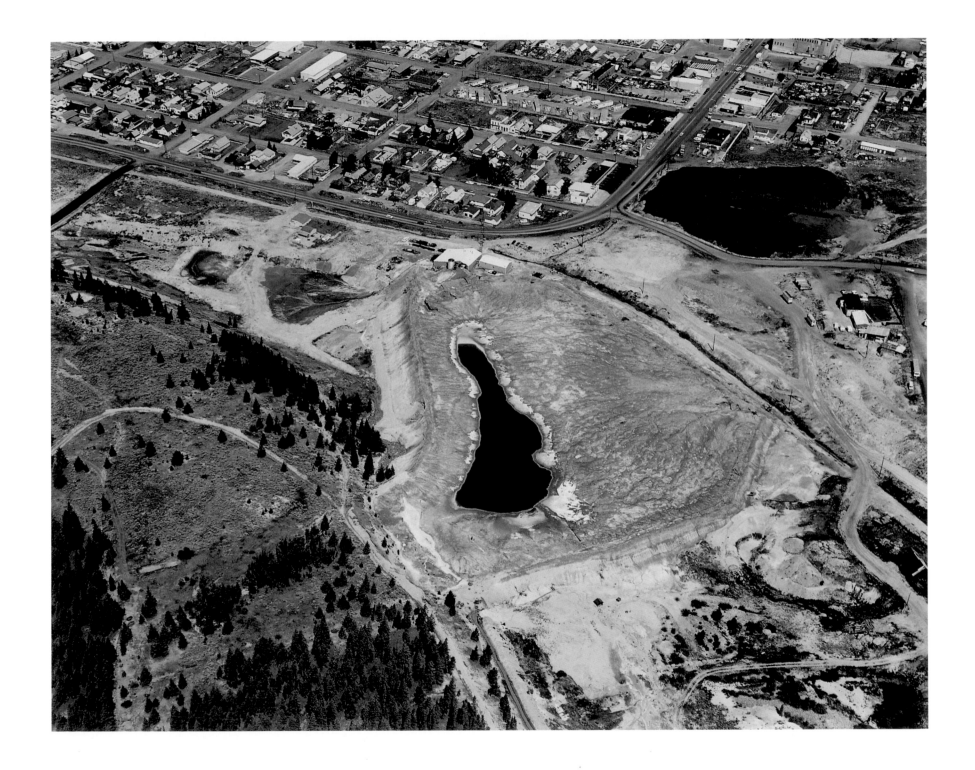

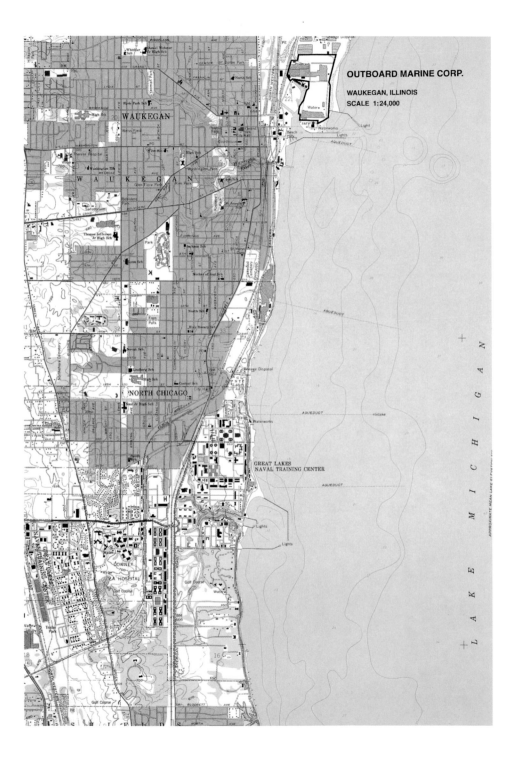

OUTBOARD MARINE CORP.

WAUKEGAN, ILLINOIS

SCALE 1:24,000

National Priorities List Site

Hazardous waste site listed under the
Comprehensive Environmental Response, Compensation and Liability Act of 1980 (CERCLA) ("Superfund")

OUTBOARD MARINE CORP.
Waukegan, Illinois

From 1959 to 1971, the Johnson Motors Division of Outboard Marine Corp. (OMC) in Waukegan, Illinois, purchased about 9 million pounds of PCBs. The material was used in aluminum die cast machines, which routinely leaked. In 1976, the company was found to be discharging PCBs into the Waukegan Harbor and the North Ditch; both feed into Lake Michigan. This finding was of great concern because a number of Lake Michigan fish species contain PCBs in quantities exceeding Food and Drug Administration guidelines. EPA and the State issued administrative orders requiring that the company take certain steps to eliminate discharges of PCBs. Although those steps were taken and discharges significantly reduced, a great deal of PCBs had been released to the environment.

In 1976, EPA began studies to determine the nature and extent of the PCB problem. The studies show that PCBs are distributed throughout the sediments of Waukegan Harbor, with the highest concentrations in Slip 3. About 11,000 cubic yards are at a concentration of 500 parts per million (ppm) or more, about 50,000 cubic yards beyond 50 ppm, and substantially more greater than 10 ppm. In addition, the flowing waters in the ditch annually carry sediments containing 11 pounds of PCBs into the lake. A parking lot next to the lake shore is contaminated.

In 1978, with a special $1.5 million appropriation from Congress, EPA's Region V Office investigated the extent of contamination and identified options for cleanup. In 1980, an additional $436,000, made available under Section 311 of the Clean Water Act and the Resource Conservation and Recovery Act, were used to study the site.

Following a breakdown of negotiations between Illinois and OMC, the Department of Justice, on behalf of EPA, filed a Federal civil action seeking injunctive relief against parties potentially responsible for wastes associated with the site.

In February 1983, EPA approved $100,000 to do a feasibility study, largely based on existing data, to identify alternatives for remedial action at the site.

This is the top priority site in Illinois.

U.S. Environmental Protection Agency/Remedial Response Program

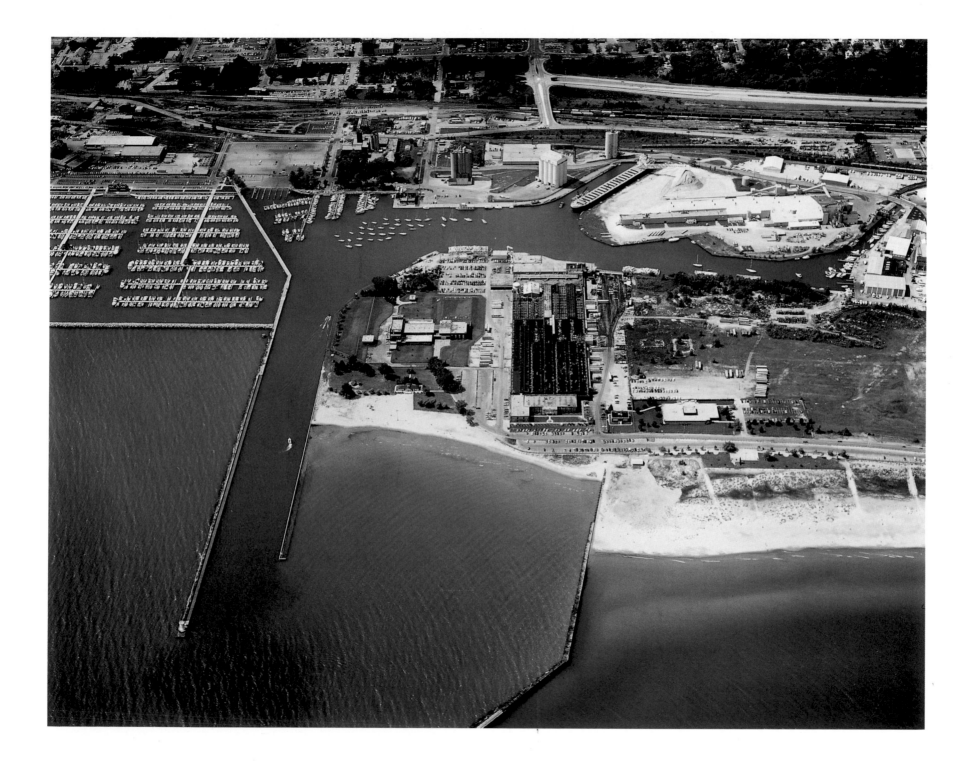

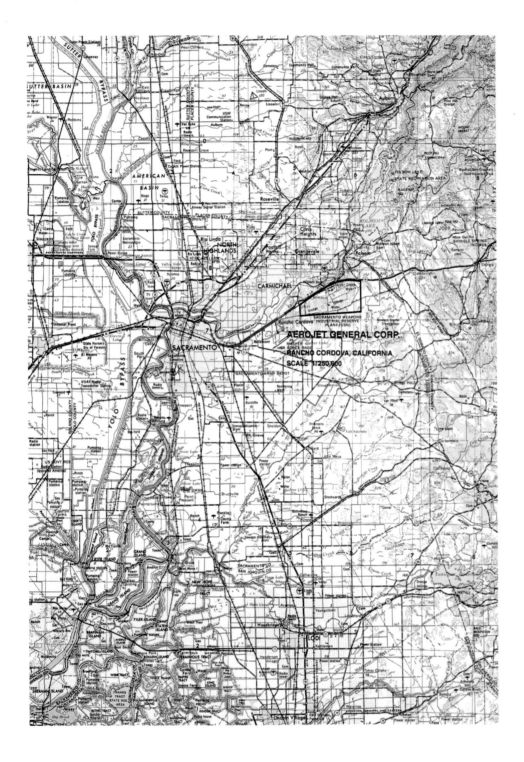

National Priorities List Site
Hazardous waste site listed under the
Comprehensive Environmental Response, Compensation and Liability Act of 1980 (CERCLA) ("Superfund")

AEROJET GENERAL CORP.
Rancho Cordova, California

The Aerojet General Corp. Site covers 8,500 acres in the eastern portion of Sacramento County, California, adjacent to the Rancho Cordova area (population 40,000). The northeast edge of the site is approximately 0.5 miles from the American River. Underlying the site are extensive (50-foot deep) gold dredge tailings, a remnant of past mining operations. The upper aquifer is 80 feet below the surface. Ground water is used extensively throughout the Rancho Cordova area to supply municipal, domestic, and industrial water.

Since 1953, Aerojet and its subsidiaries have disposed of, on-site, unknown quantities of hazardous waste, including trichloroethylene, tetrachloroethylene, chloroform, Freon and other chemicals associated with rocket propellants, and various chemical processing wastes. Soil on-site is contaminated. Monitoring data show extensive ground water contamination on- and off-site, primarily with trichloroethylene. In April 1979, Aerojet and its subsidiaries started ground water studies to examine the impact of past disposal practices and to determine the requirements for cleanup.

In December 1979, the State filed suit against Aerojet and a subsidiary, Cordova Chemical.

EPA has worked with the State since 1979, providing technical assistance through the Emergency Response Team, the Las Vegas lab, and Region IX. In March 1982, the State requested EPA's assistance in evaluating Aerojet's "Proposal for a Ground Water Quality Control Program." EPA found major technical problems in Aerojet's proposal. In the past, a confidentiality agreement between Aerojet and the State limited EPA access to the documents that would allow EPA to independently assess the company's progress toward cleanup. The agreement is no longer in effect.

On February 25, 1983, Region IX requested information from Aerojet regarding soil and ground water contamination. EPA will soon complete review of the documents received in response.

U.S. Environmental Protection Agency/Remedial Response Program

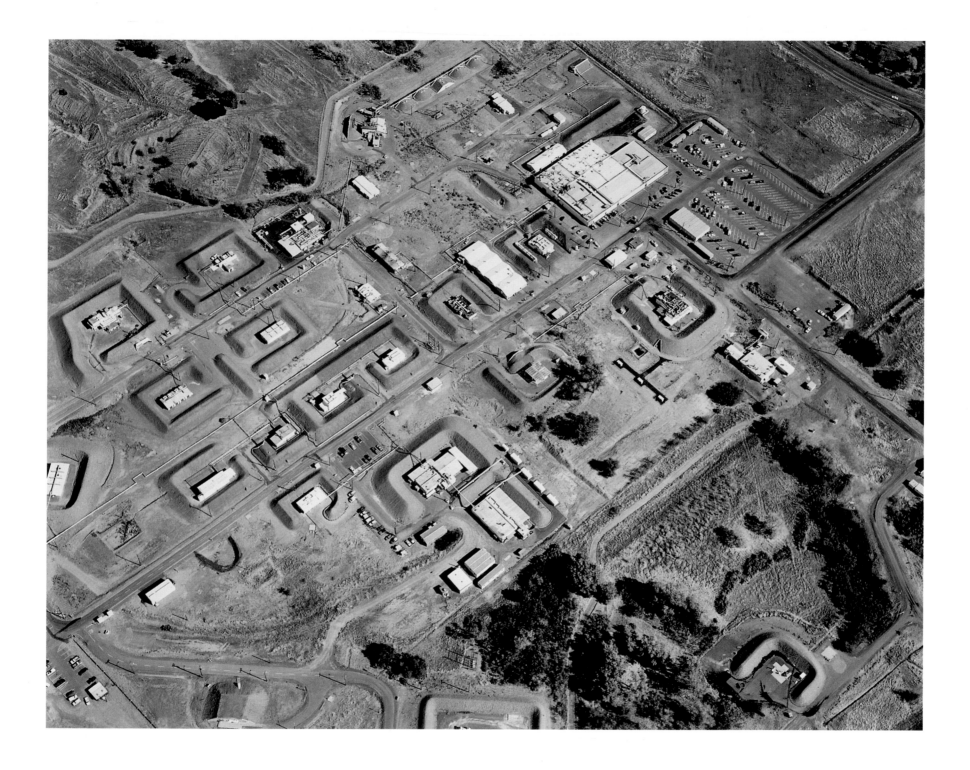

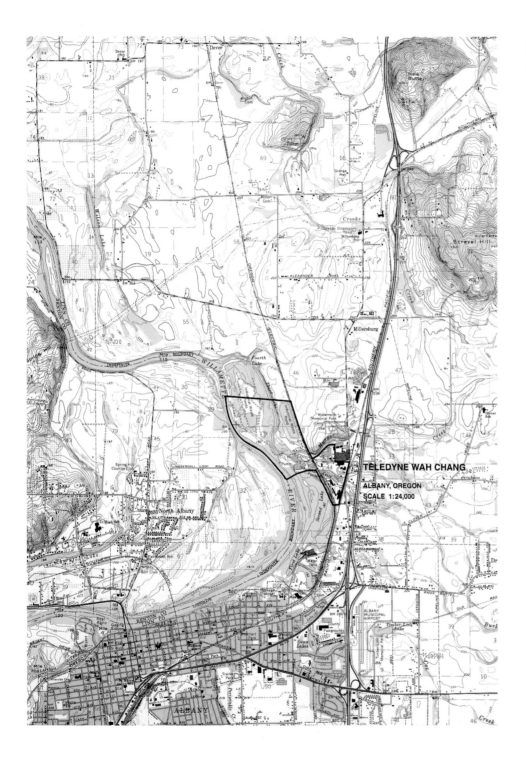

TELEDYNE WAH CHANG
ALBANY, OREGON
SCALE 1:24,000

National Priorities List Site
Hazardous waste site listed under the
Comprehensive Environmental Response, Compensation and Liability Act of 1980 (CERCLA) ("Superfund")

TELEDYNE WAH CHANG
Albany, Oregon

The Teledyne Wah Chang Site covers 100 acres in Albany, Linn County, Oregon. The company is the largest producer in the Western world of zirconium and other rare earth metals and alloys. Production began in 1957. Wastes have generally been disposed of on-site. Process wastes contain a large volume of solids that contribute radiation, heavy metals (barium, cadmium, chromium, and lead), and chlorinated solvents to ground water, surface water, and air. Radiation off-site is generally below established limits. Until 1980, sludges were taken to unlined storage ponds on company property adjacent to the Williamette River. In 1979, the plant added a process to reduce radiation in sludges and waste water. Sludges now have lower levels of radiation than previously and are taken to lined dewatering ponds about 1 mile from the plant.

Wah Chang had requested permission from the State to cover the old storage ponds to minimize percolation that could contribute to possible leachate into the Williamette. In January 1983, the State drafted a permit indicating its preference for moving the sludges to another location on company property farther from the river. This action has been appealed.

EPA recently completed a remedial plan outlining the investigations needed to determine the full extent of cleanup required at the site. It will guide further actions at the site.

U.S. Environmental Protection Agency/Remedial Response Program

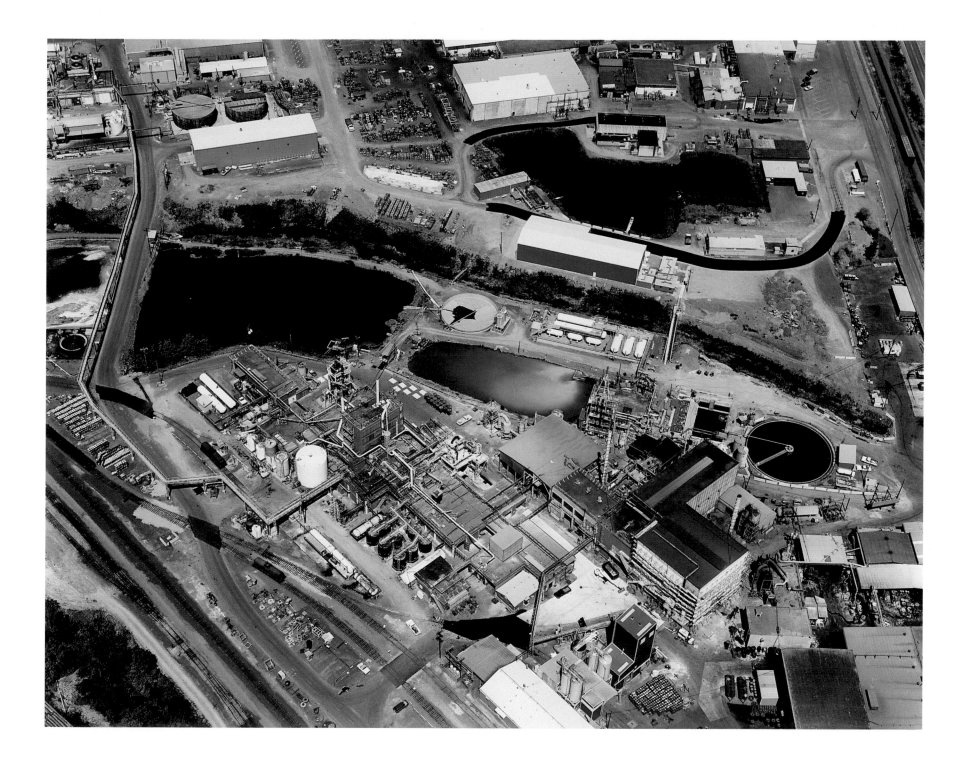

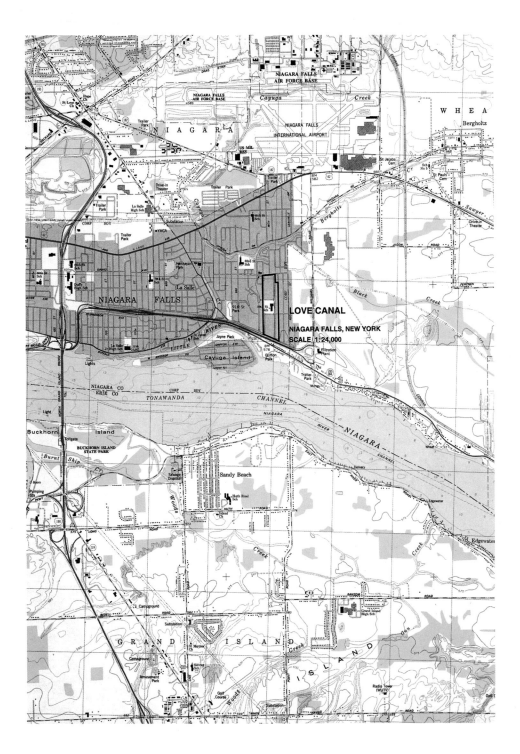

NIAGARA FALLS AIR FORCE BASE

NIAGARA FALLS INTERNATIONAL AIRPORT

LOVE CANAL
NIAGARA FALLS, NEW YORK
SCALE 1:24,000

National Priorities List Site
Hazardous waste site listed under the
Comprehensive Environmental Response, Compensation and Liability Act of 1980 (CERCLA) ("Superfund")

LOVE CANAL
Niagara Falls, New York

Love Canal is a 16-acre landfill in the southeast corner of the city of Niagara Falls, New York, about 0.3 miles north of the Niagara River. In the 1890s, a canal was excavated to provide hydroelectric power. Instead, it was later used by Hooker Electrochemical for disposal of over 21,000 tons of various chemical wastes. Dumping ceased in 1952, and in 1953 the disposal area was covered and deeded to the Niagara Falls Board of Education. Extensive development occurred near the site, including construction of an elementary school and numerous homes.

Problems with odors and residues, first reported at the site during the 1960s, increased in the 1970s as the water table rose, bringing contaminated ground water to the surface. Studies indicate that numerous toxic chemicals have migrated into surrounding areas. Run-off drains into the Niagara River at a point 2.8 miles upstream of the intake tunnels for Niagara Falls' water treatment plant, which serves about 77,000 people. At this discharge point, the river sediment has also become contaminated.

Between 1977 and 1980, New York State and the Federal government spent about $45 million at the site: $30 million for relocation of residents and health testing, $11 million for environmental studies, and $4 million for a demonstration grant (under the Resource Conservation and Recovery Act) to build a leachate collection and treatment system.

A study completed in 1982 recommended construction of a slurry wall and cap to contain ground water in the site as the long-term solution.

In July 1982, EPA awarded a $6,995,000 Cooperative Agreement to New York for (1) construction of a slurry wall and cap, (2) four feasibility studies, and (3) a long-term monitoring study to determine seasonal variations in ground water levels and leaching. In September 1982, $892,800 was added to (1) demolish the school, (2) install a synthetic membrane over a temporary clay cap, and (3) erect a fence.

The Department of Justice, on behalf of EPA, has brought a federal civil action seeking injunctive relief against parties potentially responsible for wastes associated with the site.

U.S. Environmental Protection Agency/Remedial Response Program

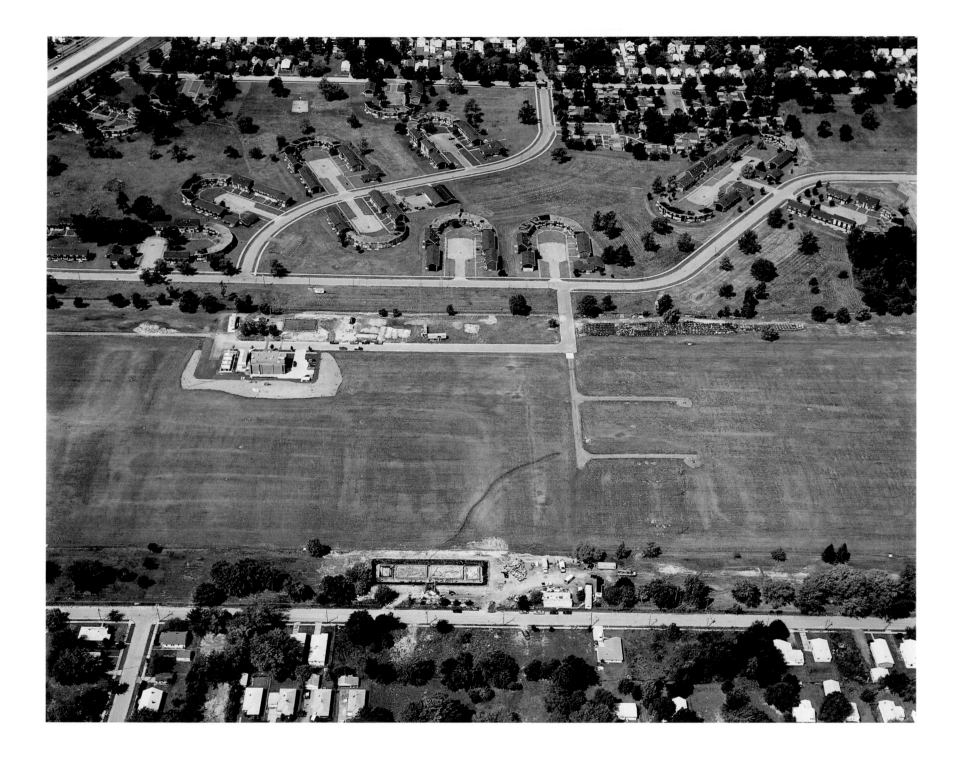

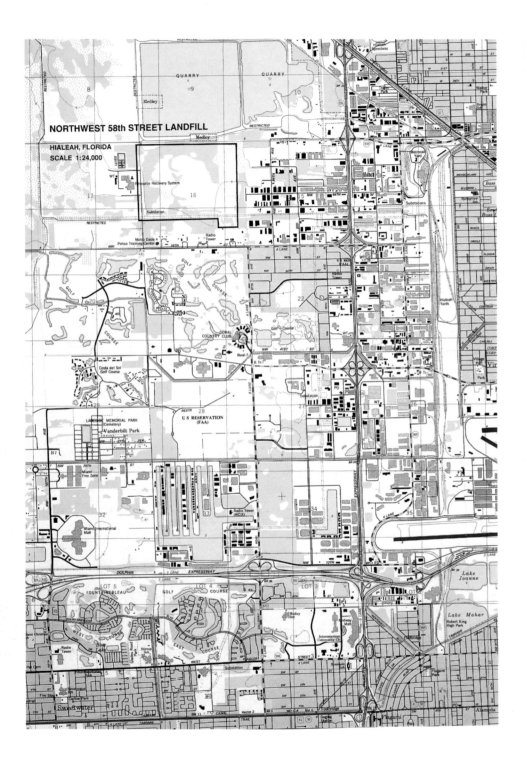

NORTHWEST 58th STREET LANDFILL

HIALEAH, FLORIDA
SCALE 1:24,000

National Priorities List Site
Hazardous waste site listed under the
Comprehensive Environmental Response, Compensation and Liability Act of 1980 (CERCLA) ("Superfund")

NORTHWEST 58th STREET LANDFILL
Hialeah, Florida

The Northwest 58th Street Landfill is a large active municipal landfill covering 1 square mile near Hialeah, Florida, along the eastern edge of the Everglades. Operated continuously since 1952 by Dade County, this facility receives as much as 3,000 tons per day of municipal solid waste. Leachate from the landfill has contaminated ground water with metals such as arsenic, cadmium, chromium, and lead, as well as phenols and halogenated organic compounds. Two major public water supply wells are located downgradient within 3 miles of the site.

To emphasize the threat to the regional water supply, this site, the Miami Drum Services Site, and the Varsol Spill Site were collectively designated as the "Biscayne Aquifer Site" when they were first listed.

The State has a civil suit pending against Dade County for failure to cease operations by August 1981 (as required by a 1979 consent decree). The State and county are working together to develop a final plan for closing the facility.

EPA recently completed a remedial investigation at this site as part of the area-wide "Biscayne Aquifer" project. In January 1983, EPA approved $200,000 for a feasibility study of the aquifer.

U.S. Environmental Protection Agency/Remedial Response Program

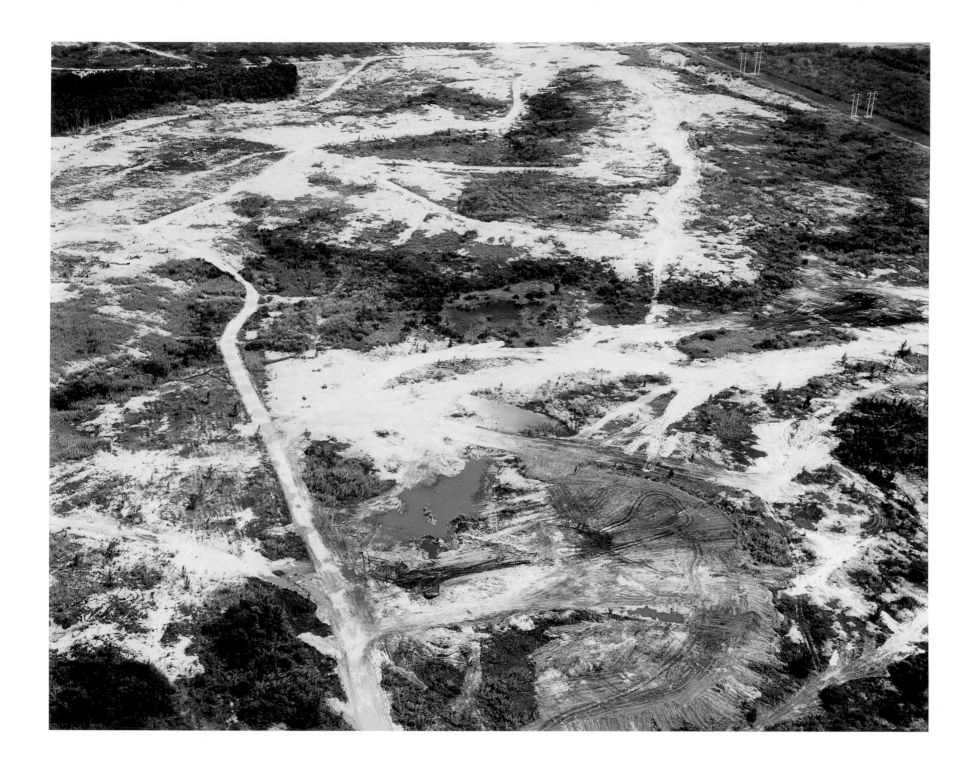

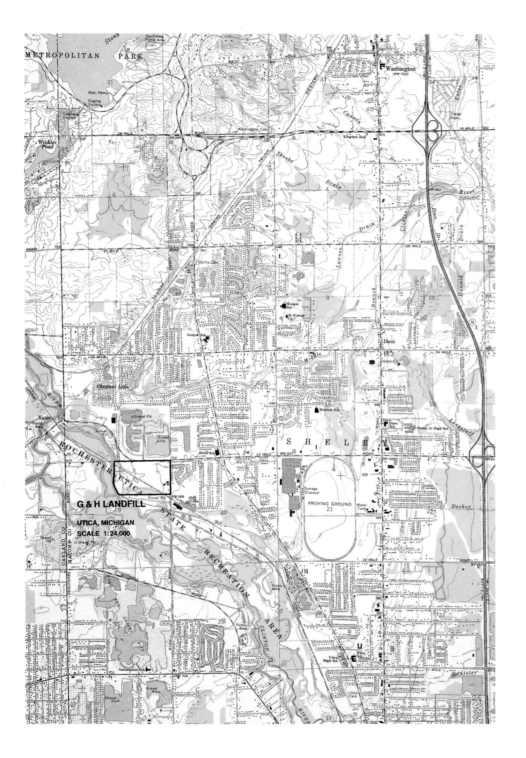

G & H LANDFILL

UTICA, MICHIGAN
SCALE 1:24,000

National Priorities List Site

Hazardous waste site listed under the
Comprehensive Environmental Response, Compensation and Liability Act of 1980 (CERCLA) ("Superfund")

G & H LANDFILL
Utica, Michigan

The G & H Landfill covers 40 acres in Utica, Macomb County, Michigan. From the late 1950s to 1966, millions of gallons of industrial wastes, including oils, solvents, and process sludges, were dumped into pits and lagoons at the site. In response to a law suit filed by the State, a Consent Order was entered in 1967. It required the company to stop disposal of all liquid wastes, but not to clean up wastes already at the site. The site was operated as a refuse landfill from 1967 until it closed in 1974. EPA and the State have documented contamination of soil, surface water, and ground water in the vicinity of the site.

In July 1982, EPA spent $6,902 in CERCLA emergency funds to fence an area contaminated with high levels of PCBs.

EPA recently completed a Remedial Action Master Plan outlining the investigations needed to determine the full extent of cleanup required at the site. It will guide further actions at the site.

U.S. Environmental Protection Agency/Remedial Response Program

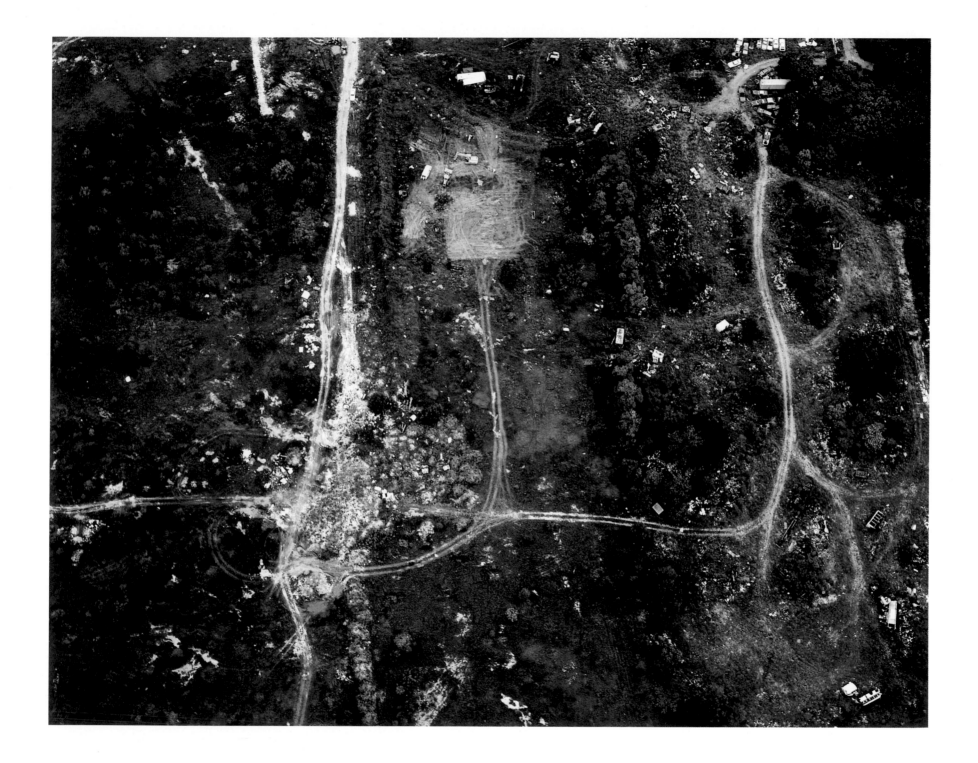

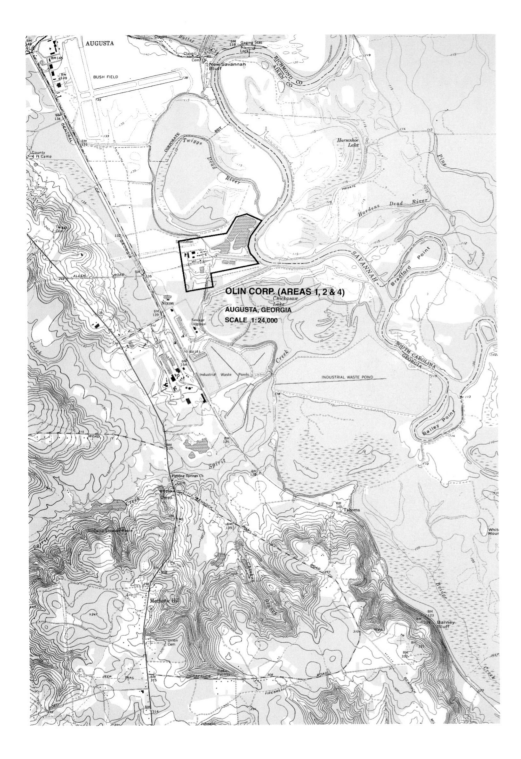

OLIN CORP. (AREAS 1, 2 & 4)
AUGUSTA, GEORGIA
SCALE 1:24,000

National Priorities List Site

Hazardous waste site listed under the
Comprehensive Environmental Response, Compensation and Liability Act of 1980 (CERCLA) ("Superfund")

OLIN CORP. (AREAS 1, 2, & 4)
Augusta, Georgia

Olin Corp.'s plant in Augusta, Richmond County, Georgia, manufactures chlorine and caustic soda, generating a mercury-contaminated brine sludge in the process. Since the early 1970s, Olin has disposed of its mercury-brine sludge in two dumps and in a lined surface impoundment. All three disposal facilities, plus a retort ash and filter cake dump, occupy about 5 acres and are located at the southern portion of the plant property. The two sludge dumps are unlined. The liner in the impoundment may have been destroyed by dumping of construction rubble. About 32,000 tons of mercury-contaminated wastes have been disposed of in Olin Areas 1, 2, and 4. In April and July 1981, the company's on-site monitoring wells near the disposal facilities detected mercury in ground water.

Within 3 miles of the disposal areas are 11 Richmond County drinking water supply wells. More than 10,000 people use ground water in this area. Large areas of fresh water wetlands, formed as a result of the nearby Savannah River, are within 1.5 miles of the Olin plant.

A State Consent Order executed in January 1984, requires Olin to cease waste disposal in the two pits and to retain a consultant to fully define the extent of contamination. The company submitted the resulting Groundwater Assessment Program Report to the State, where it is currently under review.

U.S. Environmental Protection Agency/Remedial Response Program

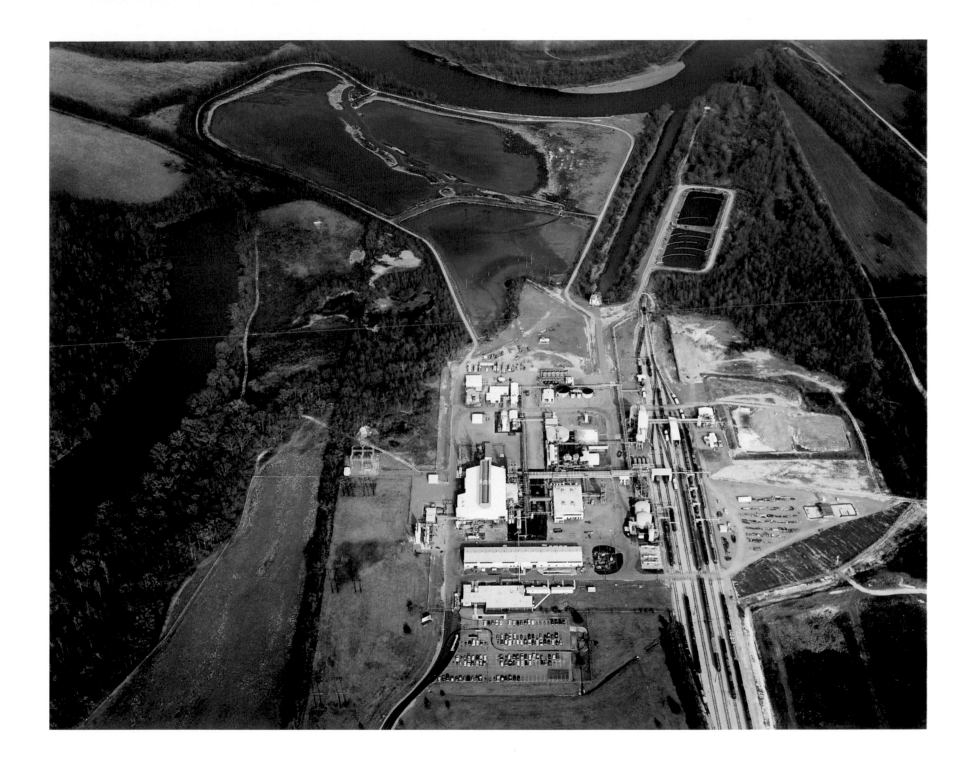

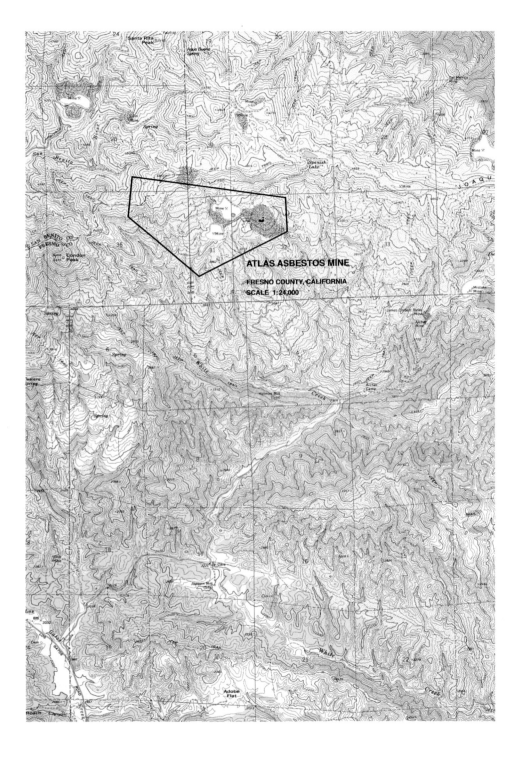

ATLAS ASBESTOS MINE

FRESNO COUNTY, CALIFORNIA

SCALE 1:24,000

National Priorities List Site
Hazardous waste site listed under the
Comprehensive Environmental Response, Compensation and Liability Act of 1980 (CERCLA) ("Superfund")

ATLAS ASBESTOS MINE
Fresno County, California

The Atlas Asbestos Mine operated from 1963 to 1980 on a 16-acre site about 19 miles northwest of Coalinga, Fresno County, California. The abandoned site consists of the asbestos mine, a processing mill, support buildings, and extensive asbestos tailings. Drainage from the site is directly downslope into White Creek, then into Los Gatos Creek. Los Gatos Creek is a tributary to the Arroyo Pasajero, a flood area along the California Aqueduct. During the rainy season, the California State Department of Water Resources drains the Arroyo into the aqueduct. Analysis of water in the aqueduct, conducted by the Southern California Metropolitan Water District and the Department of Water Resources, indicates high concentrations of asbestos fibers.

EPA has conducted initial planning activities for this site. The purpose was to gather and review existing data on the site, define areas of insufficient data, and define the scope of any remedial investigation. The plan also examined what remedial actions would be necessary to respond to the release or substantial threat of release of asbestos into the environment. Remedial investigation activities are being formulated and are expected to begin soon.

U.S. Environmental Protection Agency/Remedial Response Program

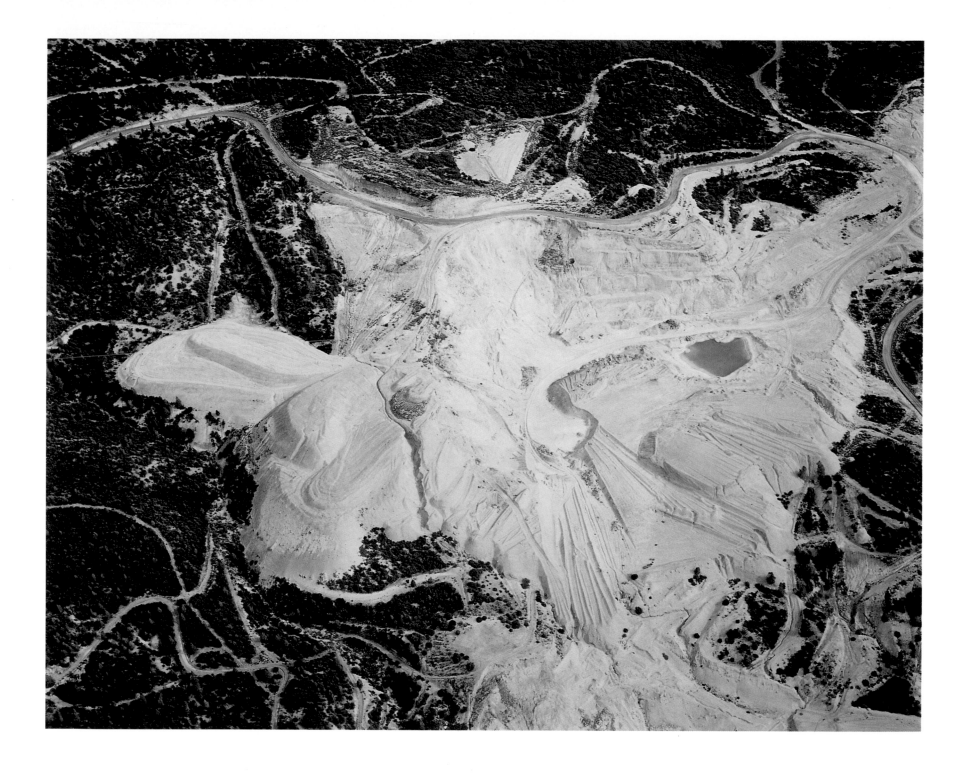

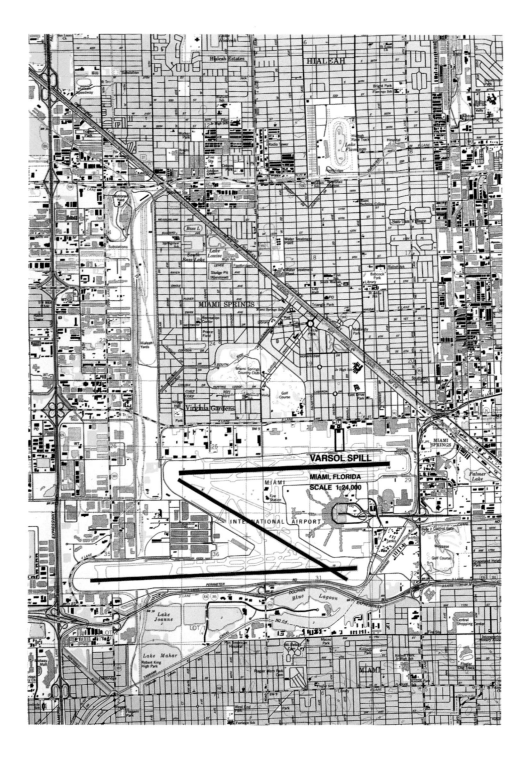

National Priorities List Site
Hazardous waste site listed under the
Comprehensive Environmental Response, Compensation and Liability Act of 1980 (CERCLA) ("Superfund")

VARSOL SPILL
Miami, Florida

An underground pipeline leak resulted in the discharge of about 1.6 million gallons of Varsol (a petroleum solvent) at the Miami International Airport, Florida. After the spill was discovered in 1968, concrete walls were installed. The walls, along with an existing storm drain, contain the solvent, which floats on top of the Biscayne Aquifer, within the airport. About 2,000 feet from the walls is the Miami Springs Well Field, which provides some of Miami's drinking water. At the time of the spill, Dade County took an enforcement action against Eastern Airlines, owner of the material.

To emphasize the threat to the regional water supply, this site, the Miami Drum Services Site, and Northwest 58th Street Landfill were collectively designated as the "Biscayne Aquifer Site" when they were first listed.

EPA recently completed a remedial investigation at this site as part of the area-wide "Biscayne Aquifer" project. In January 1983, EPA approved $200,000 for a feasibility study of the aquifer.

U.S. Environmental Protection Agency/Remedial Response Program

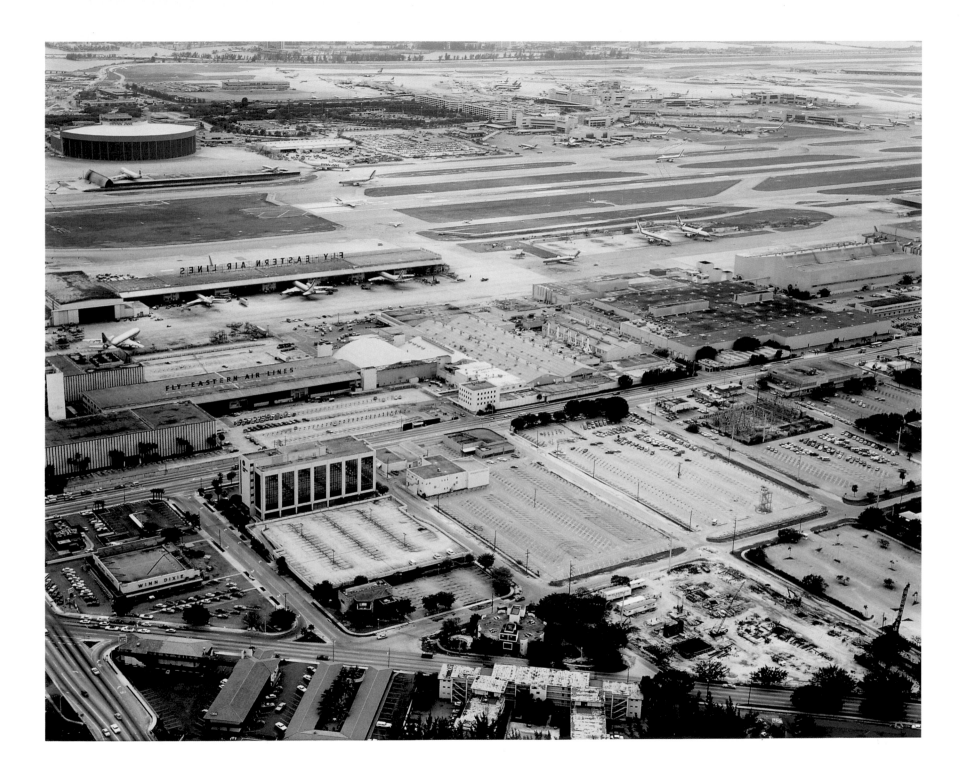

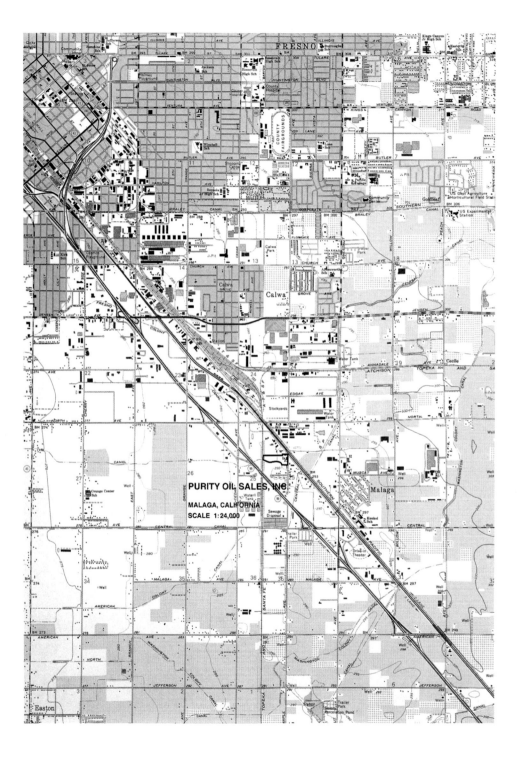

PURITY OIL SALES, INC.
MALAGA, CALIFORNIA
SCALE 1:24,000

National Priorities List Site

Hazardous waste site listed under the
Comprehensive Environmental Response, Compensation and Liability Act of 1980 (CERCLA) ("Superfund")

PURITY OIL SALES, INC.
Malaga, California

The Purity Oil Sales, Inc., Site covers 6 acres in an industrial-residential area 2 miles south of Fresno in Malaga, Fresno County, California. To the north is a mobile home park, scrap metal recycling/reclaiming facility, and a combination service station, market and coffee shop. An irrigation canal is to the south, Santa Fe Railroad to the west, and South Maple Avenue to the east. The Fresno Aquifer, about 30 feet below the surface, provides water for municipal, industrial, and agricultural purposes, as well as for a number of private wells. The area is also a ground water recharge zone.

Oily liquids and sludges have been disposed of on-site for many years. Some liquid wastes remain in a concrete pond. Former sludge disposal ponds have been filled with construction debris. Soil samples contain significant concentrations of PCBs, lead, copper, zinc, and various volatile organics. An unknown sludge-like substance is oozing from the filled area and has, in places, entered adjacent properties. The site was closed in 1974. All buildings were removed, and the site was fenced.

The State has requested CERCLA funding for a remedial investigation/feasibility study to determine the type and extent of contamination at the site and identify alternatives for remedial action.

U.S. Environmental Protection Agency/Remedial Response Program

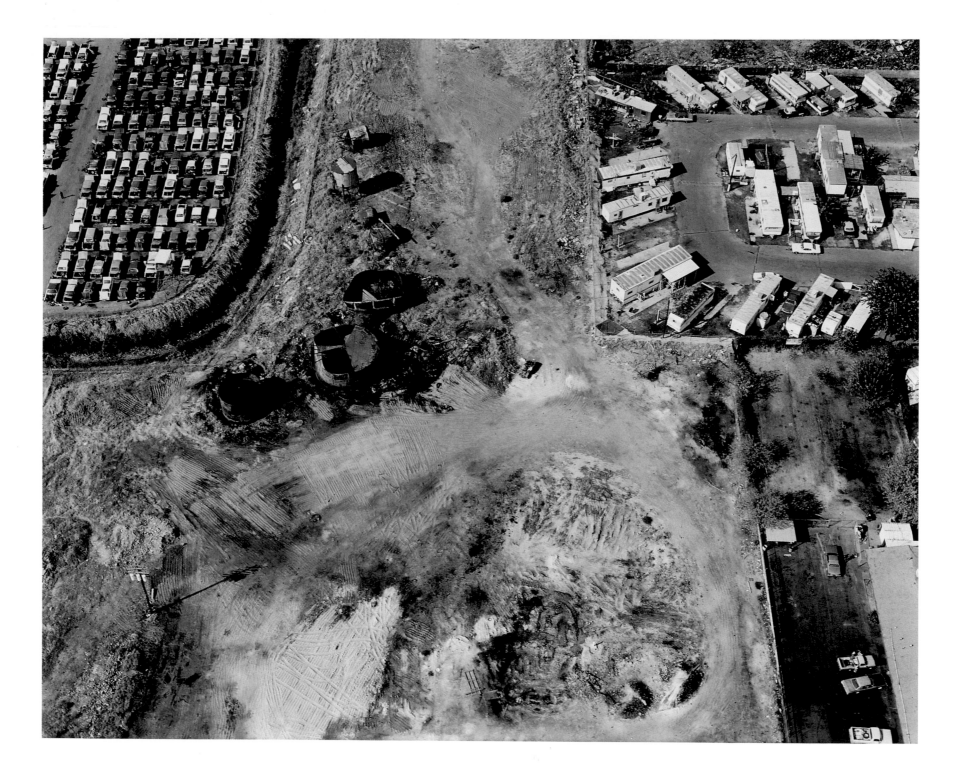

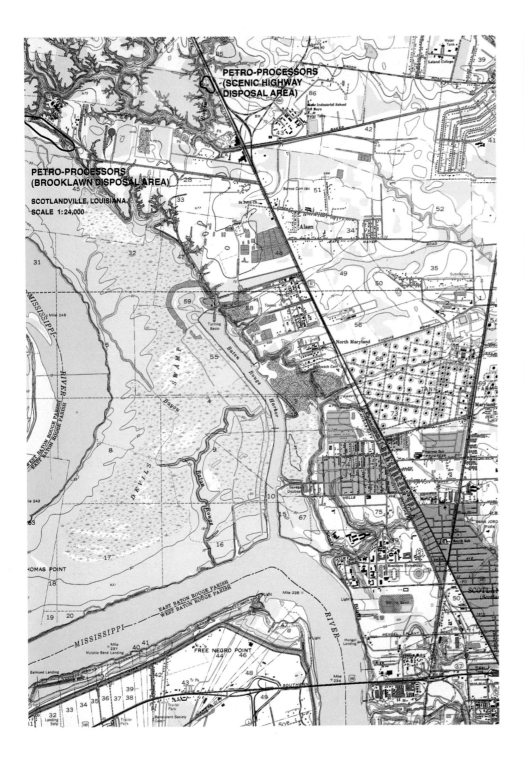

PETRO-PROCESSORS
(SCENIC HIGHWAY
DISPOSAL AREA)

PETRO-PROCESSORS
(BROOKLAWN DISPOSAL AREA)

SCOTLANDVILLE, LOUISIANA
SCALE 1:24,000

National Priorities List Site

Hazardous waste site listed under the
Comprehensive Environmental Response, Compensation and Liability Act of 1980 (CERCLA) ("Superfund")

PETRO-PROCESSORS OF LOUISIANA, INC.
Scotlandville, Louisiana

The Petro-Processors of Louisiana, Inc., Site covers a total of about 55 acres near Scotlandville, East Baton Rouge Parish, Louisiana. It is comprised of two disposal areas on the banks of Bayou Baton Rouge in and/or near the floodplain of the Mississippi River. Although the two areas are about 1.5 miles apart, they both threaten the same surface waters and aquifer systems. Both areas were operated by the same management and equipment, and personnel were used interchangeably. The areas were operated concurrently from approximately 1969 until 1972. Generators in the area contracted with Petro-Processors for disposal of hazardous wastes, and the truck drivers took the wastes to the closest pit or the one with the most capacity at the time.

EPA filed suit against the owners and 10 waste generators in July 1980, alleging that toxic organic compounds and heavy metals had been released into local waterways, eventually finding their way to the Mississippi River, and were posing a threat to an underground drinking water supply.

The Scenic Highway disposal area is a pit in an area of permeable to semipermeable soils. Monitoring by EPA and the defendants detected a variety of organic chemicals in ground water outside the pit area. In addition, leachate is travelling through the banks of the bayou and rising to the surface of the closed pits. The U.S. Geological Survey has expressed concern that the area poses a serious threat to the "400 foot aquifer," a major aquifer in the area. The Scenic Highway disposal area was filled and closed around 1974. Liquid wastes were solidified, fill dirt added, a partial plastic cap installed, and a vegetative cover established. The primary problem is the potential for leachate migration and for exposure of toxic materials by erosion. About 3.5 million cubic feet of contaminated materials may be at the Scenic Highway area.

Brooklawn, the larger of the two areas, opened in the late 1960s. It did not completely cease operation until July 1980, when EPA filed suit. Brooklawn is believed to hold about 8 million cubic feet of contaminated materials. The area has three ponds—upper, lower, and cypress—and several disposal pits that have been covered. In June 1983, the cypress pond was inundated by the Mississippi River, and the flood waters came within 4 inches of overtopping the lower pond. An old channel of the bayou runs through part of the area and may be a conduit for subsurface migration of wastes.

On February 16, 1984, a Federal judge approved a Consent Decree requiring the 10 generators to clean up the site. The cleanup must meet the substantive standards of the Resource Conservations and Recovery Act, and the defendants are responsible for perpetual maintenance. There is no monetary limit on the cleanup. The estimates for ultimate cost start at $50 million.

U.S. Environmental Protection Agency/Remedial Response Program

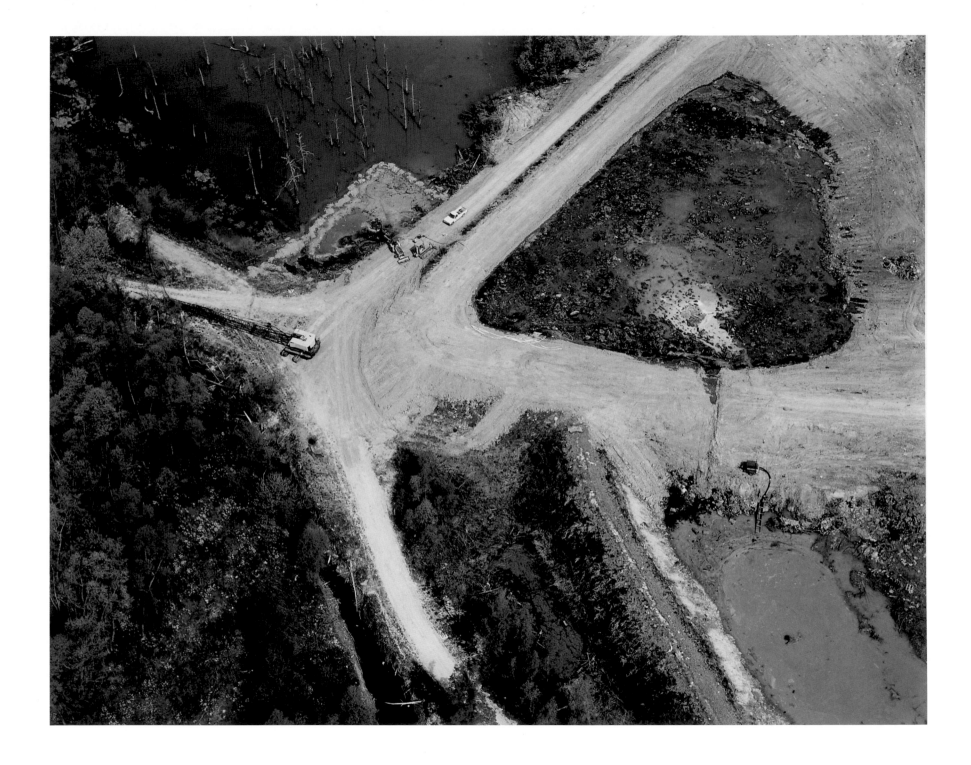

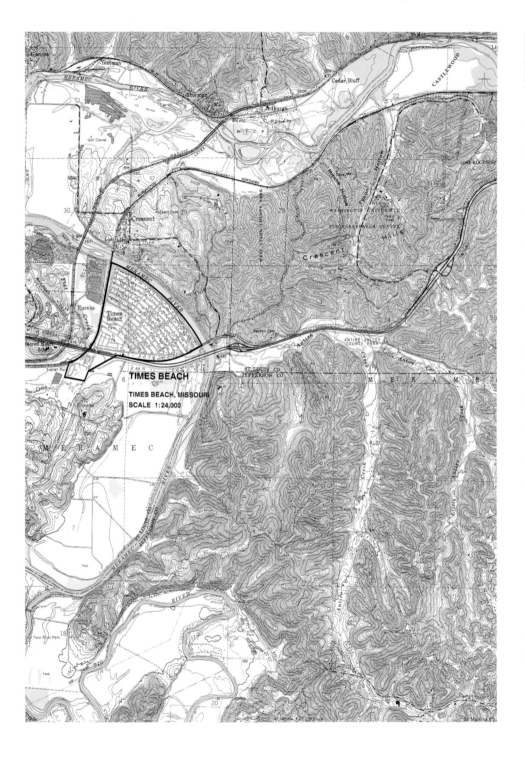

TIMES BEACH

TIMES BEACH, MISSOURI
SCALE 1:24,000

National Priorities List Site
Hazardous waste site listed under the
Comprehensive Environmental Response, Compensation and Liability Act of 1980 (CERCLA) ("Superfund")

TIMES BEACH
Times Beach, Missouri

The city of Times Beach (population 2,800) covers 8 square miles on the floodplain of the Meramec River in St. Louis County, Missouri. In 1972 and again in 1973, the city contracted with a waste oil hauler to spray oil on unpaved roads for dust control. It was later learned that the waste oil contained dioxin. In November and early December 1982, EPA sampled the roads and right-of-ways in Times Beach. Soon afterward, the Meramec River flooded the city. EPA expedited the sample analyses and found dioxin at levels from less than 1 part per billion (ppb) to 127 ppb. As a result, the Centers for Disease Control (CDC) issued a health advisory on December 23, 1982, recommending that people relocated from Times Beach due to flooding should stay away, and that those remaining should leave. EPA resampled the area in January 1983 to determine if flood waters had deposited contaminated soil into homes and yards. In the second week of January, EPA allocated $500,000 to CDC to collect health questionnaires and examine the people of Times Beach. On February 22, 1983, EPA pledged $33 million from Superfund to purchase the Times Beach property under a relocation plan to be developed and implemented by the Federal Emergency Management Agency.

EPA is preparing a Remedial Action Master Plan outlining the investigations needed to determine the full extent of cleanup required at Times Beach. The next step is a feasibility study to identify alternatives for remedial action. CDC will continue its questionnaires and examinations and is also working with EPA to define cleanup levels for dioxin at Times Beach.

U.S. Environmental Protection Agency/Remedial Response Program

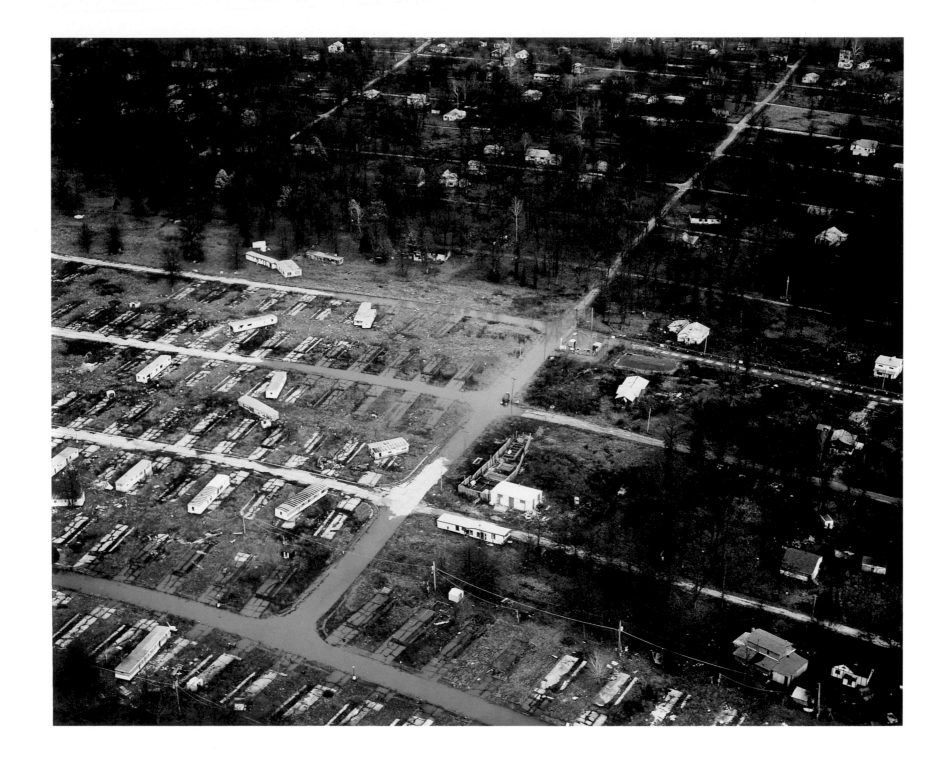

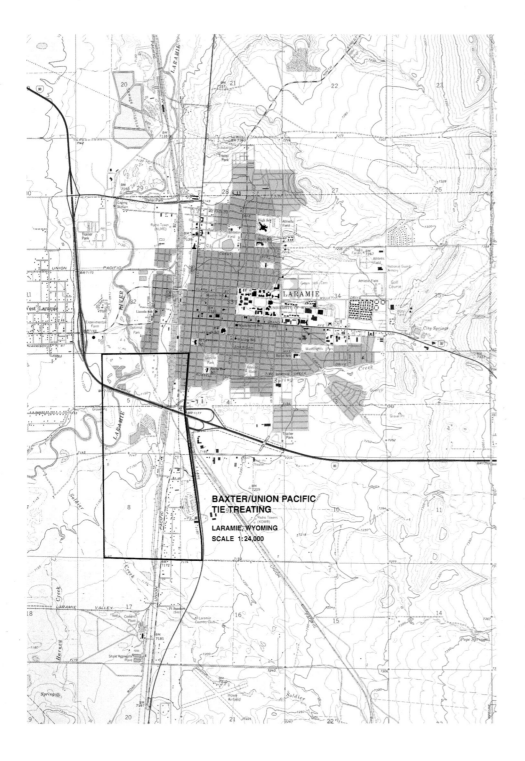

**BAXTER/UNION PACIFIC
TIE TREATING**

**LARAMIE, WYOMING
SCALE 1:24,000**

National Priorities List Site
Hazardous waste site listed under the
Comprehensive Environmental Response, Compensation and Liability Act of 1980 (CERCLA) ("Superfund")

BAXTER/UNION PACIFIC TIE TREATING
Laramie, Wyoming

The Baxter/Union Pacific Tie Treating Facility covers 100 acres just southwest of Laramie, Wyoming. It has been operating since the 1880s. The site includes unlined surface impoundments that contain approximately 1 million cubic feet of waste. Pollutants, including pentachlorophenol, benzene, naphthalene, toluene, and phenol, have migrated from the ponds, contaminating the shallow ground water beneath the site and the Laramie River.

The State and both companies agreed to conduct investigations to define the contamination problem.

U.S. Environmental Protection Agency/Remedial Response Program

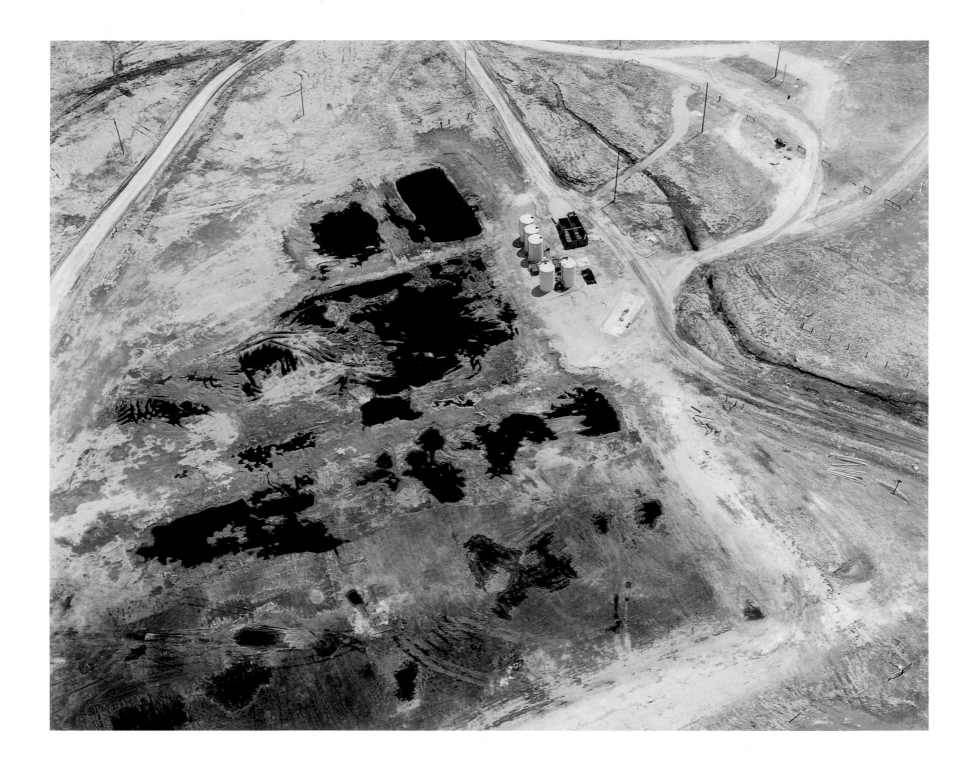

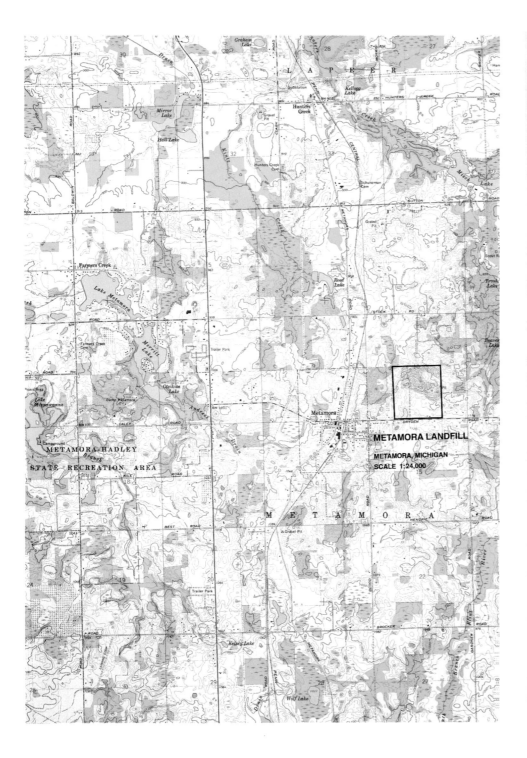

METAMORA LANDFILL
METAMORA, MICHIGAN
SCALE 1:24,000

National Priorities List Site
Hazardous waste site listed under the
Comprehensive Environmental Response, Compensation and Liability Act of 1980 (CERCLA) ("Superfund")

METAMORA LANDFILL
Metamora, Michigan

The Metamora Landfill occupies about 80 acres (about 50 actually landfilled) in a mostly rural area in Metamora, Lapeer County, Michigan. The privately-owned site operated from 1966 to 1980. The generators, amounts, and types of wastes buried at the site are unknown. A magnetometer survey conducted by the State indicated as many as 35,800 drums could be buried. The 100 exposed drums contain ethyl benzene, chloroform, toluene, xylene, and other organic chemicals. Ground water is contaminated with heavy metals, according to the State, although no residential wells have been contaminated to date. Several fires occurred at the site in 1972 and 1979.

EPA is considering various alternatives for the site.

U.S. Environmental Protection Agency/Remedial Response Program

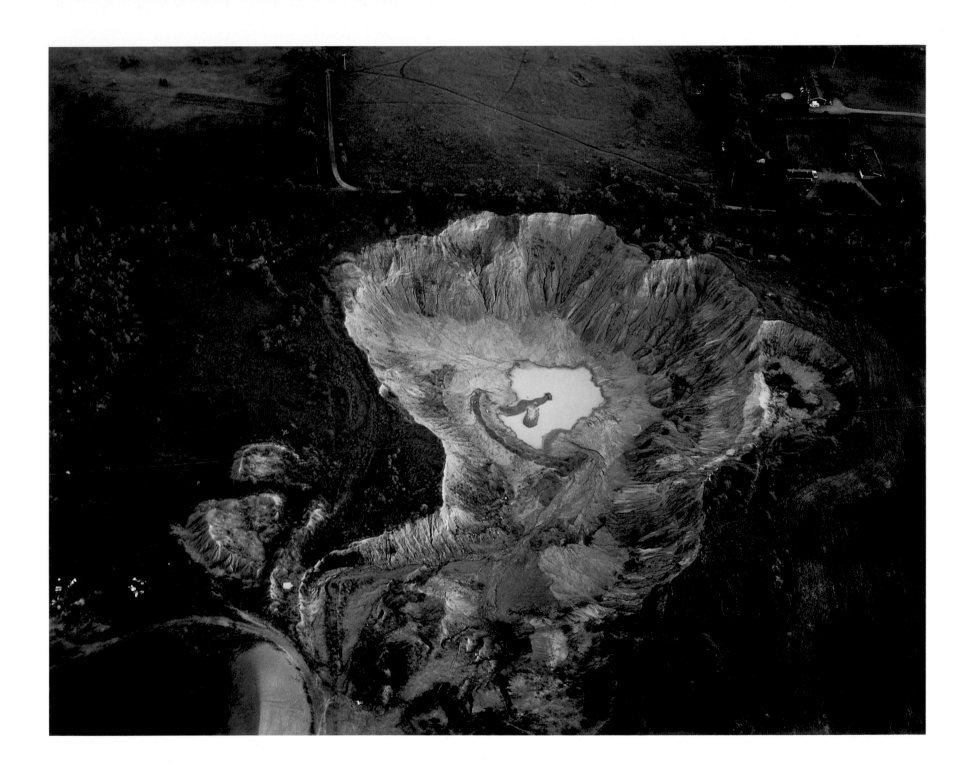

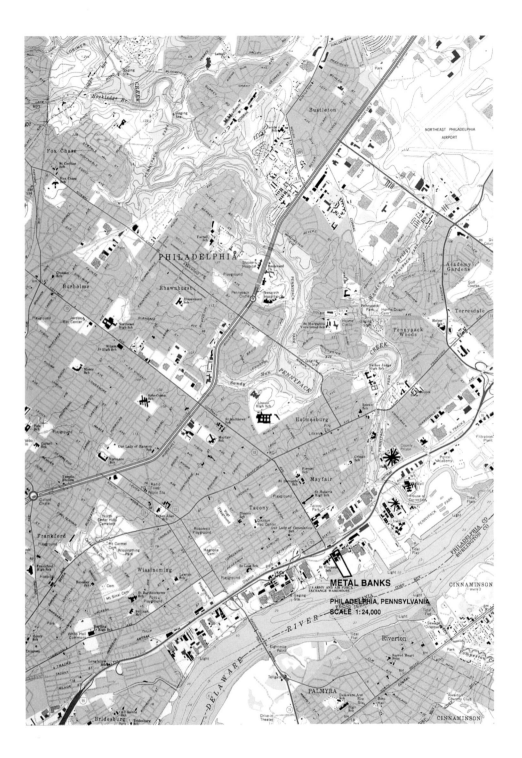

METAL BANKS
PHILADELPHIA, PENNSYLVANIA
SCALE 1:24,000

National Priorities List Site
Hazardous waste site listed under the
Comprehensive Environmental Response, Compensation and Liability Act of 1980 (CERCLA) ("Superfund")

METAL BANKS
Philadelphia, Pennsylvania

The Metal Banks Site covers 6 acres in an urban/industrial neighborhood next to the Delaware River in Philadelphia, Pennsylvania. After processing transformers and oil contaminated with PCBs there for a number of years, Metal Banks closed the operation in 1972. In 1977, EPA determined that periodic oil slicks found in the Delaware River adjacent to the site were contaminated with PCBs. The site was subsequently identified as a source of the slicks. A U.S. Coast Guard study revealed that up to 20,000 gallons of PCB-contaminated oil were in the ground water under the site and were leaking into the Delaware River.

Negotiations are now in progress on a suit filed by EPA against Metal Banks in 1980. The company is currently pumping the contaminated ground water and treating it to remove the contamination.

U.S. Environmental Protection Agency/Remedial Response Program

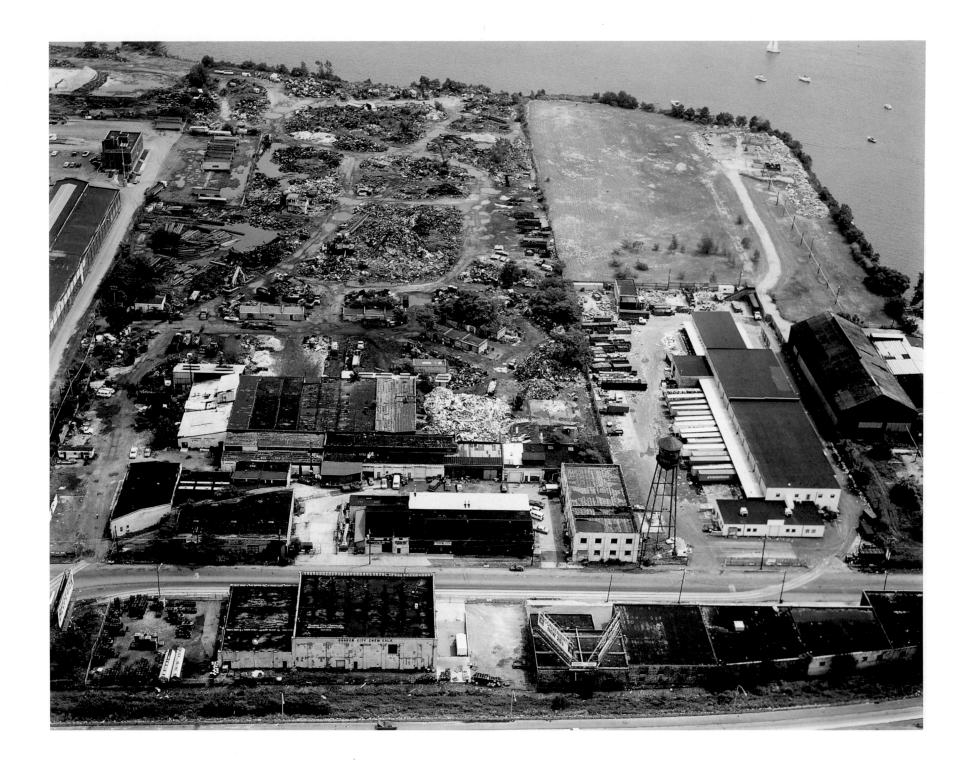

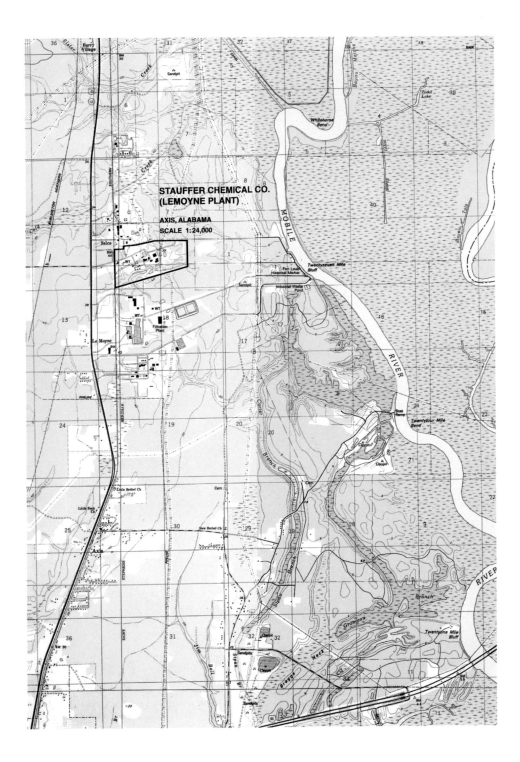

STAUFFER CHEMICAL CO.
(LEMOYNE PLANT)

AXIS, ALABAMA
SCALE 1:24,000

National Priorities List Site
Hazardous waste site listed under the
Comprehensive Environmental Response, Compensation and Liability Act of 1980 (CERCLA) ("Superfund")

STAUFFER CHEMICAL CO. (LEMOYNE PLANT)
Axis, Alabama

Stauffer Chemical Co.'s LeMoyne Plant began operations in the early 1950s in Axis, Mobile County, Alabama. At first it manufactured carbon disulfide. In 1964, it started to produce chlorine and caustic soda, using the mercury cell process. In 1974, the plant expanded again, producing additional industrial inorganic compounds.

During the 1950s and 1960s, Stauffer used an on-site landfill located east of the manufacturing facility and between the facility and the Mobile River. Stauffer reports that the landfill contains drums of wastes that may include organics, solvents, heavy metals, acids, and bases. The exact quantities and types of wastes are not known. The landfill was constructed in native clay and covered with a 20-mil vinyl plastic cap. Topsoil was spread over the cap, and the area was revegetated and fenced.

Ground water is the sole source of drinking water in this area. About 4,000 people (employees of local industries and residents of Falco) are served by wells within 3 miles of the LeMoyne Plant landfill. Ground water in the vicinity of the landfill is contaminated with lead, chromium, cadmium, chloroform, and carbon tetrachloride, according to analyses conducted by EPA. EPA is considering various alternatives for the site.

U.S. Environmental Protection Agency/Remedial Response Program

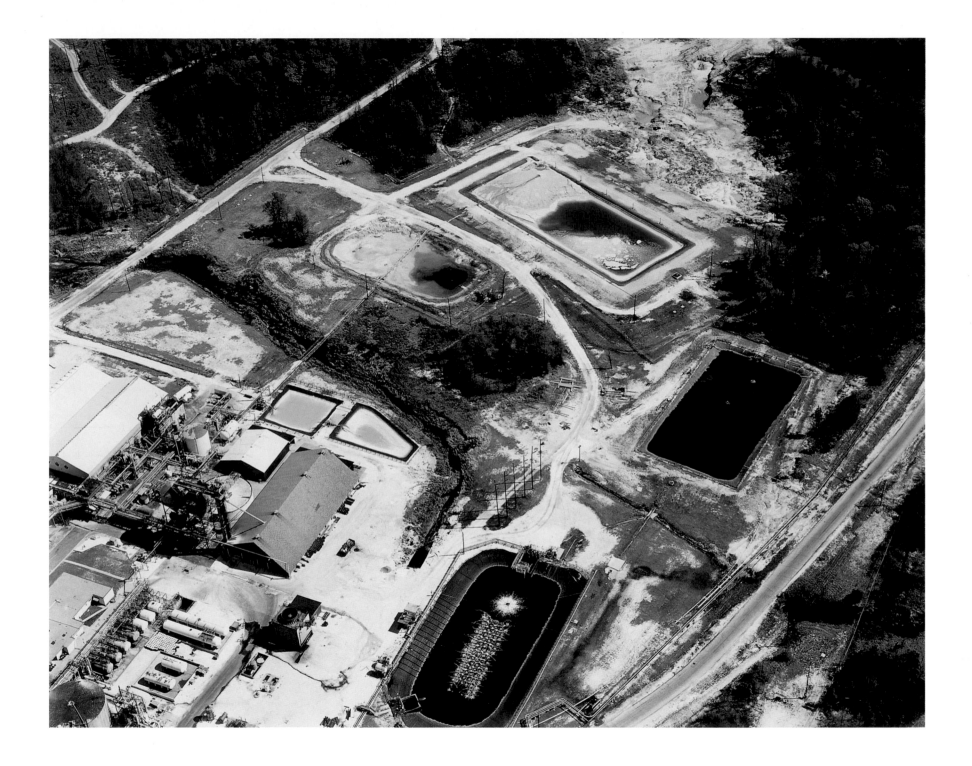

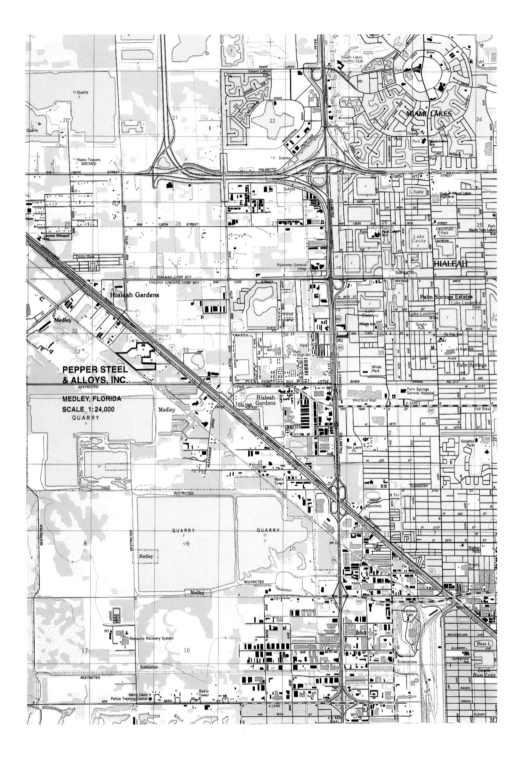

National Priorities List Site

Hazardous waste site listed under the
Comprehensive Environmental Response, Compensation and Liability Act of 1980 (CERCLA) ("Superfund")

PEPPER STEEL & ALLOYS, INC.
Medley, Florida

Pepper Steel & Alloys, Inc., has processed scrap metals since the early 1970s on a 10-acre site in Medley, Dade County, Florida. A portion of its business has been the recycling of transformers and other electrical equipment. The company reportedly disposed of transformer oil containing PCBs on the site and on two adjacent sites.

In 1975, a county inspector sampled an area of oil-soaked ground at Pepper Steel. Results showed high levels of oil and grease. In December 1982, the County observed an oily layer up to 6 inches deep in six pits, each 2 to 4 feet deep, on the site. Analyses of the oil revealed high concentrations of PCBs.

Early in 1983, EPA conducted a geophysical survey of the site and identified about a dozen zones requiring further investigation. Soil sampling determined that PCBs were present in at least two zones. Using approximately $250,000 in CERCLA emergency funds, EPA removed soil in "Zone A," the most highly contaminated portion of the site, and oil floating on the shallow aquifer underlying the site. EPA also drilled observation wells and sampled on-site wells and surface water in the immediate area. Florida Power and Light Co., which allegedly sent electrical equipment to Pepper Steel for recycling, has agreed to perform further sampling and analysis outside of "Zone A" and to recommend remedial alternatives.

EPA is conducting a remedial investigation/feasibility study to determine the type and extent of contamination at the site and identify alternatives for remedial action.

U.S. Environmental Protection Agency/Remedial Response Program

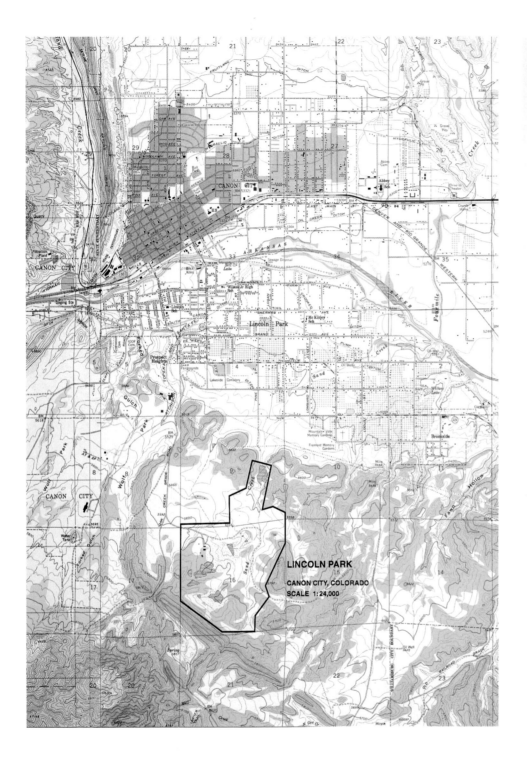

LINCOLN PARK

CANON CITY, COLORADO

SCALE 1:24,000

National Priorities List Site

Hazardous waste site listed under the
Comprehensive Environmental Response, Compensation and Liability Act of 1980 (CERCLA) ("Superfund")

LINCOLN PARK
Canon City, Colorado

Ground water supplies in the Lincoln Park section of Canon City, Colorado, have been affected by the waste disposal activities of a nearby uranium mill operated by Cotter Corp. since 1958. Liquid waste containing both radionuclides and heavy metals from the mill was discharged for years into unlined tailings ponds. Cotter is in the process of transferring this material into lined impoundments. The company's monitoring data indicate a plume of contaminants, including molybdenum, uranium, and selenium, extending from the mill along Sand Creek and affecting private wells serving about 200 people in Lincoln Park. Sand Creek is an intermittent tributary to the Arkansas River.

Cotter has taken several actions challenging the proposed listing on the NPL of Lincoln Park. In August 1983, Cotter filed suit in U.S. District Court seeking injunctive and declaratory relief to prevent listing in the September proposal. The court denied the preliminary injunction request. Cotter appealed the denial to the 10th Circuit Court of Appeals. A hearing on EPA's motion to dismiss Cotter's request for permanent injunction and declaratory relief from the U.S. District Court was held on March 6, 1984. EPA's motion was granted in April 1984.

On December 7, 1983, Cotter filed a formal petition in the District of Columbia Circuit Court of Appeals to review the September proposed listing of Lincoln Park.

Cotter's Radioactive Materials License, issued by Colorado under delegation from the Nuclear Regulatory Commission, was subject to renewal in the summer of 1984.

U.S. Environmental Protection Agency/Remedial Response Program

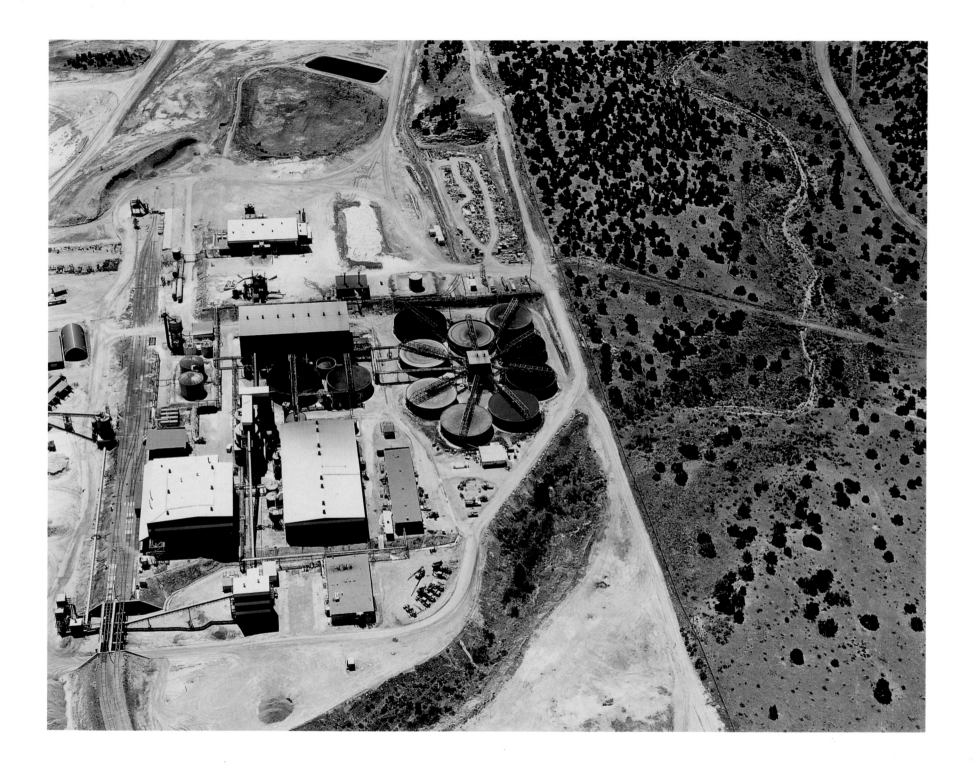

SMUGGLER MOUNTAIN

ASPEN, COLORADO

SCALE 1:24,000

National Priorities List Site

Hazardous waste site listed under the
Comprehensive Environmental Response, Compensation and Liability Act of 1980 (CERCLA) ("Superfund")

SMUGGLER MOUNTAIN
Aspen, Colorado

The Smuggler Mountain Site covers approximately 75 acres in and adjacent to Aspen, Pitkin County, Colorado. The site includes many old silver and lead mines that were most active between 1879 and 1920. Little mining is conducted at present. The primary concern is the exposure to toxic metals contained in mine wastes, mill tailings, and smelter by-products. Some of these wastes have been or may be used as fill material for building foundations or street/road construction. A potential health hazard exists through direct contact, airborne, waterborne, or food-chain exposure to the high concentrations of toxic metals, especially lead. An EPA site investigation found elevated concentrations of cadmium, copper, and zinc in wells near the site; three wells contained cadmium over the maximum level specified by the Safe Drinking Water Act. High concentrations of toxic metals, including more than 20,000 parts per million of lead, have been measured in the soils and tailings on the site. Previously, investigators at the Colorado State University Extension Service measured high concentrations of lead in leafy green vegetables grown in contaminated soils.

Approximately 4,500 full-time residents of the community may be exposed.

U.S. Environmental Protection Agency/Remedial Response Program

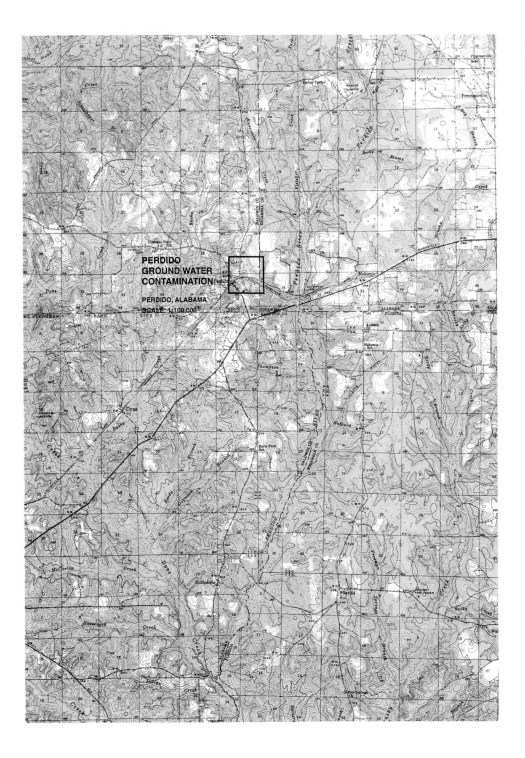

National Priorities List Site

Hazardous waste site listed under the
Comprehensive Environmental Response, Compensation and Liability Act of 1980 (CERCLA) ("Superfund")

PERDIDO GROUND WATER CONTAMINATION
Perdido, Alabama

The Perdido Ground Water Contamination Site covers about 125 acres in Perdido, Baldwin County, Alabama. No public drinking water is available. In November 1981, Perdido residents began to complain to the State that the ground water from their wells tasted bad. In February 1982, the State detected benzene in excess of the Federal drinking water standards in several residential wells. Additional sampling confirmed benzene in 8 wells. In September 1982, health officials announced that ground water in Perdido was harmful to human health and recommended that people stop drinking their well water if they lived within 1 mile of a 1965 train derailment in which benzene and other chemicals were spilled. The county then arranged for delivery of two mobile drinking water tanks to Perdido.

In February 1983, the railroad agreed to fund installation of an alternate water supply for the community.

The State, with help from EPA and the Centers for Disease Control, is investigating the ground water contamination problem. In addition, EPA is preparing a Remedial Action Master Plan outlining the investigations needed to determine the full extent of cleanup required at the site. It will guide further actions at the site.

U.S. Environmental Protection Agency/Remedial Response Program

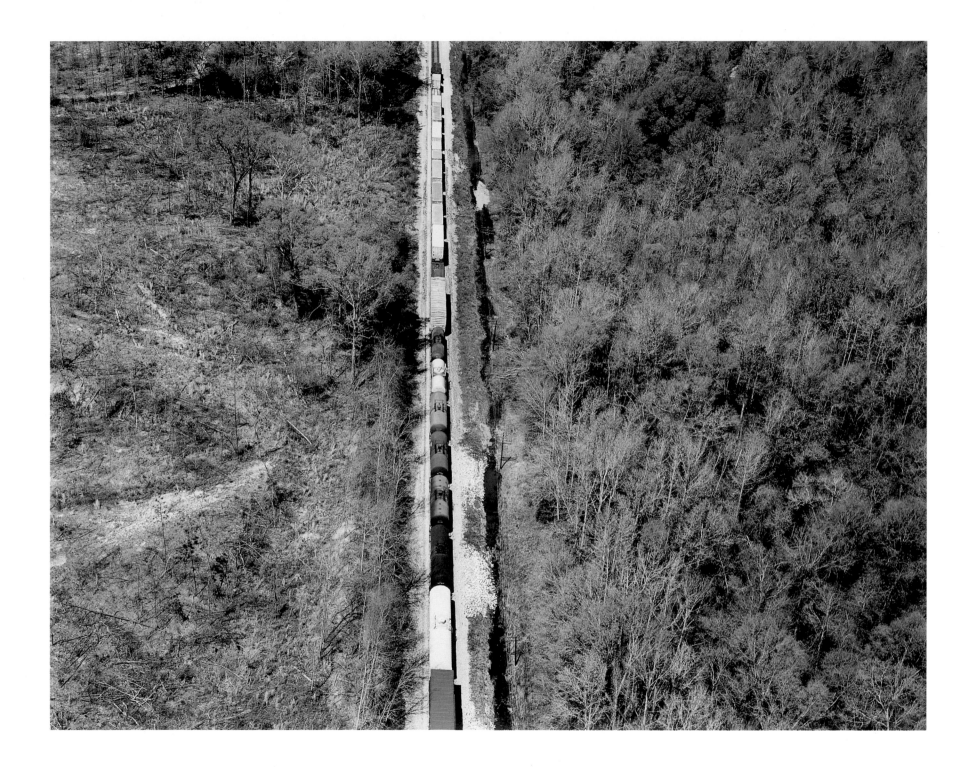

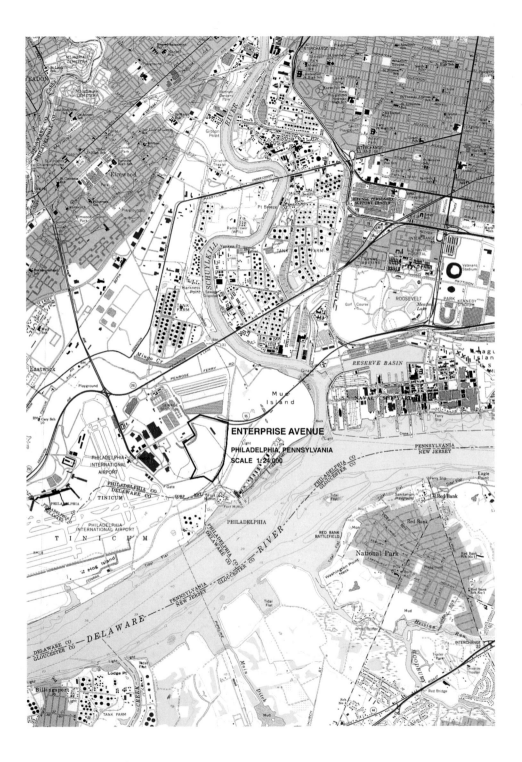

ENTERPRISE AVENUE
PHILADELPHIA, PENNSYLVANIA
SCALE 1:24,000

National Priorities List Site
Hazardous waste site listed under the
Comprehensive Environmental Response, Compensation and Liability Act of 1980 (CERCLA) ("Superfund")

ENTERPRISE AVENUE
Philadelphia, Pennsylvania

The Enterprise Avenue Site covers about 57 acres along the Delaware River in Philadelphia, Pennsylvania. From 1971 to mid-1976, the city operated the site as a municipal landfill. At least 10,000 drums of hazardous wastes were dumped there without the city's permission. In 1978, the city discovered that various toxic wastes were being disposed of illegally at the site. In 1982, the city started cleanup actions, including removal of drums and soil. In October 1982, after spending $7 million cleaning up the site, the city ran out of money, leaving on-site 20,000 tons of contaminated soil.

EPA and the State are reviewing the site for potential CERCLA funding.

U.S. Environmental Protection Agency/Remedial Response Program

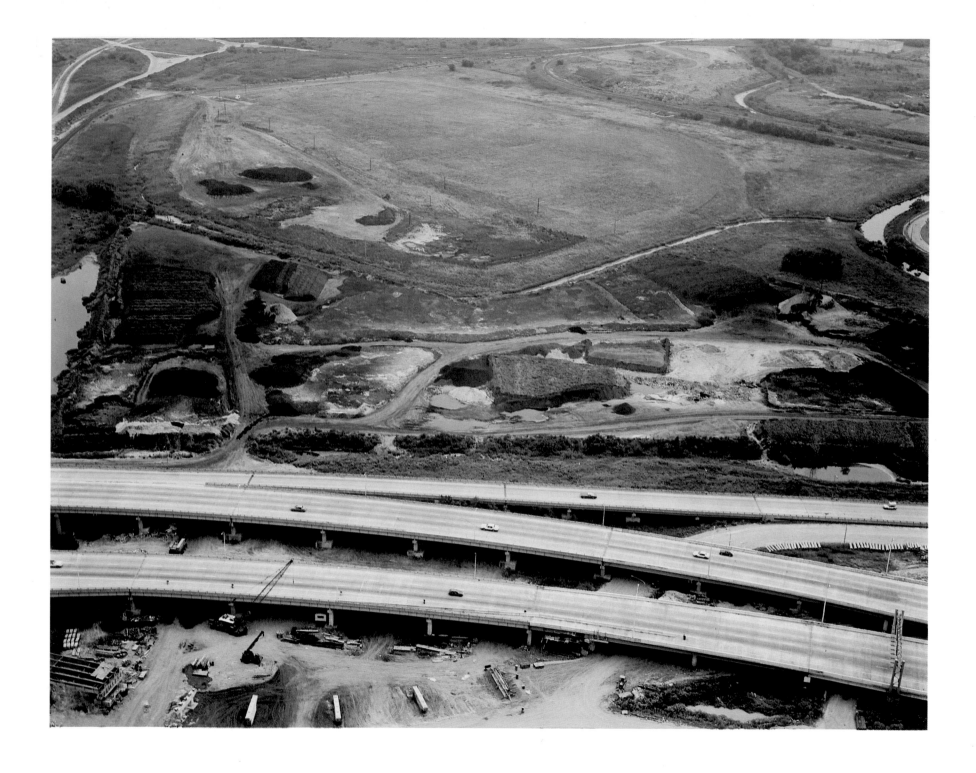

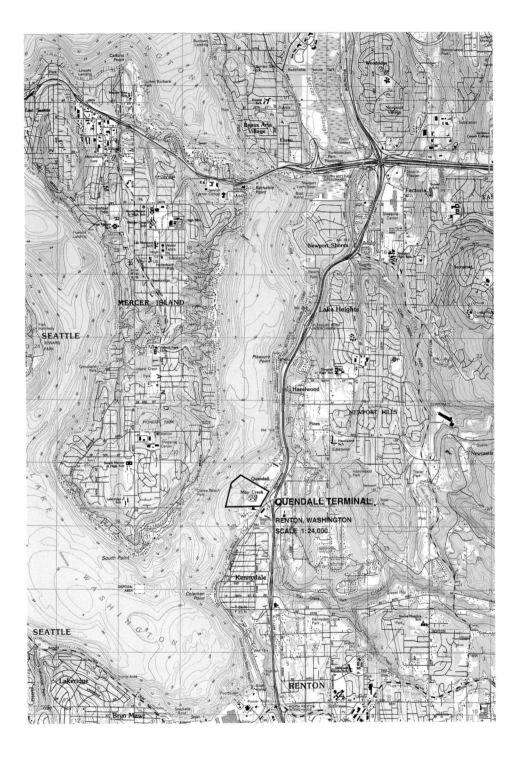

National Priorities List Site

Hazardous waste site listed under the
Comprehensive Environmental Response, Compensation and Liability Act of 1980 (CERCLA) ("Superfund")

QUENDALL TERMINAL
Renton, Washington

Quendall Terminal is one of three properties on the shore of Lake Washington in Renton, King County, Washington. The three are the site of a proposed commercial and residential development known as Port Quendall. The Quendall Terminal property is the site of an old Reilly Tar & Chemical Co. Refinery established in the early 1900s to receive coal gas residues from the old Seattle Gas Co. plant on Lake Union. Reilly closed the operation in 1970 and demolished the refinery.

The owners of Quendall Terminal contracted for an on-shore investigation of the property. In May and June 1983, 18 soil borings were drilled and 12 monitoring wells were installed. Analyses of soil and water samples indicated the presence of polycyclic aromatic hydrocarbons (PAH) in concentrations up to 4.8 percent. Also in June, four trenches were dug in different locations on the property to profile the soil to identify reported fill areas. The contractor estimates that probably at least 165,000 cubic yards of soil are contaminated with at least 1 percent PAH.

In June and July 1983, EPA surveyed Lake Washington. Analyses of sediment samples from 13 locations show PAH concentrations as high as 1.3 percent.

In April 1984, Quendall Terminal's contractor submitted a scope of work for a proposed remedial action to deal with the on-shore contamination. A series of wells would be installed to intercept the contaminated ground water, which would be pretreated on-site and then discharged to the municipal sewer system. The plan also called for capping the site prior to commercial development of the property.

U.S. Environmental Protection Agency/Remedial Response Program

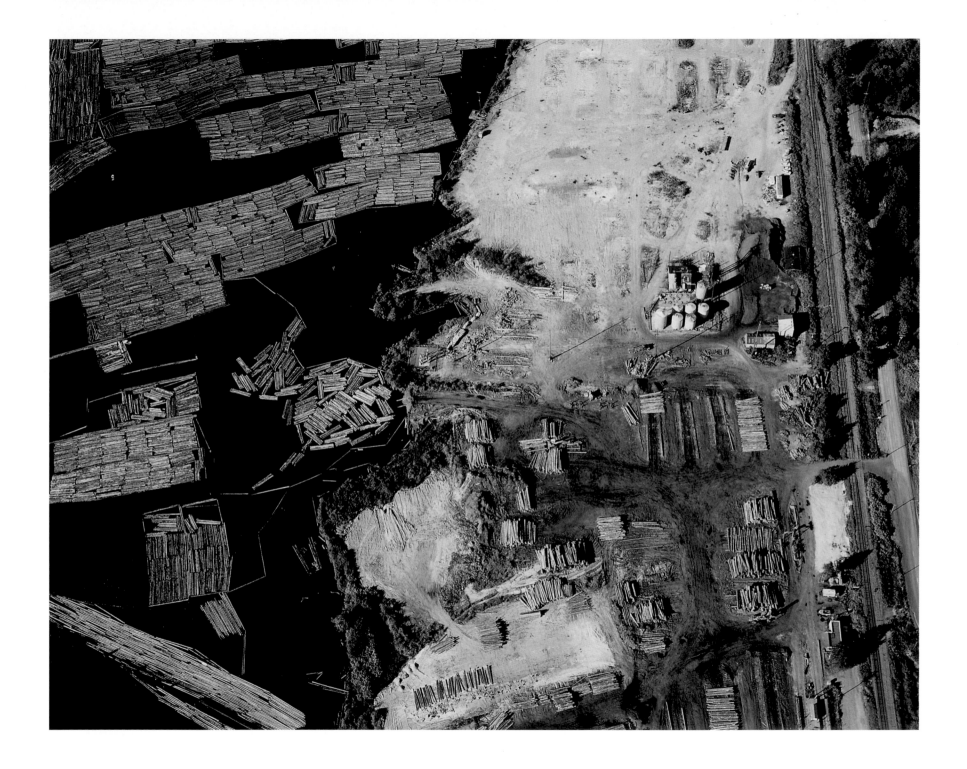

Cutthroat by Terry Tempest Williams

I once fell in love with a fly-fisherman. He was an elegant man engaged in the justice of rivers. His preference was always toward small streams, tributaries to the Missouri. He dreamed of retiring in Montana.

He would walk the creek's willowed edges, halfway hidden, his fly rod in hand with an eye upstream and down for trout. And when he saw the sweet risings of lips to water, he entered the current.

This fly-fisherman, whose name I cannot speak, would stand thigh-high in the Madison with rod in hand and make the most beautiful undulations, waving with his right arm, pulling line with his left. Back and forth, the graphite extension of himself would arc above his head seconds before he cast his line of light.

"It is an art that is performed on a four-count rhythm between ten and two o'clock," Norman Maclean writes in *A River Runs Through It*. This I saw on the river and recognized as the hours we secretly inhabited. Ten at night until two o'clock in the morning. We were awake while others slept.

Letting the line gracefully slip through his fingers, he placed the dry fly (I believe it was a Royal Wulf) perfectly inside the eddy where he imagined the cutthroat to linger. The ritual of the cast like a tease was repeated again and again between the man's daydreams. The trout would strike. The man would smile with a quick flick of the wrist to plant the hook and then slowly reel the creature toward him until it was time to surface the fish. Out of the water, the man would kneel on the bank with the rod between his legs, steady the trout (this time a brook trout with red circles on its side), unhook the fly from its white upper lip (she feels no pain, he assured me) then return the fish cradled in both hands gently to the water (let her adjust and get her bearings), face the trout downstream, tickle her belly and then let her go.

Catch and release.

Our friendship was no different. It wasn't until he slipped with his tongue and said, "I made love to you because it was the only way I knew how to reel you in. I was afraid I was losing you."

Catch and release.

This man loves trout. This man loves women. To fish is to flirt. To flirt is to fish. Is this the sporting nature of love? Lips to water. We kiss. We bite the hidden barb. We are pulled out of the river and brought to shore barely breathing. Through the lens of a cutthroat's eye, we look up to what has desired us.

That night, I pulled the hook of the dry fly out of my own lip and swam downriver.

Catch and release.

There is an aspect of love that is not much talked about: the making use of another human being. The lover invariably feels like an object with which the beloved may take liberties. . . . In being loved and desired we become flesh in the hands of someone else. And so whoever loves me makes possible the miracle of my incarnation.

—Aldo Carotenuto

In Butte, Montana, Our Lady of the Rockies stands at an elevation of 8,500 feet on the Continental Divide. She is ninety feet tall and weighs fifty-one tons. Her spine is steel. Draped in the compassionate folds of her white robes, her hands open to the Berkeley Pit below where nearly one and a half billion tons of earth have been removed, including more than 290 million tons of copper.

Anaconda Copper Mining Company had loved Butte, Montana, for almost one hundred years. On December 18, 1985, Anaconda pulled out, leaving behind one of America's largest Superfund sites, with pit-water so toxic, local citizens use firecrackers and flares to keep native birds from landing. On December 20, 1985, the last piece of Our Lady of the Rockies was brought to the mountain by helicopter and erected by miners now out of work. She was their spark of hope, something new to love, the second largest statue in America next to Miss Liberty.

Call 1-800-800-LADY.

Call the cutthroat with scarred lips swimming in the Madison.

Call me.

"The Treasure State": Montana 1889–1989

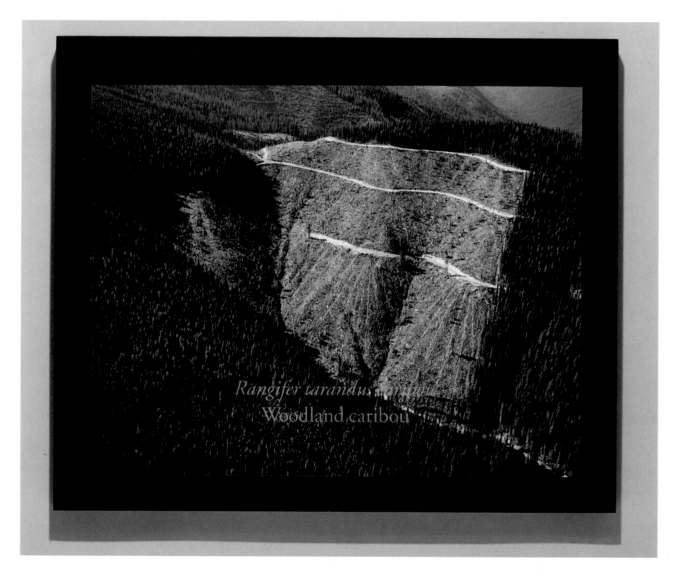

Kootenai River Valley timber clear-cut, Kootenai National Forest, Lincoln County.
Installation view. Series of framed Ektacolor prints with etched glass, each 20 x 23 ¹/₂".

1991–93

This series is a study of land use in Montana, as represented by the major economic and industrial forces that have had an impact on the region's environment. Each piece in *"The Treasure State": Montana 1889–1989* pairs a particular site with an imperiled species of wildlife that has been affected by it. The Latin and common names of the species are etched onto the glass in front of the photograph, casting a shadow of the name onto the image. The numbers of each species have declined significantly, and all are now vulnerable to extinction or already extirpated. The works are sequenced by species' name, alphabetically within taxonomic class.

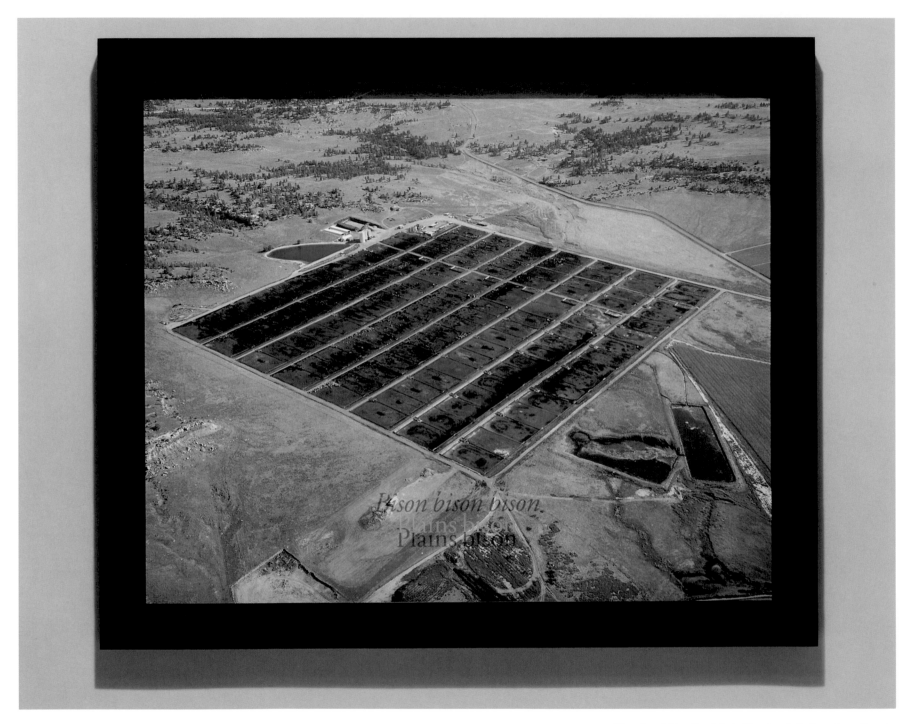

Weschenfelder Feed Lot, Shepherd, Yellowstone County

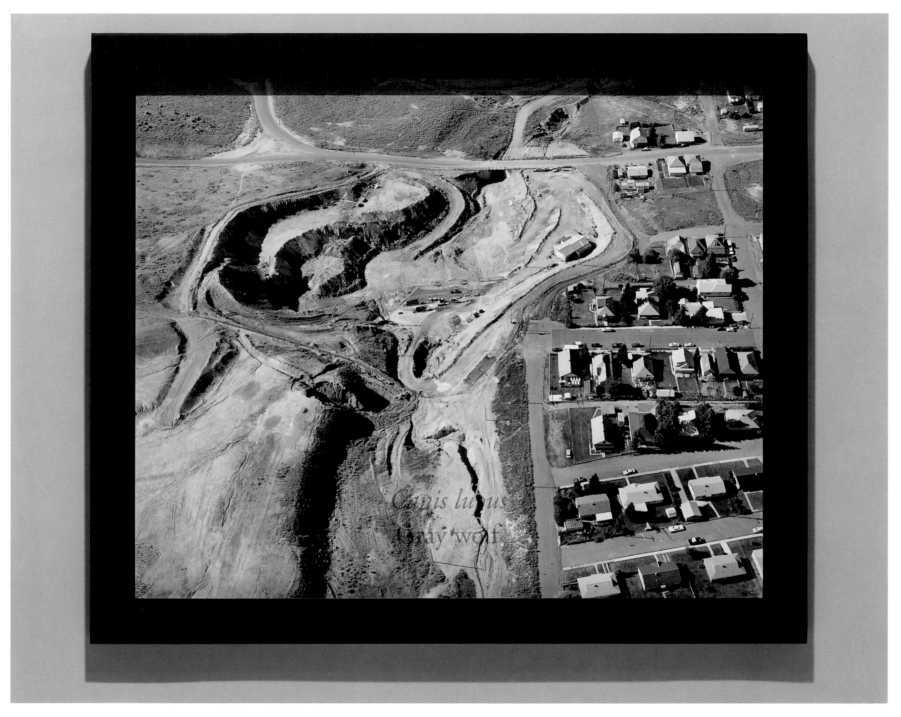

Abandoned mines, tailings piles and residential area [EPA Superfund Hazardous Waste Site], Butte, Silver Bow County

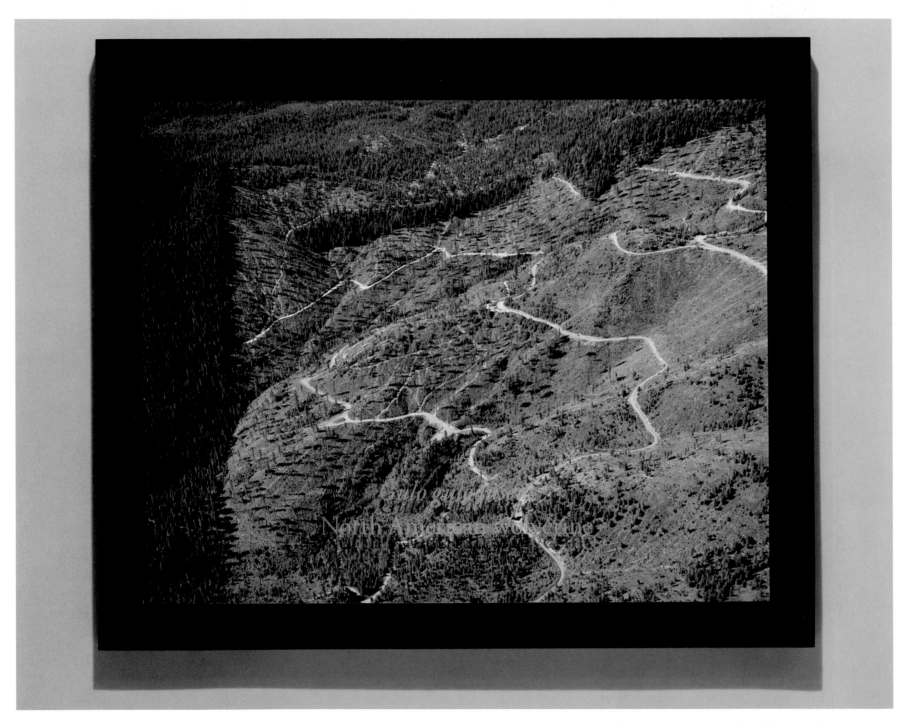

Sapphire Mountain timber clear-cut, Lolo National Forest, Missoula County

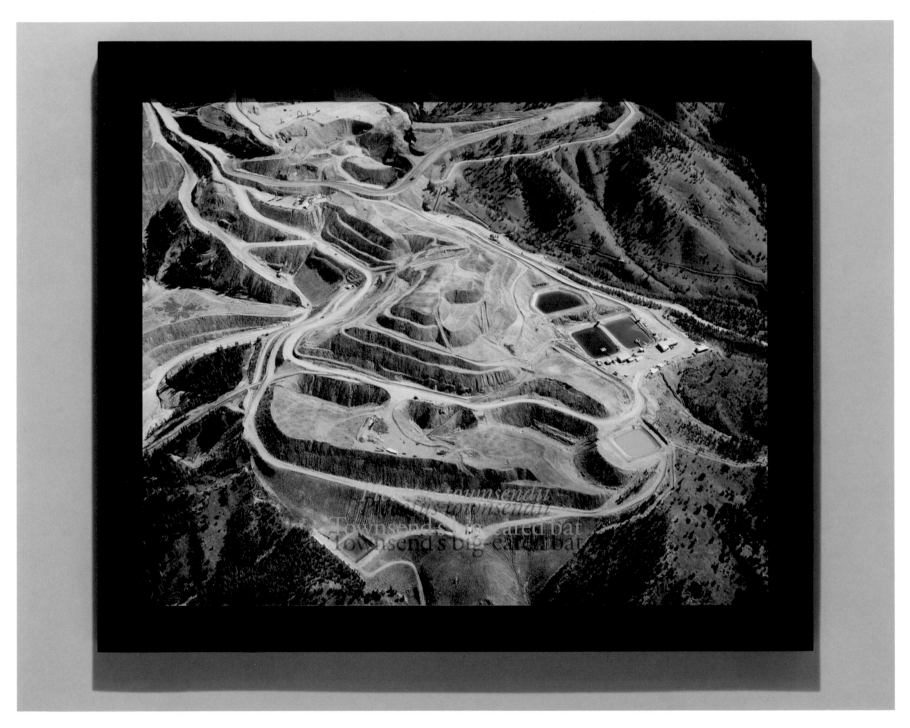

Pegasus Gold Co. cyanide-leach gold mine and waste ponds (formerly Spirit Mountain),
Little Rocky Mountains adjacent to Fort Belknap Indian Reservation, Zortman-Landusky, Phillips County

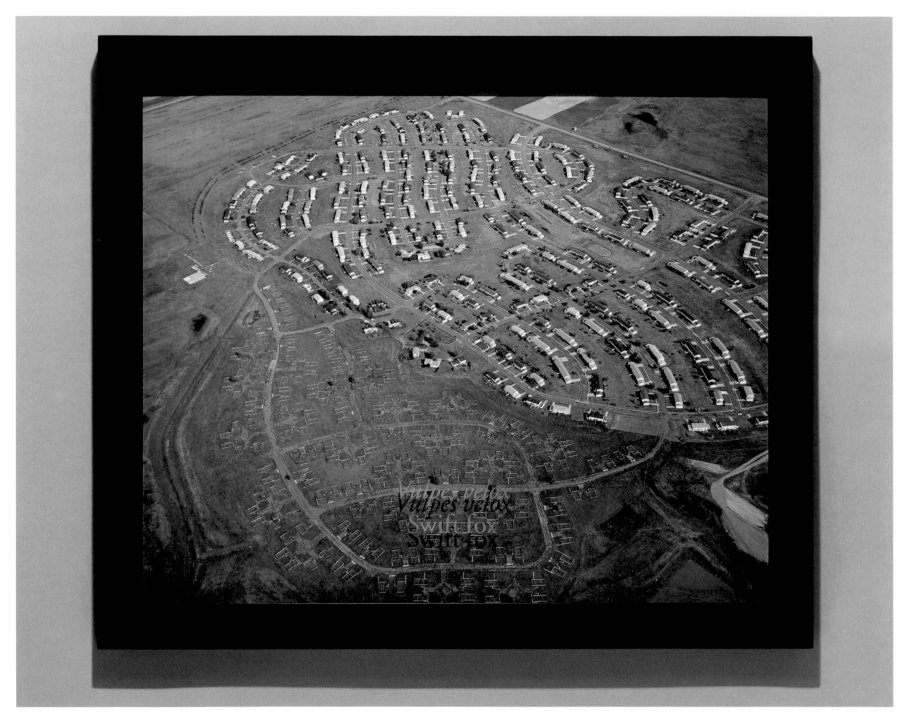

Abandoned Glasgow Air Force Base and military housing, with wheat fields,
adjacent to Fort Peck Indian Reservation, Valley County

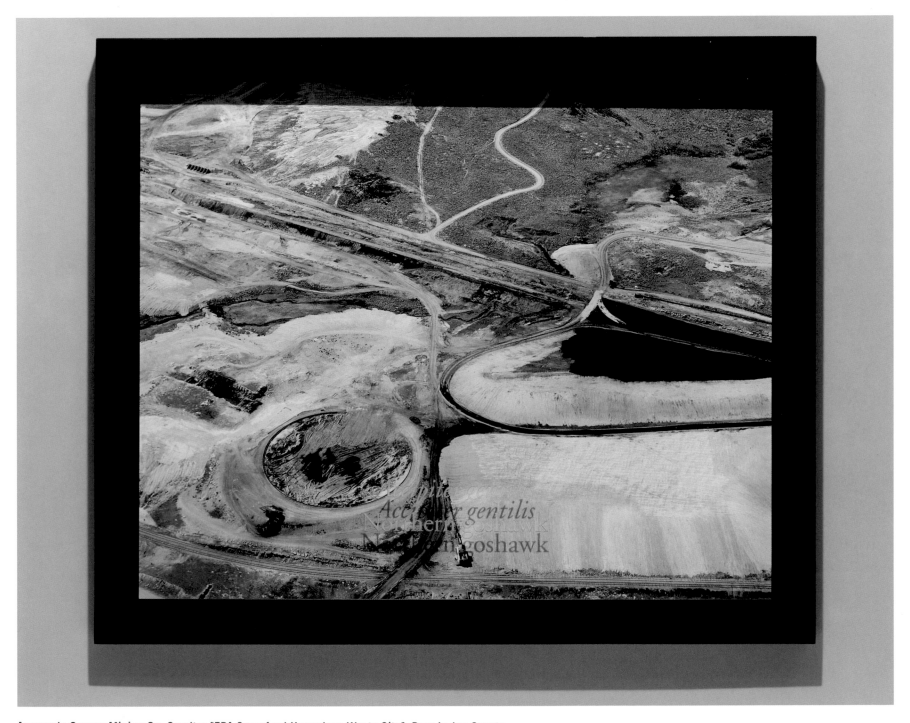

Anaconda Copper Mining Co. Smelter [EPA Superfund Hazardous Waste Site], Deer Lodge County

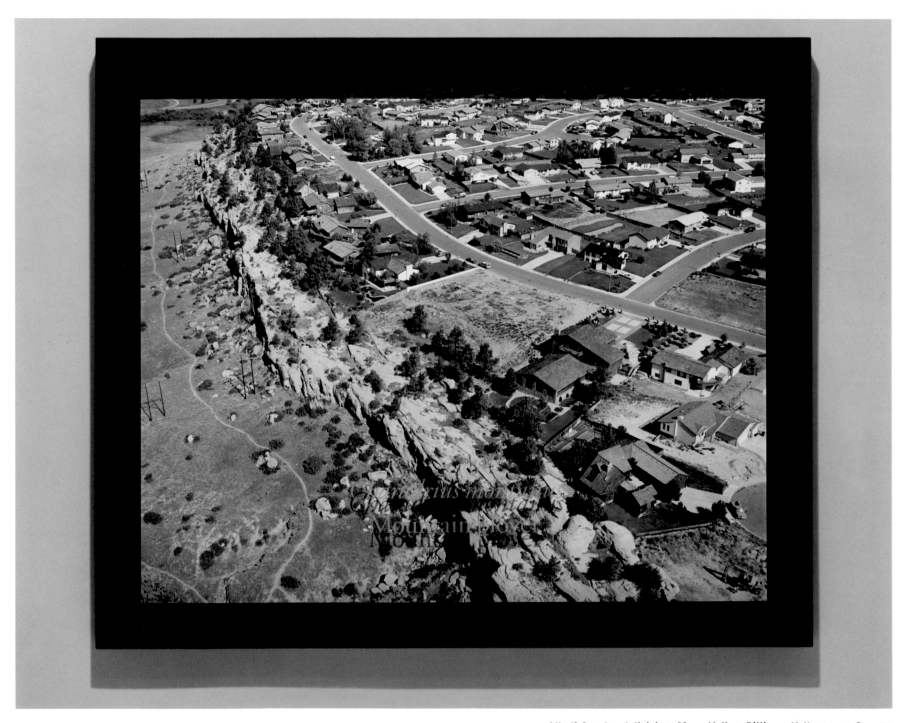

Alkali Creek subdivision, Moon Valley, Billings, Yellowstone County

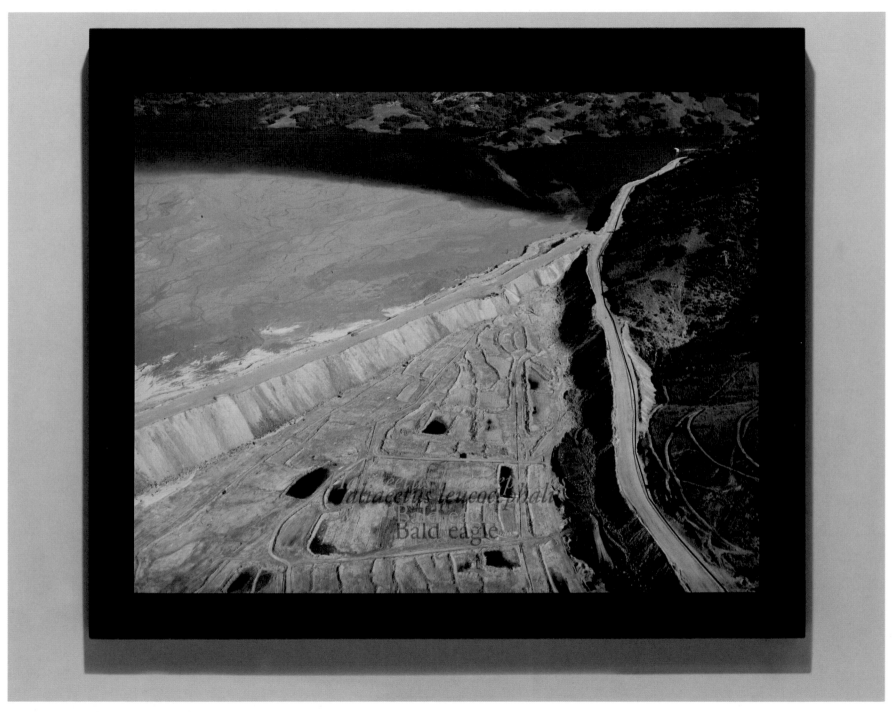

Yankee Doodle tailings pond, tailings dam and waste dumps, Montana Resources' open-pit copper mine [EPA Superfund Hazardous Waste Site], Butte, Silver Bow County

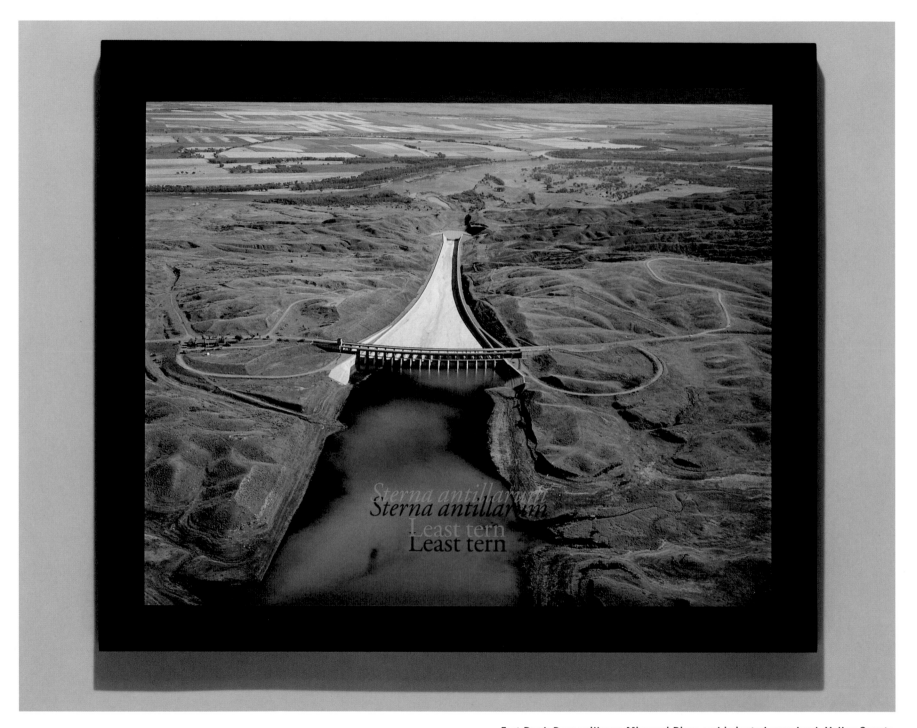

Fort Peck Dam spillway, Missouri River and irrigated crop land, Valley County

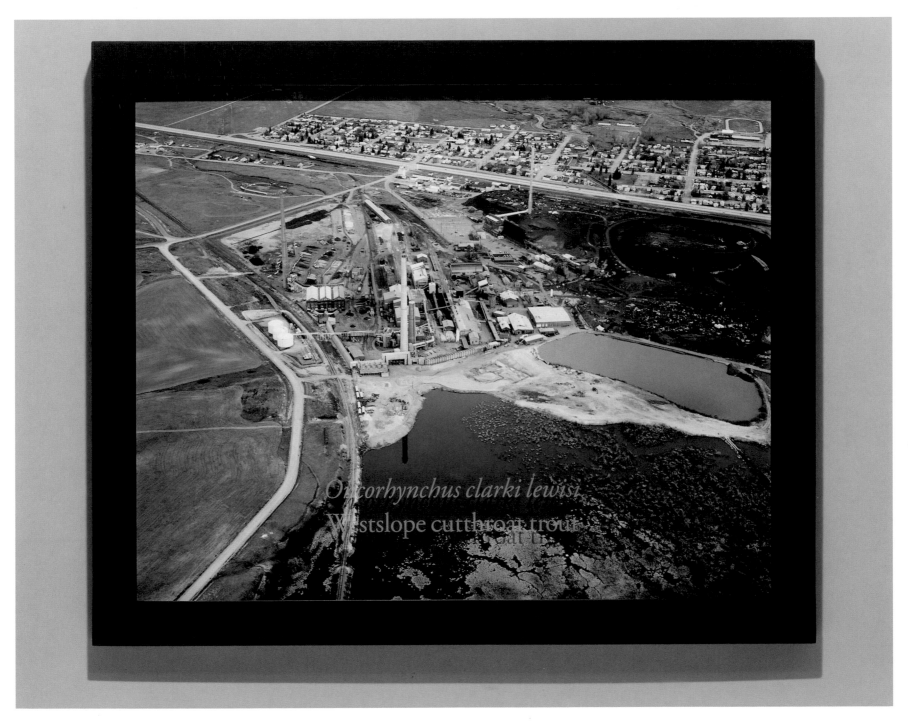

Oncorhynchus clarki lewisi
Westslope cutthroat trout

ASARCO East Helena Lead Smelter and waste ponds [EPA Superfund Hazardous Waste Site]
and town of East Helena, Lewis and Clark County

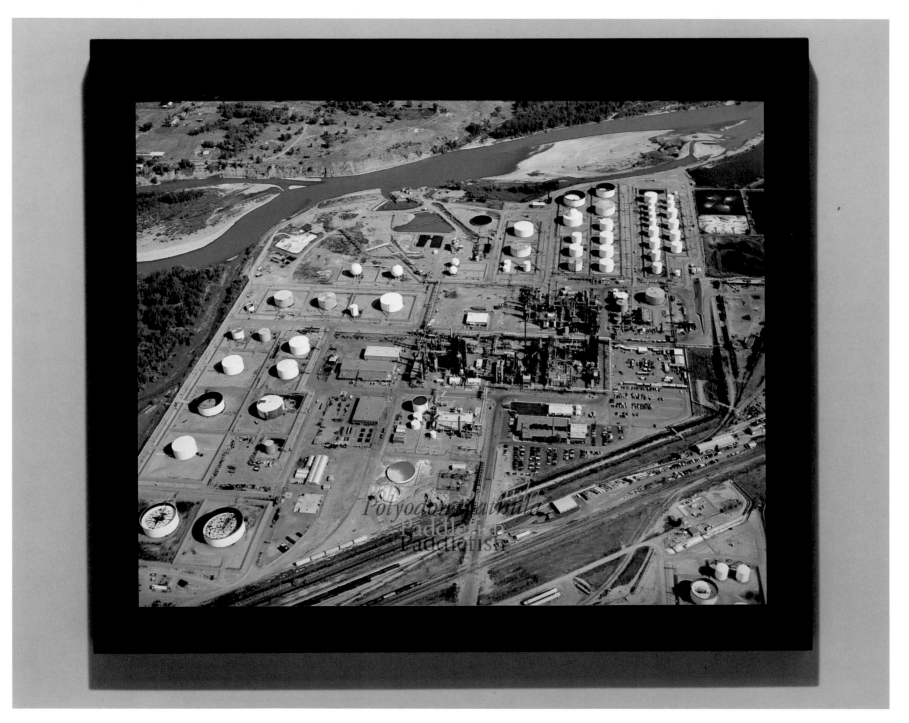

Exxon Oil Refinery and Yellowstone River, Billings, Yellowstone County

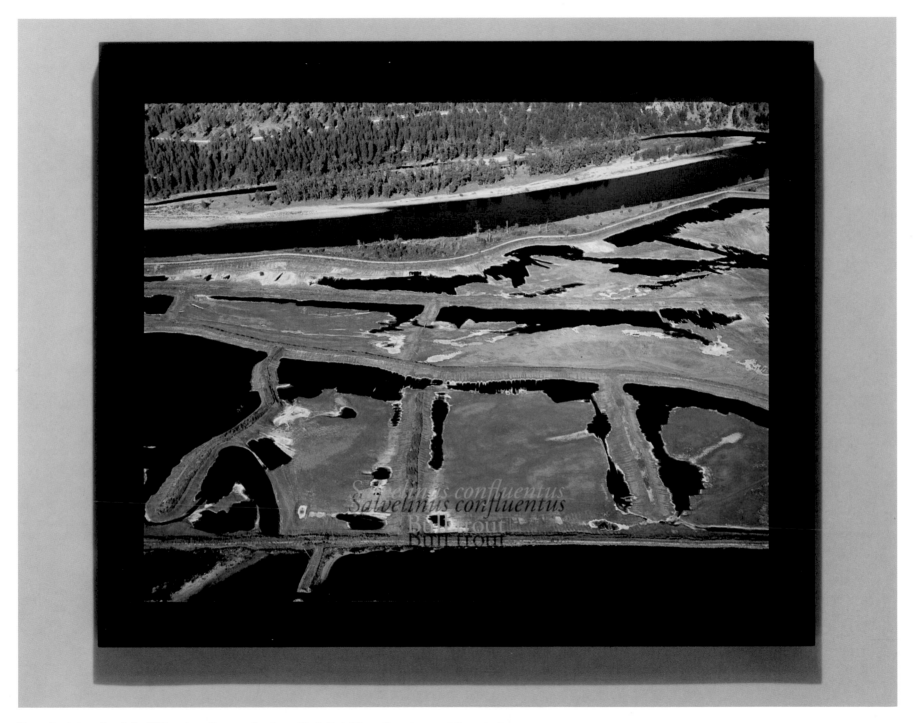

Stone Container Co. Pulp Mill and settling ponds along Clark Fork River, Frenchtown, Missoula County

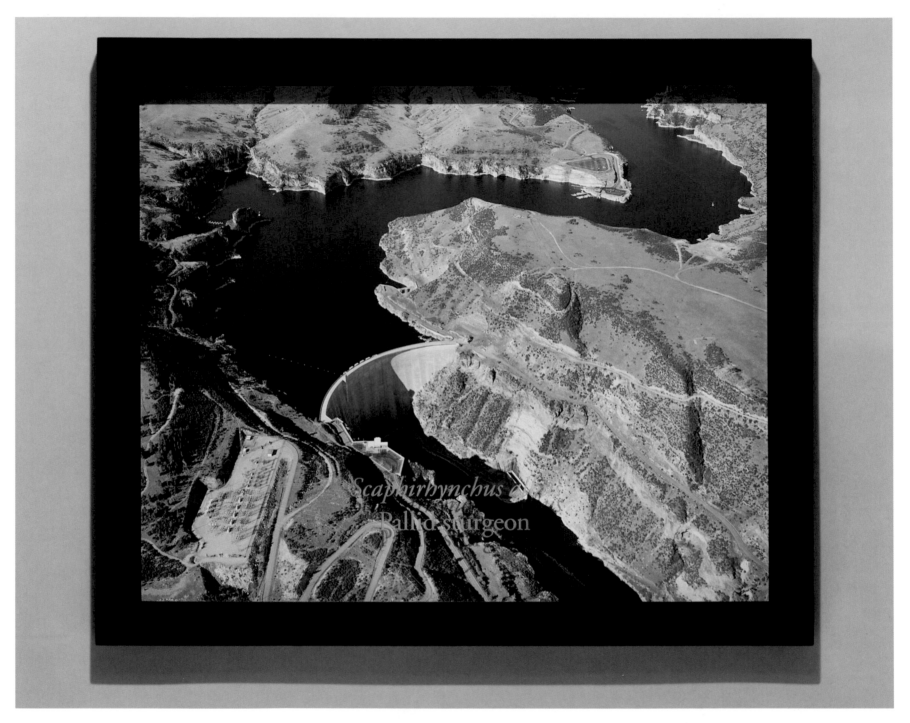

Scaphirhynchus albus
Pallid sturgeon

Above: **Yellowtail Dam and Bighorn Canyon National Recreation Area, Crow Indian Reservation, Bighorn County**

Opposite: **The Latin and common names of the thirty imperiled wildlife species included in the series. The names are configured in an arrangement based on an astronomical map of star positions at dusk in Helena (the state's first capital) on November 8, 1889, the day that Montana became a state.**

Sterna antillarum
Least tern

Bison bison bison
Plains bison

Lanius ludovicianus
Loggerhead shrike

Rana pipiens
Leopard frog

Histrionicus histrionicus
Harlequin duck

Canis lupus
Gray wolf

Acipenser transmontanus
White sturgeon

Cynomys ludovicianus
Black-tailed prairie dog

Oncorhynchus clarki lewisi
Westslope cutthroat trout

Haliaeetus leucocephalus
Bald eagle

Grus americana
Whooping crane

Euderma maculatum
Spotted bat

Polyodon spathula
Paddlefish

Falco peregrinus
Peregrine falcon

Salvelinus confluentus
Bull trout

Felis lynx
North American lynx

Scaphirhynchus albus
Pallid sturgeon

Ectopistes migratorius
Passenger pigeon

Gulo gulo luscus
North American wolverine

Charadrius montanus
Mountain plover

Charadrius melodus
Piping plover

Martes pennanti
Fisher

Mustela nigripes
Black-footed ferret

Buteo regalis
Ferruginous hawk

Plecotus townsendii
Townsend's big-eared bat

Athene cunicularia
Burrowing owl

Rangifer tarandus caribou
Woodland caribou

Vulpes velox
Swift fox

Ursus arctos horribilis
Grizzly bear

Accipiter gentilis
Northern goshawk

Notes on *Waste Land* by David T. Hanson

दिवि सूर्यसहस्रस्य
भवेद्युगपदुत्थिता ।
यदि भाः सदृशी सा स्याद्
भासस्तस्य महात्मनः ॥१२॥
कालोऽस्मि लोकक्षयकृत्प्रवृद्धो
लोकान्समाहर्तुमिह प्रवृत्तः ।

If the radiance of a thousand suns were to burst into the sky, that would be like the splendor of the Mighty One. . . . I am become Death, the shatterer of worlds.[1]

—Dr. Robert Oppenheimer, quoting from the *Bhagavad Gita* when describing the explosion of the world's first atomic bomb

When I was 16 years old my father taught me to sing some of the songs that talk about the land. . . . One day, I went fishing with Dad. As I was walking along behind him I was dragging my spear on the beach which was leaving a long line behind me. He told me to stop doing that. He continued telling me that if I made a mark, or dig, with no reason at all, I've been hurting the bones of the traditional people of that land. We must only dig and make marks on the ground when we perform [rituals] or gather food.[2]

—Galarrwuy Yunupingu, son of the Australian Aboriginal artist Munggurrawuy

This, finally, is the punch line of our two hundred years on the Great Plains: we trap out the beaver, subtract the Mandan, infect the Blackfeet and the Hidatsa and the Assiniboin, overdose the Arikara; call the land a desert and hurry across it to get to California and Oregon; suck up the buffalo, bones and all; kill off nations of elk and wolves and cranes and prairie chickens and prairie dogs; dig up the gold and rebury it in vaults someplace else; ruin the Sioux and Cheyenne and Arapaho and Crow and Kiowa and Comanche; kill Crazy Horse, kill Sitting

Bull; harvest wave after wave of immigrants' dreams and send the wised-up dreamers on their way; plow the topsoil until it blows to the ocean; ship out the wheat, ship out the cattle; dig up the earth itself and burn it in power plants and send the power down the line; dismiss the small farmers, empty the little towns; drill the oil and the natural gas and pipe it away; dry up the rivers and the springs, deep-drill for irrigation water as the aquifer retreats. And in return we condense unimaginable amounts of treasure into weapons buried beneath the land that so much treasure came from—weapons for which our best hope might be that we will someday take them apart and throw them away, and for which our next-best hope certainly is that they remain humming away under the prairie, absorbing fear and maintenance, unused, forever.[3]

—Ian Frazier, *Great Plains*

On October 15, 1988, the *New York Times* reported on the Feed Materials Production Center in Fernald, Ohio (where uranium is processed for use in nuclear weapons parts and fuel for military reactors):

Government officials overseeing a nuclear weapons plant in Ohio knew for decades that they were releasing thousands of tons of radioactive uranium waste into the environment, exposing thousands of workers and residents in the region, a Congressional panel said today. The Government decided not to spend the money to clean up three major sources of contamination. . . . Runoff from the plant carried tons of the waste into drinking water wells in the area and the Great Miami River; leaky pits at the plant, storing waste water containing uranium emissions and other radioactive materials, leaked into the water supplies, and the plant emitted radioactive particles into the air.[4]

On December 3, 1984, in the world's worst industrial disaster, the poisonous gas methyl isocyanate leaked from a Union Carbide pesticide plant in Bhopal, India, killing an estimated 8,000 residents of the impoverished community and injuring at least 300,000 others. Blindness, lung damage, and psychological problems persist in many of the survivors, with more injuries becoming apparent over time. The Indian Government filed suit for $3.3 billion in damages on behalf of 500,000 claimants, charging poor maintenance, design flaws, and willful negligence at the plant. After four years of litigation, Union Carbide agreed to settle all claims for $470 million—the average victim eventually received about $300. The U.S.–based multinational corporation shut down its Bhopal plant and

has refused to clean up the abandoned site and its extensive contamination. India had filed criminal charges of "culpable homicide" against Union Carbide as a corporate entity and ten of its officials, including Carbide's chairman Warren Anderson, who was arrested in India and posted bail, fled the country, and remains an unextradited fugitive from justice.[5]

· · ·

Of the nearly half-million hazardous waste sites spread across the United States, those resulting from nuclear production have the most deadly and long-lasting effects on the land and its inhabitants.[6] The unlikely coalition of political conservatives, industry representatives, and environmental advocates who support nuclear energy rarely discuss with any honesty the massive destruction of the earth caused by the mining of uranium, which is only the first stage in the long, waste-intensive process of producing nuclear fuel. Few of these supporters acknowledge that the development of nuclear fuel also requires massive amounts of conventionally generated electricity. For example, when operating at full capacity, the U.S. Department of Energy's Oak Ridge National Laboratory and Reservation in Tennessee (one of the largest nuclear production facilities) consumes more electricity than the entire city of New York.

Some of the largest uranium mines in the United States are located in central Wyoming's Wind River Basin in the Gas Hills area. These mines have transformed over one hundred square miles of native grasslands and buttes into a vast network of pits, waste ponds, uranium mills, and tailings piles. The mines and tailings have greatly increased the levels not only of uranium in the soil and water but also of the toxic elements selenium, arsenic, and molybdenum— these four elements react with one another to create significantly higher levels of toxicity. Ground water, surface water, and air spread the contamination. Cancer rates in the area are unusually high. On a ranch in the region owned by the geologist David Love, there has been a 700 percent increase in the level of uranium in a local creek; this increase is solely attributable to occasional flood waters. Contaminated wildlife spread the toxins farther afield in the environment and food chain. Since the 1950s, ranchers in the area have been regularly compensated by the mining companies for dead livestock. Some unfenced waste ponds are so poisonous that many antelope and stray cattle that drank from them died before they had gone more than half a mile.[7]

The writer Winona LaDuke has pointed out that nearly all of the uranium mined in the world today—primarily in North America, Australia, South Africa, and Namibia—is located on the small remaining land bases of the indigenous peoples of these areas. Two-thirds of all uranium in North America is located on or adjacent to Native American reservations. The same figures are true for Aboriginal Australia. LaDuke has described, in very different terms from U.S. Environmental Protection Agency (EPA) documents, the effects on a Native American community of one of the radioactive spills at United Nuclear Company's uranium mill in Church Rock, New Mexico (a site included in the photographic series *Waste Land*):

> *The United Nuclear Company's Churchrock* [sic] *accident (on July 16, 1979), which followed Three Mile Island by four months, occurred when an impoundment dam busted open. One hundred million gallons of highly radioactive water and 1,100 tons of mill tailings were immediately released into the Rio Puerco River, near Grants, New Mexico. The company had known that the dam was faulty; it had cracked two years prior to the break. The Dine community of Churchrock was immediately affected by the spill. Animals became so contaminated with radiation that their internal organs completely deteriorated. Since the Dine depended on the animals, particularly the sheep, for their subsistence, their supply of food as well as water was eliminated. Young children were brought to Los Alamos for radiation counts, but the studies were conducted inappropriately and inadequately. Despite the fact that it was the worst spill of radioactive materials in U.S. history, the Churchrock accident received minimal press coverage. Perhaps the press and Kerr-McGee thought that because the accident occurred in an area of low population, where radiation levels were already quite high, it was not really news. If the same spill had happened in a wealthy white community, the media might have responded differently.*[8]

Since 1943, the Hanford Reservation, a U.S. Department of Energy (DOE) facility with nine nuclear reactors in Richland, Washington, has processed uranium into weapons-grade plutonium and has reprocessed nuclear fuel. Occupying 560 square miles, Hanford also stores most of the United States' high-level radioactive waste, much of it in large, deteriorating and leaking tanks located in an area of moderate earthquake activity heavily marked by faults. The plutonium reactors and waste-storage tanks are not designed to withstand an earthquake, and significant seismic activity could severely damage the tanks or cause enough vibration in their sensitive waste to ignite a hydrogen explosion. During the past fifty years, Hanford has become the most polluted and radioactive site in the nation, with over 1,500 radioactive waste dumps and contaminated buildings. Nearly 4 billion gallons of chemically contaminated waste have been dumped directly onto the ground, and 120 million gallons of high-level radioactive weapons waste have been directly discharged into the soil. On one occasion, when tank storage space ran out, 30 million gallons of high-level radioactive waste were pumped directly into unlined trenches. In addition, 200–450 billion

gallons of low-level nuclear waste have been stored in a variety of pits, ponds, and basins throughout the Reservation.[9] By the 1970s, so much plutonium had been dumped that officials feared that a critical mass ready to fission had accumulated underground. As late as 1987, Hanford was still disposing 7 billion gallons of wastewater a year into ponds and ditches. Springs and wells in the area, along with the Columbia and Yakima Rivers that border the Reservation, have been contaminated with radioactive wastes; in fact, eight of the nine reactors discharged reactor coolant directly into the Columbia. North America's second largest river and major tributary to the Pacific, the Columbia was for years considered the most radioactive waterway in the world. Particularly during the 1940s and 1950s, Hanford regularly emitted intentional or accidental airborne releases of radioactive materials that heavily contaminated the surrounding farms and countryside. In 1949, the Atomic Energy Commission conducted a top-secret military experiment of airborne radiation (code name "green run"), deliberately contaminating much of eastern Washington with more than 300 times the amount of radioactivity released by the 1979 Three Mile Island nuclear accident. In 1988, EPA added four areas within the Hanford Reservation to its National Priorities List ("Superfund"). Since it was shut down in 1991, Hanford's new mission has been cleanup and the "development of new environmental technologies." DOE has estimated that it will cost $210 billion to clean up the Hanford Reservation, and it currently spends $1.1 billion a year just maintaining and safeguarding the closed facility. DOE has not yet specified how such a cleanup could or would be effected (it would include the removal of radioactive materials with half-lives of up to 24,000 years from the soil, regional streams and rivers, and wildlife). Such nuclear waste will remain lethal for more than 250,000 years.

Another Superfund site, the Department of Energy's Rocky Flats Plant in Golden, Colorado, on the northwest edge of Denver (thirteen miles upstream and upwind from the city center), manufactured the plutonium cores for the nuclear and thermonuclear weapons produced in the United States. From 1951–1989, the plant fabricated more than 50,000 of these "pits," each of them with a destructive power roughly equivalent to the atomic bomb dropped on Nagasaki.[10] Plutonium, with a half-life of 24,000 years, is radioactive, highly flammable, and carcinogenic. It is one of the most toxic substances produced by humans. One-millionth of a gram inhaled and lodged in the lungs is sufficient to cause cancer; it has also been shown to produce substantial genetic damage, even in workers exposed to "safe" levels of it.[11] During the past forty-five years, more than 200 plutonium fires at the Rocky Flats Plant have spewed radiation into the environment. A 1957 explosion blew out all 620 industrial filters,

scattering four years of collected plutonium and uranium dust over Denver. Although the Atomic Energy Commission (AEC) publicly denied there was any "release of consequence" of plutonium, an internal AEC survey reported heavy contamination of an elementary school twelve miles away. In 1969, the second worst industrial fire in U.S. history destroyed $20 million worth of plutonium at Rocky Flats. Over the years, plutonium liquid wastes and a wide range of other dangerous toxins have seeped into the water table and contaminated the area's aquifers, streams, and lakes. In 1973, tritium and americium (two highly toxic radioactive materials) as well as carcinogenic organic chemicals were found to be leaking into the nearby water-supply reservoir of Broomfield, Colorado. Water samples showed radiation levels tens of thousands of times higher than normal. In the vicinity of the plant, 11,000 acres have been contaminated because of inappropriate disposal practices. In addition to the plant's emissions, plutonium has also become airborne dust through leaks from rusted and deteriorating waste-storage barrels left for years in an open field on the site. In 1974, soil samples several miles from the plant indicated 3,500 times the normal "background" radiation, with "hot spots" occurring farther out in Jefferson County and the Denver area. The Denver suburbs of Broomfield, Westminster, and Arvada have been particularly affected, and the neighboring tableland and underground water have been so contaminated that the surrounding cities are increasingly concerned as new urban development gets closer to the plant.

In 1989, the Federal Bureau of Investigation and EPA filed civil and criminal charges against Rockwell International, the company operating Rocky Flats for DOE, alleging that it was an "ongoing criminal enterprise" which deliberately engaged for years in covert illegal disposal practices of radioactive and chemical wastes, concealed contamination, and falsified reports.[12] Later that year, the Rocky Flats Plant was closed because of its unsafe practices and the risks posed by its continued operation. A 1994 DOE report described some buildings at the Rocky Flats Plant as "the most dangerous manufacturing facilities in the nation," in part because 14 tons of plutonium remain improperly stored there in leaking containers and deteriorating buildings.[13] Recently renamed the Rocky Flats Environmental Technology Site, its current mission is cleanup rather than nuclear weapons production.

DOE currently estimates it will cost at least $1 trillion to clean up all of the nuclear weapons sites in the United States. Although many of the necessary technologies have not yet been developed, DOE has stated that it plans to complete the cleanup by 2040.[14] The total cleanup costs for Rocky Flats alone are estimated to be $100 billion. As usual, this figure does not take into account the enormous social and health-care costs related to such extensive toxic

contamination. Cancer rates in residential areas near Rocky Flats are 16 percent higher than in the rest of Denver; leukemia rates in the area have risen sharply since the plant opened and are substantially higher than average. Rocky Flats workers have rates of brain cancer eight times higher than the Colorado norm. Although an AEC report stated that as of 1974 accidents within the plant had contaminated 171 workers, recent studies have revealed that over the years thousands of workers at Rocky Flats have actually been contaminated by excess radiation exposure.[15] One such worker, Don Gabel, died of a malignant brain tumor in 1980 after years of illness and operations. Gabel, a plutonium worker for ten years at the Rocky Flats Plant, recalled in an interview before he died: "It would be very hot. My head would be right by the pipes. I would . . . ask my boss about that. He'd say, 'It wouldn't matter about your head, it's your body you have to worry about.'"[16] Although Rockwell International and Dow Chemical Company denied that Don Gabel's death was related to his work, his widow filed a worker's compensation lawsuit against the companies and won a judgment which determined that "Don Gabel's death from cancer was caused by radiation received while on the job at Rocky Flats, which radiation was well within the safety standards set by the United States Government."[17]

Stories of the hazards suffered by workers at the hands of America's toxic industries are common within EPA. In 1984, one young man working for a chemical company in Louisiana was hired for extra pay as a "midnight dumper" for the company. He was routinely instructed to drive a tanker filled with toxic waste into a backwoods bayou, get out and open the valve at the back of the truck, return to the cab, wait until the tank was empty, and then pull away. On one occasion he happened to drive into an area that had been used earlier in the day as a dump site by a different company. When he opened the valve, the two chemicals immediately reacted to produce a lethal gas. He never made it back to the cab of his truck—his lungs were burned right out of him.

As Rocky Flats, Bhopal, and many other industrial accidents and toxic waste sites have revealed, hazardous waste is perhaps the ultimate injustice that industry perpetrates on its workers, its neighborhoods, and the environment. In a form of double jeopardy, workers are at risk not only in their workplace but also at home with their families. Numerous studies have shown that hazardous industries, toxic waste dumps, and waste-treatment facilities are located primarily in rural, poor, and working-class neighborhoods, and that minorities are even more heavily impacted. From Bhopal and the "Cancer Corridor" of Louisiana to tens of thousands of U.S. industrial sites and their surrounding communities, the effects of toxic waste clearly represent another insidious form of social discrimination and environmental injustice.[18] This injustice extends to the dumping in developing countries of carcinogenic chemicals either prohibited in the U.S. or expensive to dispose of here. In addition, some chemicals, banned in this country because of their proven health risks, are still produced by U.S. companies for use in less-regulated developing nations, or even for sale on the black market in countries where those chemicals are already outlawed. Ironically, many of these dangerous chemicals return to the United States, in a "circle of poison," through a variety of imported goods (such as carcinogenic pesticides, insecticides, and animal additives in imported foods).[19] Following a long history of plundering developing countries for their natural resources and cheap or free labor, the U.S. and other industrialized nations have now created a contemporary variation—waste colonization.

• • •

The Aboriginal tribes of Australia are the Earth's oldest known continuous civilization, dating back 40,000 years. An Aboriginal tribal elder, when asked why his culture had left behind no structures that compared with the Pyramids, the Parthenon, or other great monuments of recent civilizations, replied that his people had strived to leave the land just as they had found it: *that* was their most enduring monument. It seems frightening yet strangely appropriate that the most enduring monuments the West will leave for future generations will not be Stonehenge, the Pyramids of Giza, or the cathedral at Chartres, but rather the hazardous remains of our industry and technology. The temples of the Aztec and Mayan civilizations have survived a mere 500–2,000 years; Native American Anasazi cave dwellings and pictographs date back only 1,000–2,500 years. How much longer lasting—and how tragic in consequence—will be the contemporary wasteland that has been created in the United States during the past 200 years, and especially the past 50? The radioactive contamination from American plutonium factories will be in evidence long after the Pyramids have disappeared, our soaring modern architectural edifices have crumbled, and entire cultures have risen and fallen. Remaining deadly for more than 250,000 years, this legacy of ours will last for 10,000 *generations* into the future.[20] (To put this into perspective, Homo sapiens in its present form has been on the earth for 60,000–100,000 years.) This then is the final stage in our exploration and development of the American continent. Instead of the Zen garden of Kyoto's Ryoanji, we leave behind vast gardens of ashes and poisons. Instead of the sculpted temples of Borobudur in Java or Ajanta in India, we leave to future generations Rocky Flats and the Hanford Reservation.

Mythologies have a way of becoming flesh, of embodying themselves in social realities. Like the ancient megaliths of Stonehenge or the lines of Nazca, these waste sites may be seen as monuments to the dominant myths and obses-

sions of our culture. It is clear that our civilization and its relationship to the earth and all its inhabitants is diametrically opposed to the attitudes of certain tribal cultures that felt so devoted to and united with Nature that they could not bring themselves even to farm for fear of cutting into the Mother.[21] Instead of a sacred sense of our place within a miraculous cosmos and a deep respect for the interconnectedness of nature and our role within its vast rhythms and cycles, we have created a patriarchal society buttressed by a religion that mythologizes—and a science that justifies—the separation, even opposition, of God, humanity, and nature. Our culture and its dominant religions reinforce in us a deep fear and distrust of the natural world.[22] What we seem to be reenacting in our own time is a central myth of the Judaeo-Christian religions: the Fall and the Expulsion from the Garden. Like a self-fulfilling prophecy, we attempt to rival the power of "the gods" and as punishment for our hubris, we cast ourselves into a Paradise Lost. The American landscape at the end of the second millennium has become a contemporary reflection of our ancient vision of the Apocalypse.

These hazardous waste sites also demonstrate the dramatic contradiction between Americans' public reverence for nature—proclaiming the virtues of the "virgin" wilderness—and our inability to respect the land that we actually live on. Clearly these places signal a radical shift from the savoring and fetishizing of landscape as Nature's Body, to an unconscious American scorched-earth policy motivated by power, ambition, greed, and deceit. Instead of fulfilling the Utopian promises of the industrial-technological age, we have manifested the dark side of the American Dream and created a landscape of failed desire. In our society's insistent fear and denial of death, we are surrounding ourselves with entire landscapes of death. Geologists estimate that the North American continent as we now know it has existed for some 60 million years. What we have managed to do to it in a mere 200 years, and to the American West in much less time, defies the imagination. Driven by our distorted notions of progress, we have realized the logical conclusions of our Manifest Destiny, and have transformed our natural world from wilderness to pastoral landscape to industrial site and now to wasteland.

History seems to indicate that at some point in time all cultures reach a stage when they are held accountable by nature. There is considerable evidence that most of the major civilizations of the past destroyed themselves, at least in part, by the misuse of their natural environments.[23] Our society appears to have little responsibility or consideration for what rare and precious natural gifts we have been entrusted with, and how we have squandered them.

Perhaps we have reached that point in time when we must be held accountable for the enormous destruction that we have inflicted upon our natural world and our social communities.

The Aboriginal people of Australia give voice to this conflict between technology and nature when they ask, "What will you do when the clever men destroy your water?"[24]

Notes

This essay was originally written in 1987–88. It has been revised for this publication.

1. Michel Rouzé, *Robert Oppenheimer: The Man and His Theories*, translated by Patrick Evans, New York: Paul S. Eriksson, Inc., 1965, p. 74. The passages from the *Bhagavad Gita* are from chapter 11, verses 12 and 32.

2. Peter Sutton, "Dreamings" in *Dreamings: The Art of Aboriginal Australia*, Peter Sutton ed., New York: The Asia Society Galleries, 1988, pp. 13–14.

3. Ian Frazier, *Great Plains*, New York: Farrar, Straus & Giroux, 1989, pp. 209–10.

4. "U.S., for decades, let uranium leak at weapon plant," *The New York Times* (October 15, 1988): A1, 7. In this same article, Congressman Thomas A. Luken of Ohio charged that "DOE was waging a kind of chemical warfare against the community of Fernald." Thomas Carpenter, a lawyer representing the Fernald workers, stated that "DOE is now telling us it was willful conduct. They knew, and there's no excuse for that. That's criminal behavior."

5. "Bhopal payments by Union Carbide set at $470 million," *The New York Times* (February 15, 1989): A1, D3. See also Peter Montague, "Things To Come," *Rachel's Environment & Health Weekly* #523 (December 5, 1996); and Dan Kurxman, *A Killing Wind: Inside Union Carbide and the Bhopal Catastrophe*, New York: McGraw-Hill, 1987.

6. In a 1989 study, Congress's Office of Technology Assessment concluded that there were approximately 439,000 chemically contaminated sites in the U.S. See *Environmental Epidemiology, Vol. 1: Public Health and Hazardous Wastes*, Washington, D.C.: National Academy Press, 1991. The photographic series *Waste Land* includes four nuclear production sites: United Nuclear Company, Church Rock, New Mexico; Lincoln Park, Canon City, Colorado; Teledyne Wah Chang, Albany, Oregon; and the U.S. Department of Energy's Rocky Flats Plant, Golden, Colorado; in addition to two Air Force bases involved in handling and transporting nuclear weapons (McChord Air Force Base, Tacoma, Washington; and Mather Air Force Base, Sacramento, California).

7. Information on the Gas Hills uranium mines comes from a telephone interview with David Love, Fall 1987. Residents of the Wind River Indian Reservation have reported that nearly all of the people who have lived in the vicinity of the old Susquehanna mill tailings dump (near Riverton, Wyoming) either have cancer or died from it.

8. Winona LaDuke, "They always come back" in *A Gathering of Spirit: Writing and Art By North American Indian Women*, Beth Brant ed., Rockland, Maine: Sinister Wisdom Books, 1984, pp. 62–63. See also Simon J. Ortiz, *Fight Back: For the Sake of the People, For the Sake*

of the Land, Albuquerque: Institute for Native American Development, University of New Mexico, 1980.

9. DOE has periodically revised these figures upward, often dramatically, as recent investigations have revealed that millions—or billions—more gallons have actually leaked than previously disclosed by DOE. In the past six years, the amount of high-level radioactive waste estimated to have leaked from Hanford's aging storage tanks has been changed from 500,000 to 121 million gallons. On the Hanford Reservation, see Karen Dorn Steele, "Hanford's bitter legacy," *Bulletin of Atomic Scientists* (January/February 1988): 17–23; Eliot Marshall, "Hanford's Radioactive Tumbleweed," *Science* (26 June 1987): 1616–1620; Fred C. Shapiro, "Radwaste in Indians' Backyards," *The Nation* (May 7, 1983): 573–575; Sheldon Novick, "The dangers from radioactive wastes," *Current* (May 1970): 41–5; T.M. Beaseley et al., "Hanford-Derived Plutonium in Columbia River Sediments," *Science* (20 November 1981): 913–915; and "Hanford cleanup costly, slow and riddled with snags," *The Seattle Times* (April 26, 1994): A1, 4.

10. In a two-stage nuclear weapon, the plutonium "pit" acts as the fission device that triggers the much larger fusion reaction. The "pits" manufactured at the Rocky Flats Plant varied in explosive yield over the years, ranging up to 100 kilotons. "Fat Man," the Nagasaki bomb, had a yield of 21 kilotons. On the Rocky Flats Plant, see Peter J. Ognibene, "Living with the Bomb: How 'safe' is nuclear pollution?," *Saturday Review* (June 24, 1978): 8–12; Elaine Douglass, "Atom Bombs Also Pollute," *The Nation* (October 14, 1978): 361–362; and Samuel H. Day Jr., "The nicest people make the Bomb," *The Progressive* (October 1978): 22–27.

11. Press release from the Hanford Citizen's Advisory Board, 1992; and Peter Montague, "The Fourth Horseman, Part 2: Nuclear Technology," *Rachel's Environment & Health Weekly* #473 (December 21, 1995). In one of its more disconcerting memorandums, DOE recently noted that more than 8,000 pounds of plutonium have disappeared ("remain unaccounted for") throughout the United States over the past thirty years.

12. From a telephone interview with Ken Korkia, Rocky Flats Citizens Advisory Board, January 23, 1997.

13. Idem. See also "Flats plutonium poses danger to public," *Rocky Mountain News* (December 5, 1994): A4, 8.

14. The government's figures have radically increased over the years. As of November 1991, the total cleanup (over thirty years) of the nation's hazardous wastes was estimated to cost approximately $1 trillion: $460 billion for DOE's cleanup of radioactive and toxic wastes at atomic weapons production sites, $290 billion for Superfund hazardous waste sites, and $450 billion for an additional 37,000 industrial hazardous waste sites throughout the country. By 1996, however, DOE was estimating that its cleanups alone would cost $1 trillion. See Andrew Ross, "A Few Good Species," in *Science Wars*, Durham: Duke University Press, 1996, p. 312; and "Hanford cleanup costly, slow and riddled with snags," *The Seattle Times* (April 26, 1994): A1, 4.

15. From a telephone interview with Bruce DeBoskey, plaintiff's attorney in *Gabel vs. Dow Chemical Company and Rockwell International Corporation*, Fall 1987. DeBoskey is currently the plaintiffs' attorney in *Cook et al. vs. Rockwell International Corporation and Dow Chemical Company*, a class-action lawsuit brought on behalf of approximately 50,000 people who reside downwind from the Rocky Flats Plant.

16. Interview with Don Gabel in the film *Dark Circle* (Chris Beaver and Judy Irving, 1982, New Yorker Films), quoted in *Aperture* #93 (Winter 1982): 10.

17. DeBoskey interview. Over the past fifty years, the government's standards of "safe" radioactive exposure have been lowered by a factor of several hundred times and continue to be greatly reduced.

18. See Robert D. Bullard, *Dumping in Dixie: Race, Class, and Environmental Quality*, Boulder: Westview Press, 1990. For example, in the mid 1970s more than 50 percent of all African-American children in the United States had elevated levels of toxic lead in their blood in amounts known to produce a wide range of negative biological, neurological, and behavioral effects, many of them permanent. See also Peter Montague, "Toxics Affect Behavior," *Rachel's Environment & Health Weekly* #529 (January 16, 1997); and Ann Leonard and Jan Rispens, "Exposing the Recycling Hoax: Bharat Zinc and the Politics of the International Waste Trade," *Multinational Monitor* (January/February 1996): 30–34.

19. See, for example, Angus Wright, "Where Does the Circle Begin? The Global Dangers of Pesticide Plants," *Global Pesticide Campaigner*, Vol. 4, no. 4 (December 1994).

20. Iodine-129, another toxic product of atomic fission (in spent nuclear fuel, nuclear weapons detonation, and atomic fallout), has a much longer half-life of 16 million years. Although less lethal than plutonium, radioactive iodine accumulates in the thyroid glands of humans, where it can cause cancer.

21. On the relationship between nature and the female body, see, for example, Susan Griffin, *Woman and Nature: The Roaring Inside Her*, New York: Harper-Collins, 1979; and Carolyn Merchant, *The Death of Nature: Women, Ecology and the Scientific Revolution*, San Francisco: Harper & Row, 1980.

22. The well-known Zen Buddhist teacher Dr. D. T. Suzuki once remarked about Christianity, "God against man. Man against God. Man against nature. Nature against man. Nature against God. God against nature—very funny religion!" Quoted in Joseph Campbell with Bill Moyers, *The Power of Myth*, New York: Doubleday, 1988, p. 56.

23. For a discussion of other civilizations that destroyed themselves as a result of the overuse and misuse of their environments, and an analysis of modern land practices, see Daniel Hillel, *Out of the Earth: Civilization and the Life of the Soil*, New York: The Free Press, 1991.

24. LaDuke, p. 65.

Afterword:

Our Land, Our Wisdom by Mark Dowie

While orbiting the Earth, astronauts have seen with their naked eyes the Bingham Mine, an abandoned copper open pit mine outside of Salt Lake City. More than once, a long plume of yellow smoke has also been spotted from space, stretching across three states in whatever direction the wind was blowing that day from the Four Corners power plant in Arizona. Also visible is a huge, shining, dark emerald lake nestled against the outskirts of Butte, Montana.

These symptoms of our prosperity are impressive, some of them even hauntingly beautiful from the sky, as David T. Hanson's photographs attest, but they belie a deeper, less visible truth about our use of land. That alluring lake outside Butte, for example. It's another abandoned open-pit copper mine, now filled with water so acidic nothing can live in or near it. It is an ecological time bomb that, like many similar residues of hard-rock mining, could poison land and water far beyond its boundary.

The stains and detritus of mining, logging, and industrial agriculture are so tightly woven into the American landscape that we barely notice them from the ground. And this is only the visible evidence. Beneath these scars lie deep injection wells into which toxic chemicals are pumped: buried nerve gasses, poisoned aquifers, scattered radionuclides, and thinly covered "brown-fields" where hazardous wastes dumped into unlined pits now lie beneath a few inches of dirt. These are some of the hidden legacies of America's last century.

The term "wise use" was coined to describe a philosophy of government and industrial land management—although in the past century of currency, the term has been abused as violently as the land itself. Historians trace the idea of using land "wisely" back to the turn of the century, to Gifford Pinchot, the first professional American forester. In conversations with his friend Theodore Roosevelt, debates with Sierra Club founder John Muir, and a trenchant series of essays entitled "The Fight For Conservation," Pinchot espoused a utilitarian national policy that called for the *wise use* of American land. The term struck Roosevelt, who had seen firsthand the damage wrought by so-called cowboy capitalists, many of whom were his friends and supporters.

At the behest of Pinchot, Roosevelt initiated resource conservation in America. "The wise use of all our natural resources, which are our national resources as well, is the great material question of the day," he announced before a 1908 national conference of scientists, state governors, and business leaders. Roosevelt was the first American president to rein in the excesses of mining and timber barons. He was also the first to differentiate between renewable and nonrenewable resources. To manage our largest renewable resource, he appointed Pinchot to head the U.S. Forest Service, a branch of the Agriculture Department. The President repeated the warning made by his protégé (and by many since) that great civilizations survive only when they practice sound land stewardship. Few of his successors in the White House would heed the word; in fact, the three who followed Roosevelt—Taft, Coolidge, and Harding—were among of the least environmentally conscientious presidents of the twentieth century.

Still, Pinchot and Roosevelt were far from what today we would call "conservationists." Land and resources that were left undeveloped by human endeavor were, according to Pinchot, as "wasted" as land ravaged by miners, loggers, and ranchers. (The original meaning of the very term "wasteland" was not land that had been exploited beyond use, but, rather, land that had been left *untouched*.) A balance must be found, Pinchot insisted, between one heedless practice—land exploitation—and the other—land disuse. Only by opening all land to development, under careful national stewardship, could resources, renewable or nonrenewable, be conserved for future generations. Pinchot's philosophy was no doubt influenced by Jeremy Bentham's concept of "the greatest good to the greatest number" (to which Pinchot added "for the longest time"), and by renaissance businessman George Perkins Marsh's 1864 call for "geographical regeneration." Marsh felt that man was rendering the Earth "an unfit home for its noblest inhabitant." Pinchot's proposal was a convenient compromise between the rapacious practices of the capitalist business moguls and the extreme land-preservationist sentiments of transcendentalist John Muir. According to Muir, humans needed to "wander in wilderness"; and undisturbed land was "a window opening into heaven, a mirror reflecting the Creator." Muir believed that large sections of land had to be left entirely unused by humans in order for their restorative powers to survive. Pinchot's opposing position: Use all the land, but use it wisely.

What Pinchot meant exactly by his term "wise use" remains in dispute. In the ecological debates that raged through the rest of the century, as partisans attempted to fathom Pinchot's vision, both the land and the term became victims of further abuse. And in its long-running discourse on conservation,

the nation remained undecided about its land ethos and the true meaning of land wisdom. The consequences today are blatant—at least from the sky.

Recently, historians have started to conceive of American environmentalism as having developed in three waves. The first wave, under President Roosevelt, ushered in the era of land and wildlife conservation. The second, inspired largely by Rachel Carson's 1961 *Silent Spring*, brought a decade of landmark environmental legislation banning or limiting the pollution of land, air, and water. The third wave came during the Reagan years—and that rough wave is still washing over us. Over the course of this twentieth century, it might have been expected, as the country made strides in so many social respects—universal suffrage, civil and human rights, fair labor practices, and the liberation of women—that progressive conservation would ultimately become *truly* progressive, and the nation's use of the land more sensitive to the lives that depended upon it, both wild and human. Plainly, this has not happened. As recently as the late 1950s, half a century after the publication of Pinchot's first essay, corporate executives were arguing before congress that the owners of land bordering rivers were entitled to do whatever they pleased with the river's water, or to toss whatever they pleased into the stream. While those rights were quite sensibly denied, the acid pits, evaporation ponds, and subterranean tanks that were nevertheless deployed to store toxic industrial wastes only delayed for a decade or two the poisoning of the nation's aquifers and surface water.

Despite a ten-year initiative sparked by passage of the Federal Water Pollution Control Act in 1970, water pollution became so severe by 1980 that congress passed a law creating a $1.6 billion "Superfund" to clean up the toxic miasma left in abandoned ponds, tanks, and wells across the country. The Environmental Protection Agency has identified 1,210 sites requiring remediation. But in the seventeen years since the fund was created, only 125 have been cleaned up, while an unseemly share of the appropriation—now estimated at nearly 70 percent—has been paid to lawyers haggling over who is ultimately culpable for the mess, and who (besides their clients) should pay for the remediation. The total cost of cleaning up the remaining sites, which now includes our nuclear weapons effluvia, is estimated at close to a trillion dollars.

While attorneys litigate and congress debates Superfund amendments, every year another 275 million tons of hazardous waste are pumped into landfills, waste ponds, underground tanks, and deep-injection wells. The rest is "treated" with advanced waste-management technologies, with such lofty names as "biological decomposition," "chemical neutralization," "steam stripping," "solidification," and the perennial favorite of waste engineers, "incineration."

The bottom line of most methods, high- and low-tech, legal and illegal, old and new, is that land and water will become the eventual recipients of industrial waste.

By the mid 1980s Americans were so inured to land abuse that few even blinked when the National Academy of Sciences (NAS), in a published report, used the disturbing phrase "national sacrifice area" to describe dry western land existing above vast coal deposits, which could only be harvested, the NAS concluded, by strip mining. After it was mined, the land would be virtually dead. However, at least to some of our leading scientists, it was worth the sacrifice. What made it all easier was the fact that pristine wilderness had already been sacrificed for bombing ranges, nuclear-test sites, open-pit mines, and military-waste dumps—millions of acres rendered permanently sterile, beyond regeneration, also for the sake of *national security*.

The only thing that seems truly secure in the western wilderness is a spurious legal theory that regards mineral, timber, and grazing leases on public land as private property. It is on that theory that today's "cowboy capitalists" rely to preserve their alleged right to free or very inexpensive resources.

Concurrent with our abuse of land has been an abuse of science. When it isn't perverted outright, science is obscured by a senseless exchange of frightening scenarios and apocryphal anecdotes regarding the issues at hand. In the course of debate over environmental policy, high-profile, industry-supported "skeptics" are paraded before congress and the media to establish uncertainty about the findings of environmental scientists—uncertainty being of course the best antidote to regulation. Though few of these skeptics have ever published a peer-reviewed paper, and though they have scant credibility in their alleged field of science, their testimony is published and they are widely quoted by the press—in the interest of "objectivity."

Meanwhile, polluting industries and their representatives in congress complain that scientific testimony relating to issues such as ozone depletion, global climate change, and the human health risks of dioxin exposure are systematically exaggerated by environmentalists, and that the views of their own experts are ignored or suppressed. A positive turn appeared, however, with a recent report from the House Committee on Science, whose subcommittee on Energy and Environment hears most of the scientists on both sides. Their conclusion was that pro-industry members, many of whom had allowed industry lobbyists to draft anti-environmental legislation, had "failed to produce credible evidence substantiating any of the claims of scientific misconduct [on the part of environmentalists]. To the contrary, the record shows that environmental research was carried out in an objective manner, consistent with the norms of

scientific integrity and without preconceived political or scientific outcomes."

Environmentalists pressure governments to act on evidence that presumes a risk, while regulated industries and their scientists, heeding their own call for "sound science," insist that we wait for certainty—conclusive evidence that the environment is being damaged—before regulating industrial practices. When extractive industries outgun environmentalists ten to one with lobbyists and dollars, as they do in Washington, the result is a regulatory process that presumes great benefits from most technologies and barely keeps pace with their risks.

Land management is one of the best models for observing and understanding this conflict. As scientists have been drawn into land-use battles, conservation has inevitably become a scientific endeavor, and what wilderness remains is now a laboratory for geologists, hydrologists, foresters, biologists, agronomists, and engineers. The field of conservation biology emerged—and with it a new concept of land stewardship, often described as "managed wilderness." It sounded like an oxymoron at first, but before long most ecologists and all too many environmentalists had accepted wilderness management as a pragmatic necessity—the only way to save what was left of the wild. Today, the wild is observed, tracked, and probed with sophisticated measuring devices implanted into flora and fauna by scientists. While conservation biologists have discovered some remarkable things about the wild with these and other means, and even fostered some new concepts about how land responds to abuse, they have yet to discover how to steward the land in a truly prudent way. Excessive engineering and squandering of resources remain part and parcel of our national policy; we allow the energy industry to continue its colonization of public land, and we stand by as they battle with scientists and environmentalists over the management (or mismanagement) of our last patches of wilderness. The sanctity of wilderness, a notion that was embraced by the first Americans, has been lost in this process, along with much of our European forebears' traditional sense of affection for the land. Today it has become increasingly difficult to become impassioned about "wild" land, when it seems no longer to exist in an unmonitored state.

The manufactured tension between scientific uncertainty and presumptive evidence explains almost everything about the way we protect our environment, whether from resource exploitation, toxic pollution, or climatic chaos. The protection it offers seems minimal when one considers the number of carcinogens, mutagens, and teratogens found in human and animal body fat, nearly all of which have increased steadily since they were first assayed in the mid 1960s. That fact alone should provide adequate evidence that insisting upon scientific certainty protects neither land nor health. Yet we persist, as a matter of national policy, in waiting for disaster before changing the way we mine, log, farm, and manufacture our tools and toys.

Even with all we have learned from disaster, we have done very little. We now know, for example, that mineral tailings are an ecological mine field, capable of sudden and widespread degradations. We learned this in Church Rock, New Mexico on July 16, 1979, when an earthen tailings-dam broke, creating the largest accidental release of radioactive material in U.S. history. Thousands of acres of land and millions of gallons of fresh water were contaminated that day, contamination that will last for many generations to come.

Yet, in defense of free enterprise, and to avert a perceived "strategic mineral gap," we still allow huge corporations, domestic and foreign, to pile toxic slag up around their excavations. Our hard-rock mining law, signed by Ulysses S. Grant more than 120 years ago, allows it. The same law permits anyone who discovers a "valuable mineral" in the public domain to claim the land for $100 a year per mining claim, remove the ore without paying royalties, purchase title to the land and minerals for $2.50 or $5 an acre, and leave the site without cleaning up. And there is no Superfund for mines. That 1872 National Mining Law creates a billion-dollar annual drain on the Treasury—not including $2 to $4 billion in lost royalties. Attempts were made in the 103rd and 104th Congresses to reform the old law—to no avail. Hard-rock prospectors and miners are the stuff of legend, icons of American enterprise. And their lobby is awesome. An identical bill will be introduced in the 105th, with little chance of passage.

Though clear-cutting forests is never beneficial to watersheds or sensitive species, and is never a boon to the forest itself, the U.S. Forest Service, under a policy called "intensive management," continues to sell, at bargain prices, millions of acres of timber to transnational logging companies, permitting them to clear-cut large stands of old-growth trees and export the logs, unmilled or processed, to overseas buyers. The 1976 Forest Management Act explicitly mandates "diversity of plant and animal communities"; nonetheless, botanists, foresters, and grass-roots environmentalists are constantly suing the Forest Service to set aside areas in the forest for the preservation of biodiversity.

Heightening corporate profitability (and deepening the national debt), the government pays to construct logging roads through ecologically sensitive areas, so Weyerhaeuser Paper Company, Georgia Pacific, and Plum Creek Lumber can haul out the unmilled timber and ship it to Japan. The loss to taxpayers from this "get out the cut" policy is estimated by the Government Accounting Office to be about half a billion dollars a year. The loss of wages to mill-workers is huge.

It is difficult to see the wisdom in all this. Why keep the Forest Service in the Department of Agriculture, which regards trees as a cash crop, rather than a natural resource? As it operates today, the agency might as well be a branch of Commerce. Where is the sense in allowing a government agency to become the servant of the very industry it was formed to contain? Is single-use management *wise use*? Does cutting down the last remaining 5 percent of our ancient forest make sense? Why should we be asked to subsidize the degradation of our own land?

As the century has progressed, the concept of *wise use* has mutated to such an extent that it is now put to the service of the extractive industries. Over the past ten years, a renegade Sierra Clubber named Ron Arnold has set out, in his own words, "to destroy environmentalism for once and for all." A spellbinding speaker and brilliant organizer, Arnold has had little trouble gathering a flock of followers. Hard-rock miners, loggers, and public land ranchers—people to whom it has never been easy to sell the environmental message, people who feel their livelihoods may be in jeopardy—line up to support him. Wrapping himself in the mantle of Pinchot, Arnold has effectively organized a nationwide backlash against everything that Pinchot stood for. It is deeply ironic that the term "Wise Use" has come to be appropriated as his movement's trademark. And however deceptive it may be, the appeal of his message is very real to hard-working farmers, loggers, and miners—the very people environmentalism needs to reach if it is to survive as a relevant and effective movement.

The new Wise Use Agenda, hammered out at national conferences held in 1993 and 1994, calls for immediate development of petroleum resources in the Arctic Wildlife Refuge, logging three million acres of the Tongass National Forest, opening all public lands (including designated wilderness areas) to mining and energy production, amending the Endangered Species Act to "identify endemic species lacking the biological vigor to survive in range," the use of federal gasoline tax to create multiple-use trails for off-road vehicles, and the conversion of "all decaying and oxygen-using forest growth in the national forests into young stands of oxygen producing CO_2 absorbing trees to help ameliorate the rate of global warming and prevent the greenhouse effect." (This last provision sounds sensible enough, until one realizes that it mandates the wholesale clear-cutting of old growth timber in national forests.)

But agenda is mere propaganda to Arnold, who wants nothing less than the complete elimination of the "greens." "We're out to kill the fuckers," he exhorted a crowd of angry loggers in rural Oregon. "We have to pick up a sword and shield and kill the bastards," he told another in New Mexico. Though Arnold has recently hedged his rhetoric ("I meant politically [kill them], not

physically"), his followers are steeped in fear and anger. His movement has a magnetic appeal for small landowners who have been told time and again by itinerant organizers that the federal government is out to steal their land, and that environmentalists are conspiring in the theft. There have been some flashes of violence—face punching, arson, small bombs; so far only one death.

Arnold and his followers have achieved a disturbing level of success: the environmental covenants in the Republican majority's "Contract With America" are an adaptation of the Wise Use Agenda; and the Clinton administration, arguably the greenest ever, has been a deep disappointment to environmentalists, too many of whom politely accept the crumbs the White House has tossed to them. Most of the public land-management promises made by Clinton and Gore during the 1992 presidential campaign—reform of the Forest Service, amendment of the 1872 Mining Law, higher grazing fees from the Bureau of Land Management, and a national biological survey—have been fudged, broken, or forgotten.

We have had warnings—mostly unheeded—about the profligate expenditure of our land. In our urgency to make the desert bloom we have, in the blink of a geologic eyelash, created dust bowls from Oklahoma to Louisiana. Every year one or more of our great river systems are silted with more topsoil from our prairies. We have witnessed the extinction or near-extinction of the bison, the carrier pigeon, the gila trout and many other creatures, all seen by our fore-bears in great herds and flocks.

New consequences of our land policy and new scars seem to appear every day. The Mississippi basin floods again for the second consecutive year. So does the California coast. Every year about thirty-five square miles of coastal Louisiana (the equivalent of a football field every fifteen minutes) erodes into the Gulf of Mexico. In the winter of 1996–97 entire mountainsides of mud slid into Portland, Oregon off steep slopes recently denuded of trees. Meanwhile, human and animal cancer and birth-defect rates rise, in defiance of medical breakthroughs (which may not surprise us when we are told that nearly 100 million Americans are drinking toxic water from their taps—an undeniable consequence of land abuse).

Strangely, with these disastrous situations in place, we have deduced that we can abuse more land and survive—even as our prairies are failing and forests dying. We seem to be testing the thesis that civilizations can endure and prosper, without a wholesome natural environment, and an ethic that says we are part of, not masters of, the land.

How long will this tough but finite land support its human load before it collapses into sterility, taking with it the civilization it has carried for four

hundred years? Do we know its carrying capacity? Will we wait for the land to reveal it to us in some hideous way?

It is taking non–Native Americans a long time to overcome the myth of environmental inexhaustibility, and to realize that, as our population and economic infrastructures grow, the land upon which we exist does not. But there are signs of awakening, and some reasons to be hopeful, if not entirely optimistic, about the future of American land. The "third wave" of American environmentalism may be ebbing now, and in a few years historians and sociologists may well describe it as a last desperate attempt by corporate America to capture the nation's environmental imagination. For indeed it is American civilization's vivid environmental imagination—which has now been turned into a political movement—that may give us a future.

On an everyday level, Americans are developing new habits and coming to new awarenesses about their environment. There are organic options in supermarkets in even the remotest areas of the country. New laws on recycling are being instituted across the country—and slowly, people are changing their routines to incorporate those new rules into their lives. In servicing the demand for "greener" products, organic farmers, holistic ranchers and a few small logging companies scattered through the Northwest are discovering that in the long run, land stewardship and sustainable agriculture pay off. They may still be defining "sustainability" in their own interest, but they are discussing it with people who aren't. Gradually, small patches of stressed land are being restored to a healthier, more productive state. Meanwhile, land that has been severely overtaxed by chemically based, monocrop agriculture is being allowed to rest. Encouraged by the federal Conservation Reserve Program, 36 million acres, or 9 percent of American cropland, has been retired from production since 1985. Soil erosion on that land has dropped by 93 percent.

And the land-trust movement has taken hold. Since 1990 14 million acres have been sold or donated to regional, state, and local trusts—a 49 percent increase in just seven years. Most of that land is now protected forever from real-estate development, shopping malls, industry, or any kind of extractive use. Agricultural land protected by similar conservation easements will be farmed by families that care deeply about the future of their soil, trees, and grasses.

There are signs also of some opposition to the Wise Use backlash—creative alternatives to land abuse in the heartland. Plans and proposals are afoot, for example, to restore vast expanses of prairie to its original biological makeup—removing fences, reintroducing native grasses, and allowing the bison to roam free again. And rural communities across the country are reorienting themselves around their watersheds, over a thousand of them in the lower forty-eight states.

These collaborative ecosystem-coalitions, or "watershed groups," restore streams, replant forests, restock anadromous fish, and, most important of all, discuss the value of creating new civil authorities to protect their watersheds from national and international cut-and-run industries. In the headwater valley of California's Feather River, for example, a local citizen-based initiative called the Quincy Library Group has developed an ecosystem-management plan based on natural systems and involving all stakeholders, for the 2.5 million acres of prime federal timberland in its bioregion. The President's Council on Sustainable Development held the Quincy Library as a model of collaborative community planning.

Also heartening is the fact that scientifically astute, uncorrupted leadership is beginning to surface in the Forest Service. New officers are admitting that they may not have completely mastered the art of forestry, while the Service's biologists concede that eliminating "varmints" such as wolves and coyotes to protect cows and sheep is bad ecological policy. And there are recommendations from government analysts on both sides of the Beltway to move the agency into a more appropriate department—Interior, for example. Meanwhile farmers and manufacturers are experimenting with plant substitutes for wood fiber, such as kenaf and hemp. Millions of trees, now ground into pulp for paper, cardboard, and building materials, could be spared by these fibers.

Mining remains a problem. There are few if any examples of successful ecological turnaround in the industry. And without a strong law that protects the land, there seem to be no incentives, economic or moral, for mining corporations to apply stewardship or consider ecological sustainability their business. As long as minerals are valuable and public land accessible, miners will continue to scar it. The issue of a mining reform is regularly introduced and debated before every new congress. One day it may pass. For now, environmentalists and watchdogs will have to be content with occasional tweaks of rules and regulations from the White House.

In the meantime, environmental leaders and activists will continue to reexamine ancient ecologies in search of lost wisdoms about our relationship to land. Some will challenge the anthropocentrism found so deeply embedded in our land ethic. Others will reread the widely neglected classics of true American land wisdom, written by Henry David Thoreau, John Muir, Robert Marshall, and Aldo Leopold—who left with us the simple ethos: "A thing is right when it tends to preserve the integrity, stability and beauty of the biotic community. It is wrong when it tends otherwise."

Acknowledgments

The works included in this book were more collaborative than they might seem, and I am indebted to many generous and talented people. I cannot adequately express how deeply I appreciate their many kindnesses and contributions to my work and to my life.

Several of the photographic series represented in this book were supported in part by a John Simon Guggenheim Memorial Fellowship, two National Endowment for the Arts Visual Artist's Fellowships, and grants from the Rhode Island State Council on the Arts and Rhode Island School of Design (Faculty Development Grants). I am enormously grateful for their substantial support and for the resulting time and resources that allowed me to make much of this work. I would also like to thank H P Marketing Corp. and Ken-lab Inc. for their generous loans of equipment which significantly enhanced my work on the *Waste Land* series. In this publication, and in my *Waste Land* series, I have used modified United States Geological Survey topographic maps and quoted Environmental Protection Agency documents—I am fortunate that these materials are available for public use.

This book owes much of its existence to the assistance, commitment and hard work of Robert Glenn Ketchum and the Advocacy Arts Foundation. At a number of key stages Robert helped me to negotiate the challenges inherent in publishing a book of this nature and helped raise the funding necessary to subsidize its publication. I am most thankful for all that he has done to make my work and ideas available to a wider audience. I am also indebted to Michael Hoffman and the staff at Aperture, and especially appreciate the help and hard work that Diana Stoll, Ivan Vartanian, Helen Marra, and Stevan Baron put into the making of this book. It has been a pleasure for me to work once again with Bethany Johns, a remarkable book designer. I am delighted that Wendell Berry, Mark Dowie, Susan Griffin, William Kittredge, Peter Montague and Maria B. Pellerano, and Terry Tempest Williams all kindly agreed to write for this book on short notice and within a limited time frame. I have tremendous respect for each of them, and am honored to have them contribute to *Waste Land*.

My work and research were facilitated and assisted at key stages by a number of people who gave generously of their time and energy, sharing their knowledge and insights with me: Colstrip pilot Bill Mayo; on the military and nuclear infrastructure, Robert S. Norris and William Arkin at the Natural Resources Defense Council; at the U.S. Environmental Protection Agency, Clay Lake (Office of Research and Development) and Stephen Ostradka (Technical Support Unit); on the Rocky Flats Plant, Ken Korkia of the Rocky Flats Citizens Advisory Board, and Bruce DeBoskey; geologist David Love; Hank Fischer of Defenders of Wildlife; Edwin Dobb and Steve Blodgett in Butte; and Montana biologist David Genter, who was particularly generous and helpful with his expertise. My essays were greatly improved by the editorial insights and suggestions of Diana Johnson and Diana Stoll, and the critical readings of several colleagues and friends, particularly Lisa Dority, Tracy Coleman, Gary Metz, Peter Montague, and Manjushree Thapa. I am grateful to Tom Turner of the Sierra Club Legal Defense Fund and to Carlos Da Rosa of Mineral Policy Center for taking the time to read the texts in this book to check for factual accuracy. At Rhode Island School of Design, Wendy Snyder MacNeil, Gary Metz, and William Parker were especially helpful to me with the earlier work represented in this book—I owe a great deal to their critical insights, assistance, and support. A number of curators and critics have helped me find a wider audience for my work, and I am especially grateful for their support and interest in my work: Sally Eauclaire, Merry Foresta, Suzi Gablik, Peter Galassi, Diana Johnson, Mark Leach, Gordon McConnell, Sandra Phillips, Robert Sobieszek, John Szarkowski, David Travis, and Adam Weinberg. Among photographers, the friendship and support of Robert Adams and Lewis Baltz have meant much to me. I want to thank the skilled craftsmen who have helped me with the fabrication of my work. In printing some of the reproduction photographs, I worked with two superb printers: Bob Liles (*Minuteman Missile Sites*) and Ned Gray (*Waste Land* and *"The Treasure State": Montana 1889–1989*). In producing the *Waste Land* maps, I was greatly assisted by the refined skills of the artist Hada and the dedication of my assistant Linda Mary Remington, who also helped me with many other aspects of this publication. The care and precision of Daniel Getz Clayman's glasswork and Jamie Dearing's framing and finishing made a significant difference in my works for *"The Treasure State": Montana 1889–1989*. Renate Gokl's graphic design skills and refined sensibility have contributed greatly to several of these projects. Cathy Carver worked very hard to make the quality reproduction transparencies for this book.

I am fortunate to have a wonderful community of close friends. Many of them have helped me in a variety of ways both tangible and intangible, and I deeply appreciate their friendship, assistance and support: Lisa Dority and Jeff Bruff, Suzanne and Anthony Lawlor, Molly Lusk, Will Mentor, Mark Paul Petrick, Jarrad Powell, and Manjushree Thapa. Unfortunately, I cannot personally acknowledge here many other remarkable individuals who have helped me personally and professionally over the course of this work, and to whom I feel tremendous gratitude.

I would like to especially thank all of my teachers over the years who have given so freely of their knowledge and wisdom. I want to acknowledge here the special debt that I feel to two remarkable photographers and teachers whom I was privileged to study with and assist: Minor White and Frederick Sommer. I owe more than I can say to the time that I spent with them and the continuing inspiration of their photography and thinking.

Finally, it is impossible for me to put into words how much I owe to my family: Margaret and Jay Costan; Sara and John Walsh; my nieces and nephew, Constance, Elizabeth, Alexandra, and Jonathan, who embody my hopes for the future; and especially my parents, Constance and Norman Hanson, who have been a source of strength, wisdom, love and inspiration. I am deeply grateful for the love and support that they have all given me. I have been truly blessed.

Contributors

David T. Hanson was born and raised in Montana. He was awarded a B.A. in English Literature from Stanford University in 1970. Hanson studied with and worked as an assistant to Minor White and Frederick Sommer, and earned an M.F.A. in Photography from Rhode Island School of Design in 1983. A photographer, mixed-media installation artist, writer, and teacher, he has taught in the departments of Photography and Landscape Architecture at Rhode Island School of Design since 1983. He has received a number of awards for his work, including a John Simon Guggenheim Memorial Foundation Fellowship and two National Endowment for the Arts Visual Artists Fellowships. His work has been included in numerous museum exhibitions, including major shows at The Museum of Modern Art, The Art Institute of Chicago, the San Francisco Museum of Modern Art, the Los Angeles County Museum of Art, and the National Museum of American Art.

Wendell Berry is the author of more than thirty books, including *Fidelity*; *Entries*; and *A Place on Earth*. He is a past fellow of both the Guggenheim Foundation and the Rockefeller Foundation, and is a former Stegner Fellow at Stanford University. He lives and farms in Henry County, Kentucky.

Mark Dowie is the author of many award-winning articles on environmental topics, ranging from waste management, the automotive industry, and logging in Northern California, to the Dalkon Shield Corporation. His work has appeared in *Harper's*, the *New York Times*, the *Wall Street Journal*, and many other publications. Dowie is the former editor and publisher of *Mother Jones* magazine, and is the recipient of fourteen major journalism awards, including an unprecedented four National Magazine Awards. His latest book, *Losing Ground: American Environmentalism at the Close of the Twentieth Century* (MIT Press), was nominated for a Pulitzer Prize.

Susan Griffin is the author of many books, including *A Chorus of Stones*, which won the Bay Area Book Critics' Award, and was nominated for both a National Book Critics Circle Award and a Pulitzer Prize. She is the recipient of a MacArthur grant for Peace and International Cooperation, a National Endowment for the Arts Fellowship, as well as an Emmy Award for her play *Voices*.

William Kittredge recently retired after twenty-eight years of teaching creative writing at the University of Montana. His most recent book is *A Portable Western Reader*.

Peter Montague is the cofounder and director of the Environmental Research Foundation (ERF) in Annapolis, Maryland. He has co-authored two books on toxic heavy metals in the natural environment, has taught graduate and undergraduate courses at the University of New Mexico in Albuquerque, and has been a senior research analyst for Greenpeace. He is the editor of ERF's weekly newsletter, *Rachel's Environment & Health Weekly*, which provides grass-roots environmentalists with technical information about pollution and health.

Maria B. Pellerano is the associate director of the Environmental Research Foundation. She is the associate editor of *Rachel's Environment & Health Weekly*. She holds a master's degree in Art History from Rutgers University and has worked as an assistant curator of photography at The Art Museum at Princeton University. She is the author of several books and articles on environmental issues, as well as the co-author of *Minor White: The Eye that Shapes* (1989).

The recipient of both a Guggenheim Fellowship and a Lannan Literary Fellowship in creative nonfiction, **Terry Tempest Williams** is currently the Shirley Sutton Thomas Visiting Professor of English at the University of Utah. She is the author of several books including, most recently, *An Unspoken Hunger—Stories from the Field* and *Desert Quartet—An Erotic Landscape*.